THE ART OF THE MASS EFFECT UNIVERSE

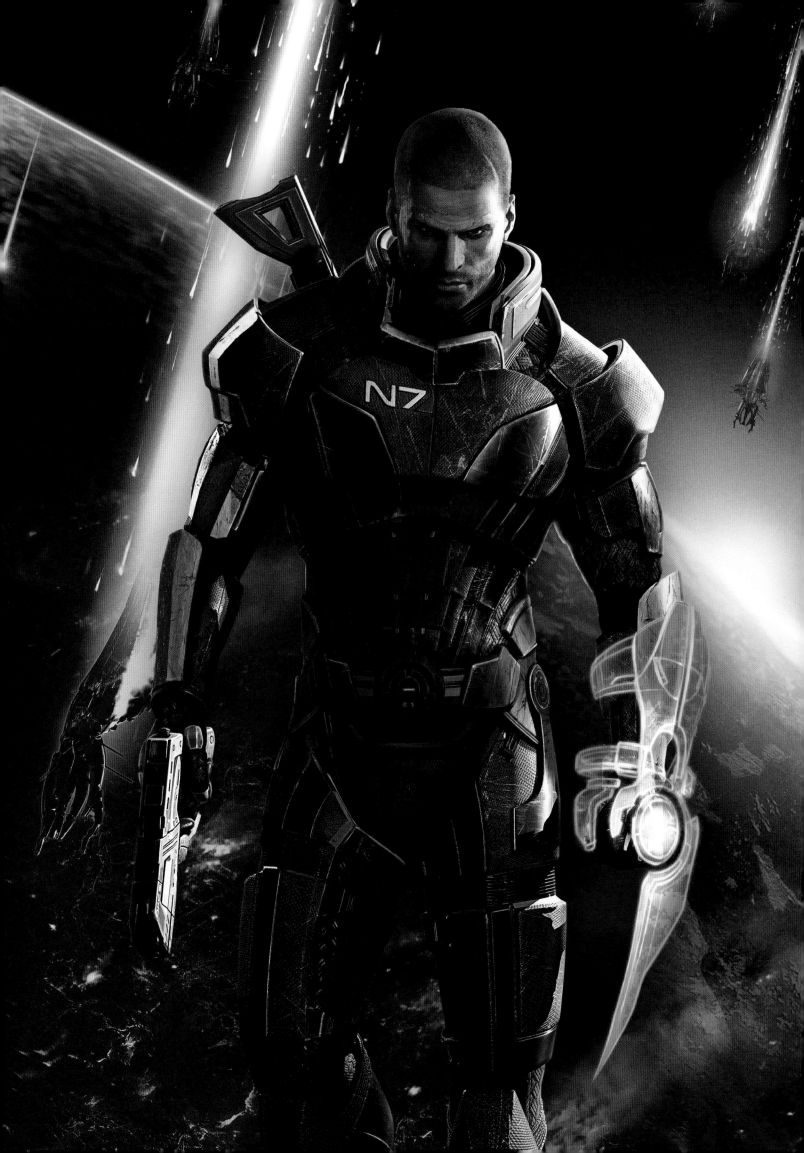

THE ART OF THE MASS EFFECT UNIVERSE

CAPTIONS BY

CASEY HUDSON
EXECUTIVE PRODUCER

DEREK WATTS
ART DIRECTOR

CHRIS HEPLER
WRITER

PUBLISHER
MIKE RICHARDSON

DESIGNER
STEPHEN REICHERT

DIGITAL PRODUCTION
CHRIS HORN

ASSISTANT EDITOR
BRENDAN WRIGHT

EDITOR
DAVE MARSHALL

THE ART OF THE MASS EFFECT UNIVERSE

PUBLISHED BY DARK HORSE BOOKS
A DIVISION OF DARK HORSE COMICS, INC.
10956 SE MAIN STREET
MILWAUKIE, OR 97222

DarkHorse.com

LIBRARY OF CONGRESS CATALOGING-IN-PUBLICATION DATA

THE ART OF THE MASS EFFECT UNIVERSE / WITH INTRODUCTIONS AND CAPTIONS BY CASEY HUDSON, EXECUTIVE PRODUCER ; DEREK WATTS, ART DIRECTOR. -- 1ST ED.
P. CM.
ISBN 978-1-59582-768-5
1. VIDEO GAMES. 2. COMPUTER GAMES. 3. COMPUTER WAR GAMES. 4. FANTASY IN ART.
I. HUDSON, CASEY. II. WATTS, DEREK.
GV1469.27.A79 2012
794.8--DC23
2011023759

FIRST EDITION: FEBRUARY 2012

5 7 9 10 8 6 4
PRINTED IN CHINA

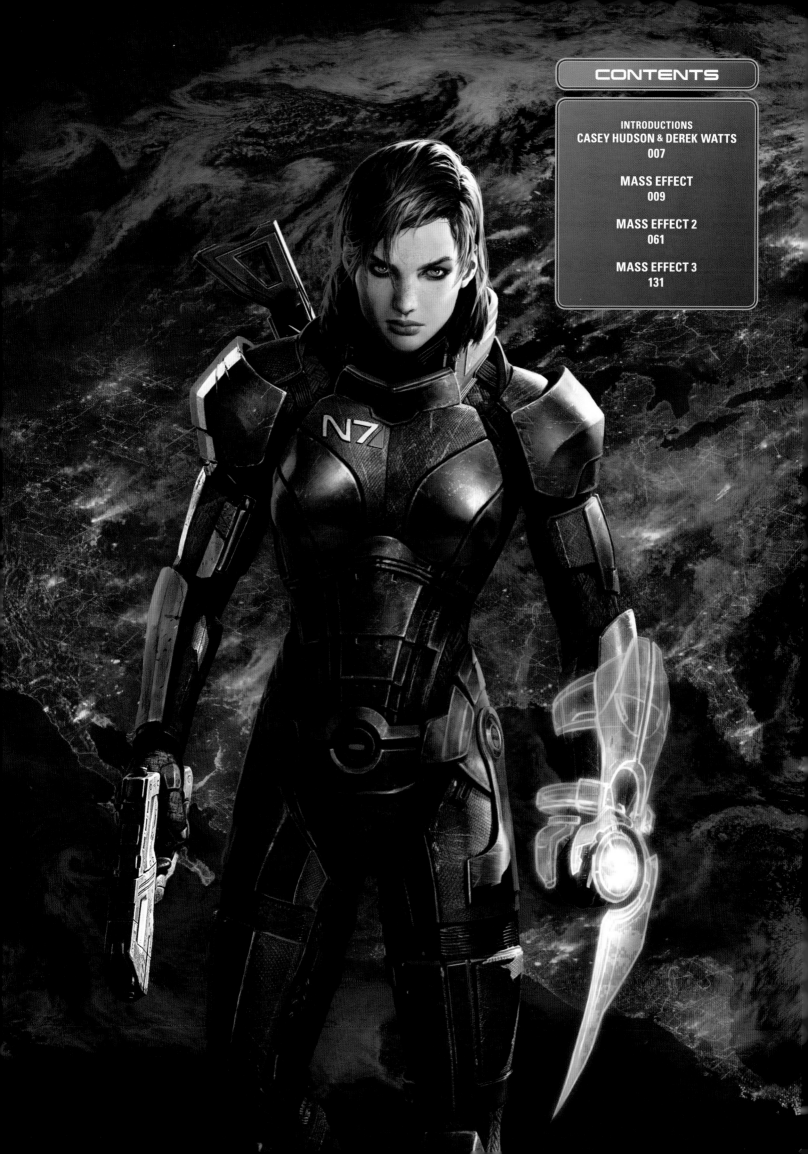

CONTENTS

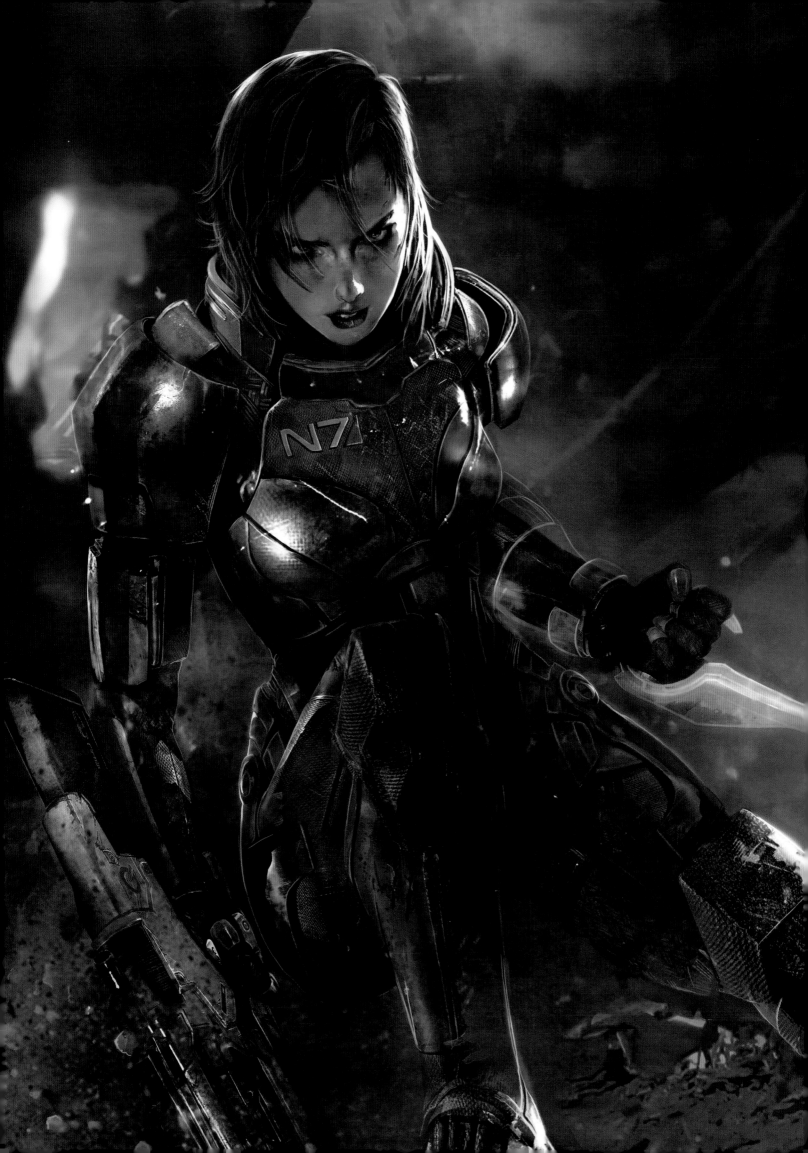

Mass Effect 3 represents the achievement of an incredible goal: a major video-game series that was envisioned as a trilogy from the very start. More importantly, it is a trilogy where *players* decide how the story unfolds—the consequences of their decisions impact not just one game, but the entire series.

The two biggest challenges in accomplishing this ambitious plan were that each game had to become popular enough to warrant a sequel, and—even harder—that each game had to get finished; both things are rarities in a winner-take-all industry where games are often delayed or cancelled altogether. Not only did our team at BioWare drive each game to completion, but each installment went on to become a commercial and critical hit. This is a testament to the talent and professionalism of the artists at BioWare, and to their creative vision for the *Mass Effect* universe.

In the eight years that we worked on this trilogy, we watched the *Mass Effect* universe take shape, from the first tentative brush strokes in 2004 to the spectacular realism of the worlds experienced in *Mass Effect 3*. While we always intended to give players an expansive new universe to play in, we never could have imagined the response we've had from fans around the world. For them, and for us, *Mass Effect* is more than a video game—it has become a place filled with the memories of friendships, rivalries, wondrous visions, and thrilling adventures.

It has been an honor and a pleasure to work with the art team in the creation of the *Mass Effect* universe. This book is a record of that artistic journey, and I hope you enjoy it.

Casey Hudson
Executive Producer

It's been eight years since Casey and I sat down and started talking about *Mass Effect*. The project's code name was *SFX*, and the rest was open territory—a scary thought when presented with the task of visualizing a new universe that needed to resonate with the audience, stand out from the crowd, and be rich enough to carry the license long after the completion of the original game.

When conceptualizing the *Mass Effect* universe, we kept a few artists and architects in mind. We drew inspiration from Syd Mead, John Harris, John Berkey, and Santiago Calatrava—just a few of the visual mavericks we looked to. We pored over thousands of images and countless movies to draw every bit of reference we could obtain.

It has been fascinating to see *Mass Effect* grow over the years. In the beginning, we were constantly compared to other games and artists, and then, as the series grew and matured, we started hearing how other games were looking like ours. People are looking at products coming out now and are saying, "Hey, that looks like *Mass Effect*!"

It is impossible to do justice to the monumental task it was to build a project of this scale. The passion and dedication of hundreds of artists, drawing over ten thousand concepts and working countless hours, doesn't fit between two covers. Without them, the vision for the universe would have failed, and *Mass Effect* would've been just another title on a long list of forgotten games. I hope this book serves as a window into our artists' minds and shows how they helped create the universe called *Mass Effect*.

Derek Watts
Art Director

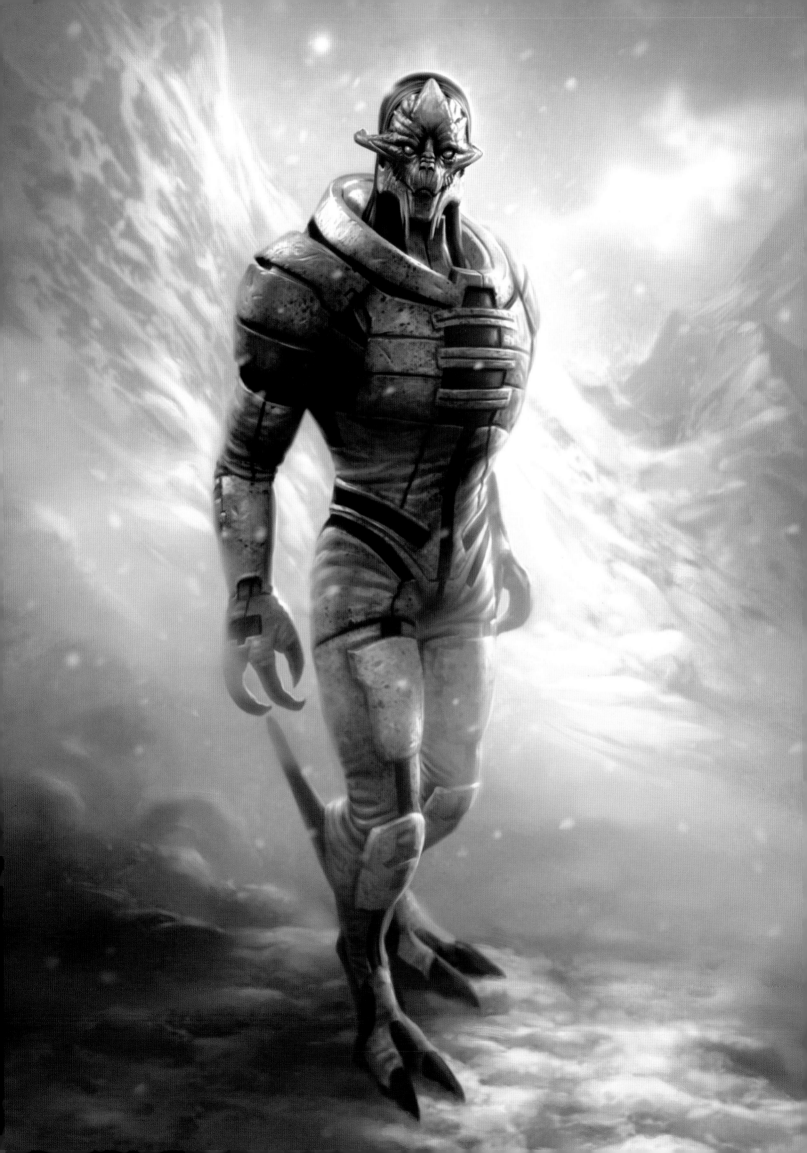

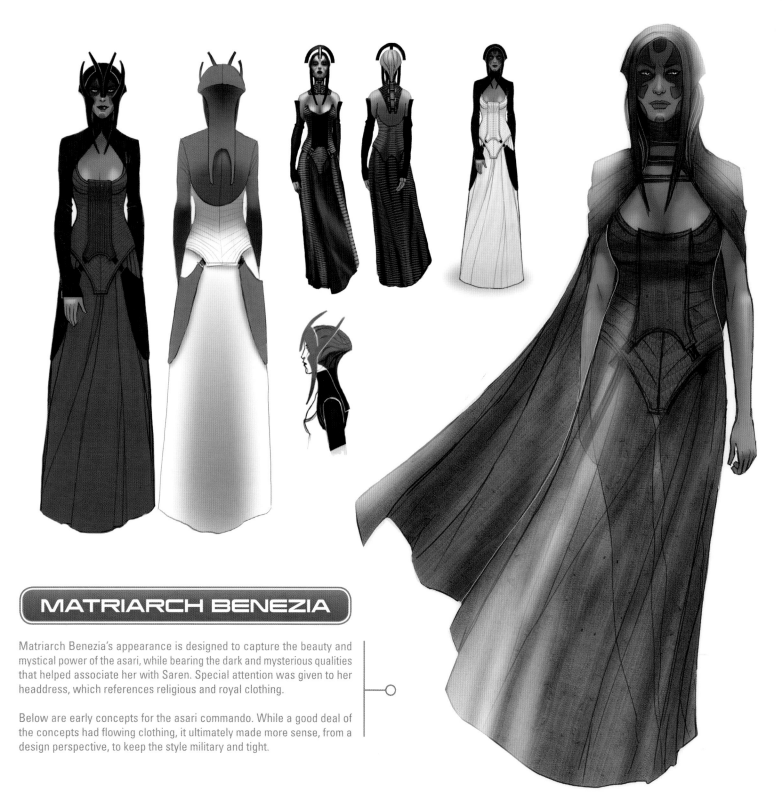

MATRIARCH BENEZIA

Matriarch Benezia's appearance is designed to capture the beauty and mystical power of the asari, while bearing the dark and mysterious qualities that helped associate her with Saren. Special attention was given to her headdress, which references religious and royal clothing.

Below are early concepts for the asari commando. While a good deal of the concepts had flowing clothing, it ultimately made more sense, from a design perspective, to keep the style military and tight.

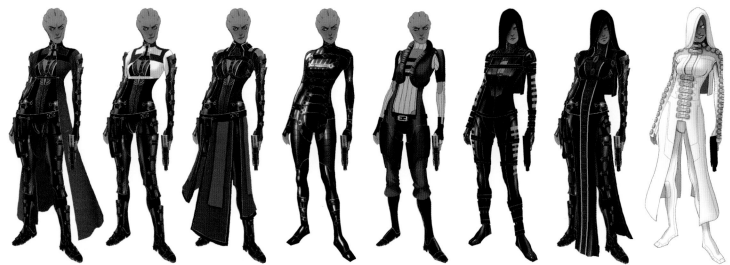

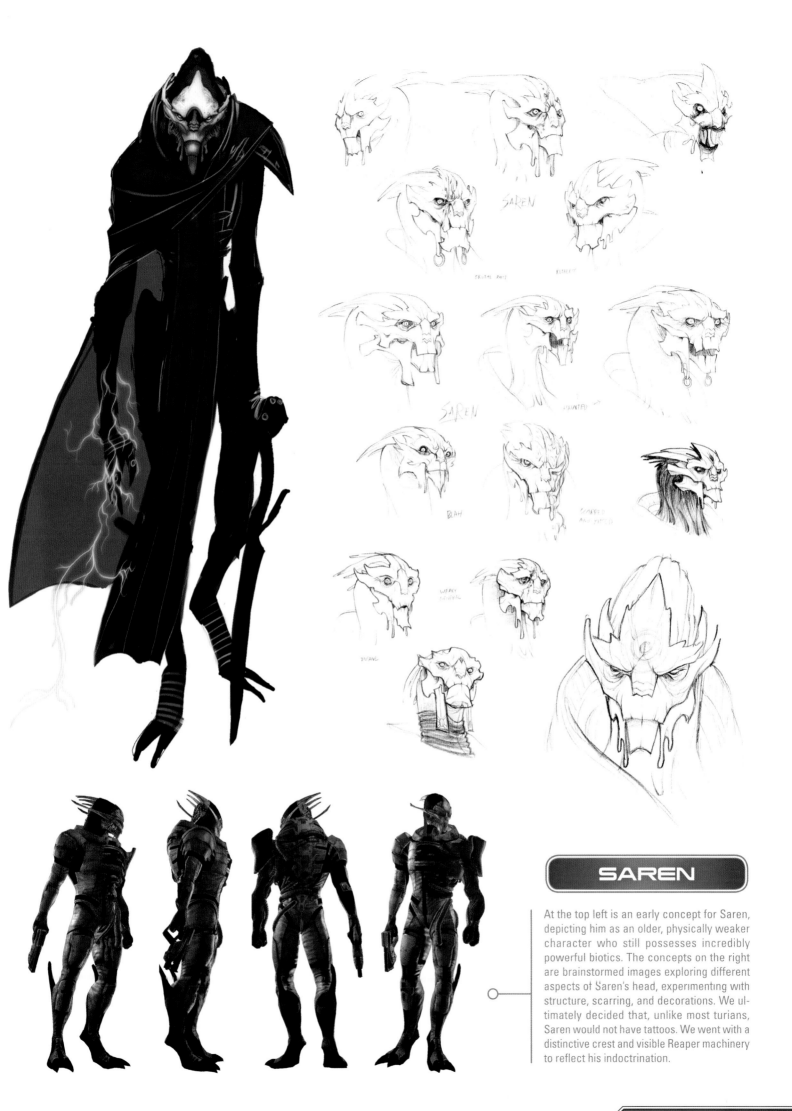

SAREN

At the top left is an early concept for Saren, depicting him as an older, physically weaker character who still possesses incredibly powerful biotics. The concepts on the right are brainstormed images exploring different aspects of Saren's head, experimenting with structure, scarring, and decorations. We ultimately decided that, unlike most turians, Saren would not have tattoos. We went with a distinctive crest and visible Reaper machinery to reflect his indoctrination.

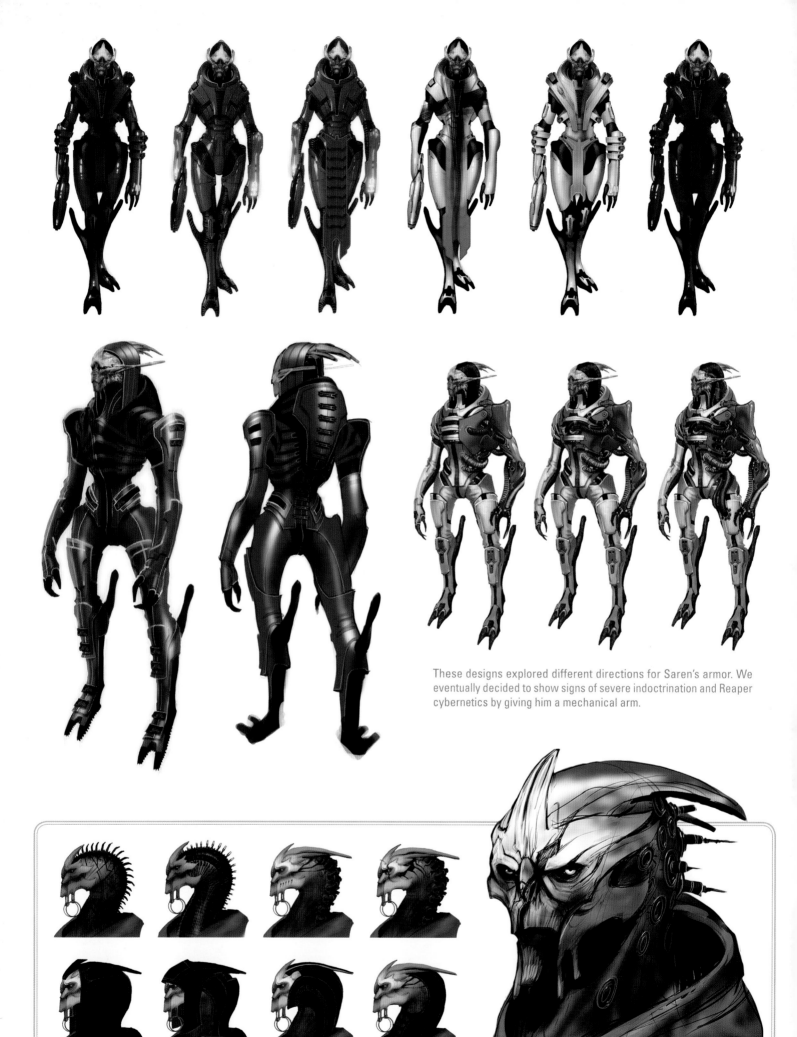

These designs explored different directions for Saren's armor. We eventually decided to show signs of severe indoctrination and Reaper cybernetics by giving him a mechanical arm.

We tried several concepts for Saren's head. His final appearance was kept similar to other turians, allowing him to blend in to society rather than be an obvious monstrosity.

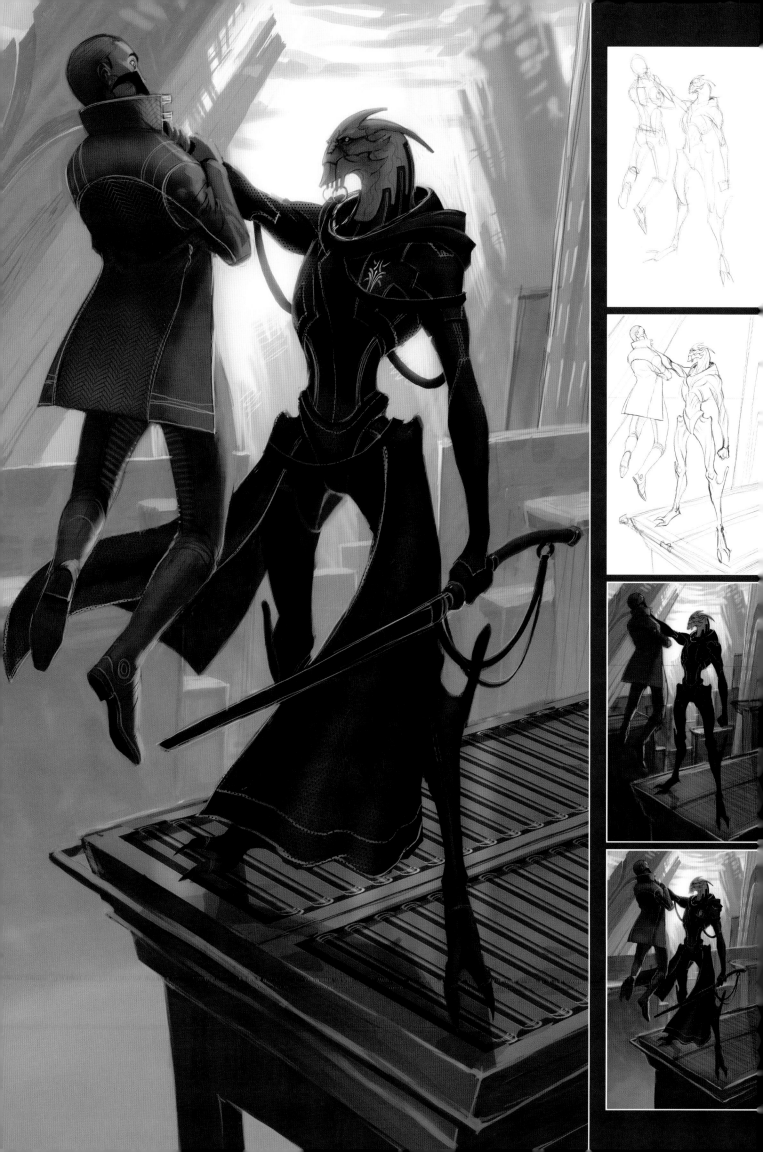

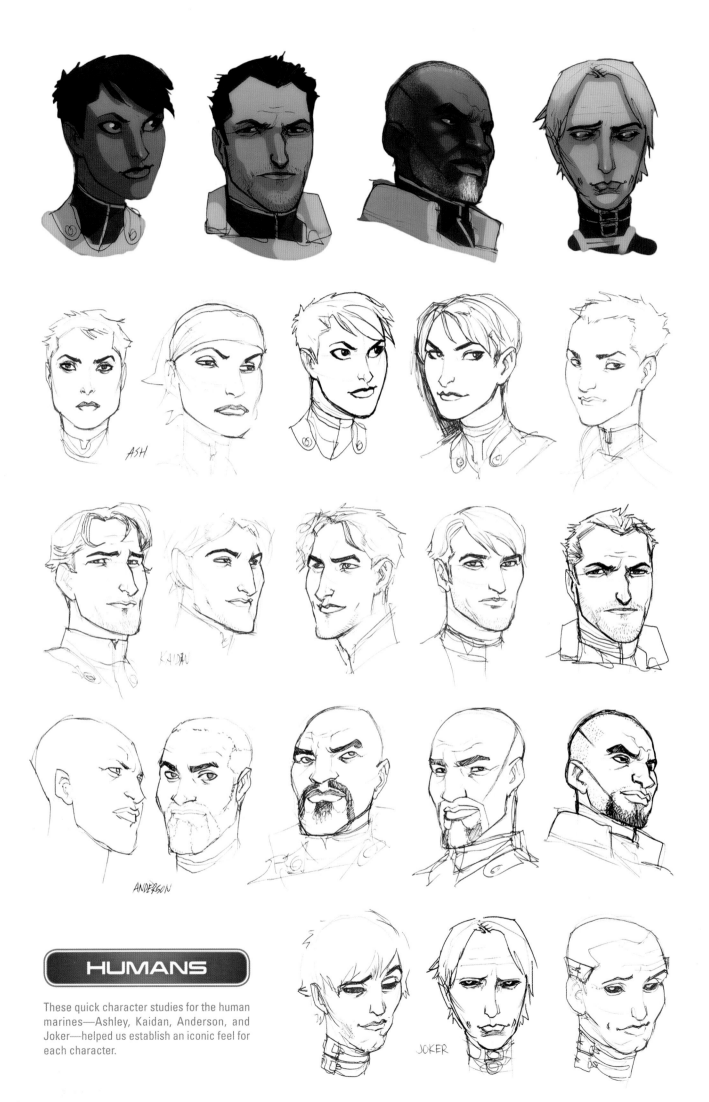

HUMANS

These quick character studies for the human marines—Ashley, Kaidan, Anderson, and Joker—helped us establish an iconic feel for each character.

ASH

KAIDAN

ANDERSON

JOKER

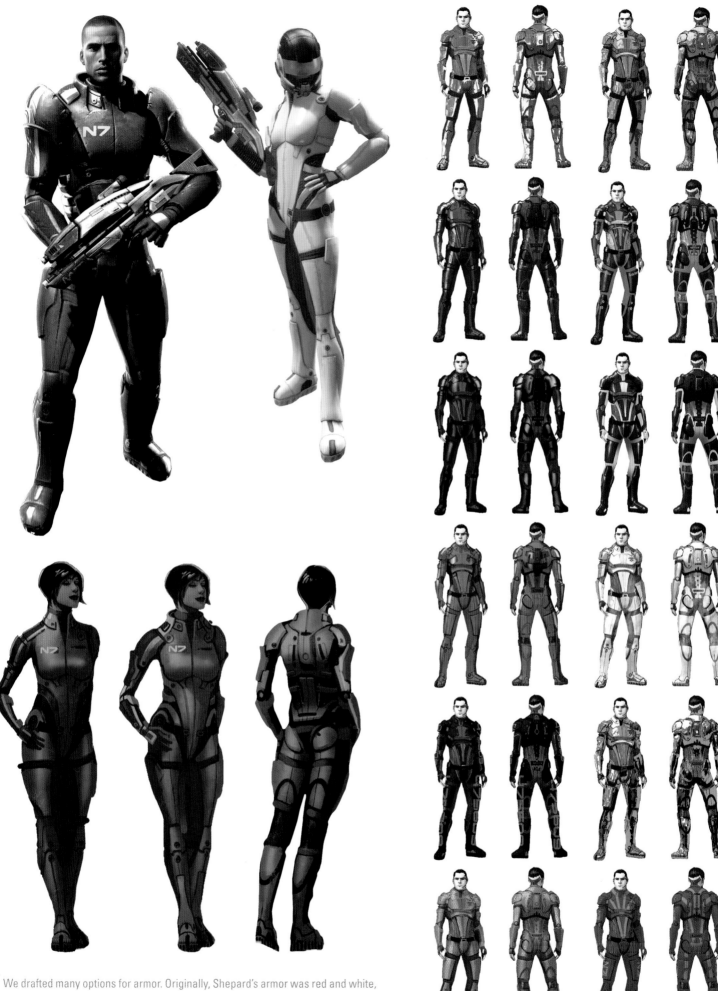

We drafted many options for armor. Originally, Shepard's armor was red and white, but that made Shepard look too much like a medic rather than a combat-ready marine. Eventually we made the armor charcoal gray and added a red-and-white stripe, as well as the iconic N7 logo. Although Shepard's armor changed with each subsequent game, these elements remained consistent.

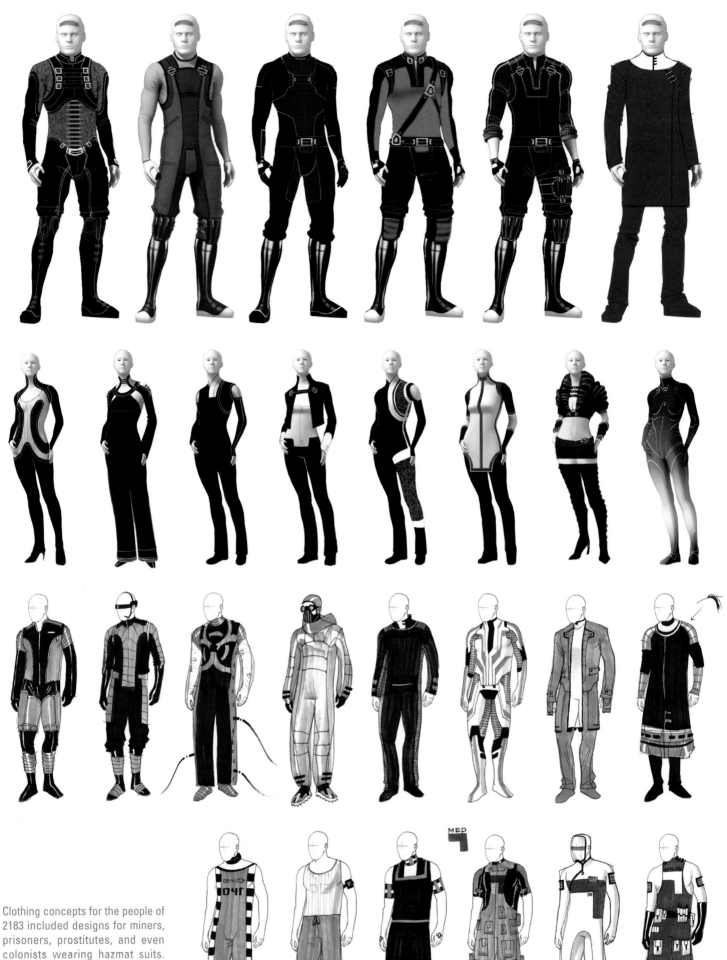

Clothing concepts for the people of 2183 included designs for miners, prisoners, prostitutes, and even colonists wearing hazmat suits. Through standardizing these concepts, we found a common visual language for human characters.

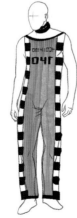
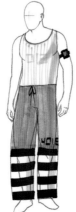

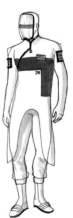

ASARI

To add a familiar element of science-fiction fantasy, we decided one of the main species in *Mass Effect* would be a race of beautiful, blue alien girls. An extensive exploration of the idea led to the asari appearing exotic and alien while still having some human qualities, which allowed them to be desirable as potential love interests. The original inspiration of the scalp tentacles was to evoke the image of a woman emerging from the water with her hair swept back.

Asari clothing was to be alluring and sexy but with a sense of class and style—more of a Hollywood red-carpet feel than that of a stripper (except for the asari who were, in fact, strippers). Once we established the general look of the asari, we examined the fine details, like the scalp tentacles.

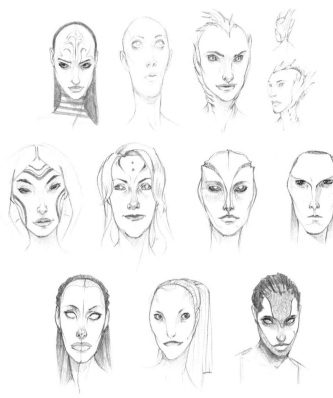

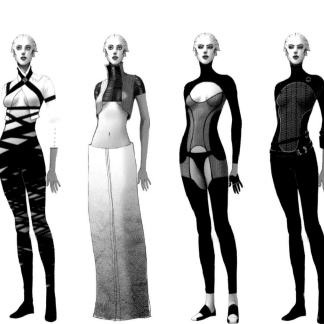

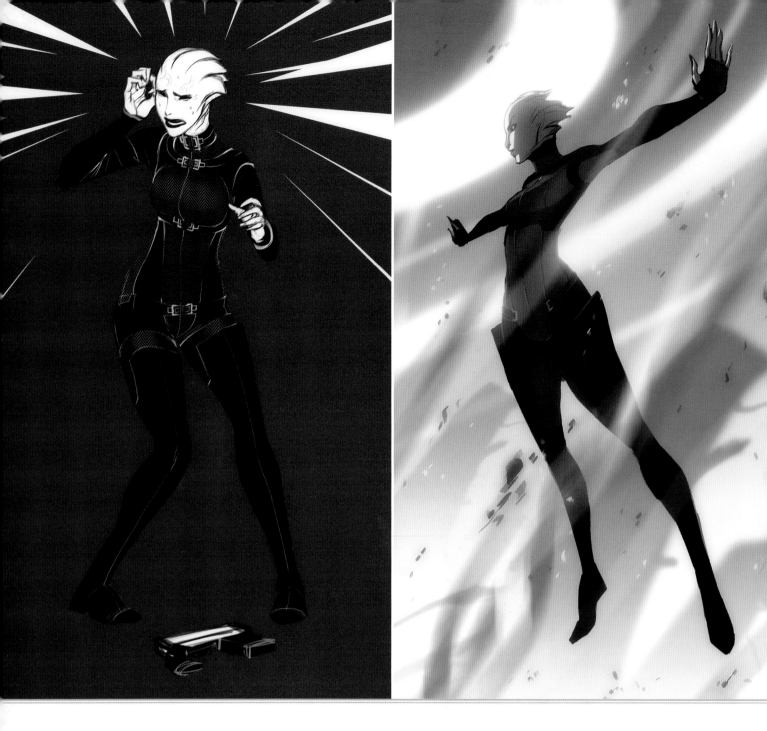

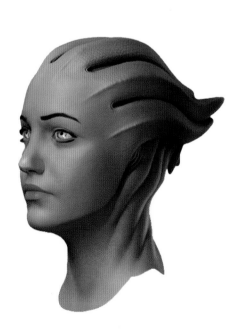

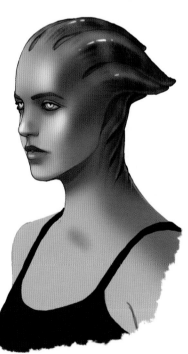

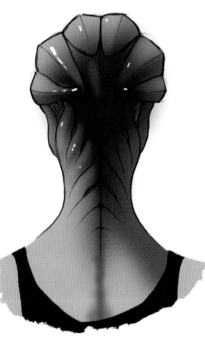

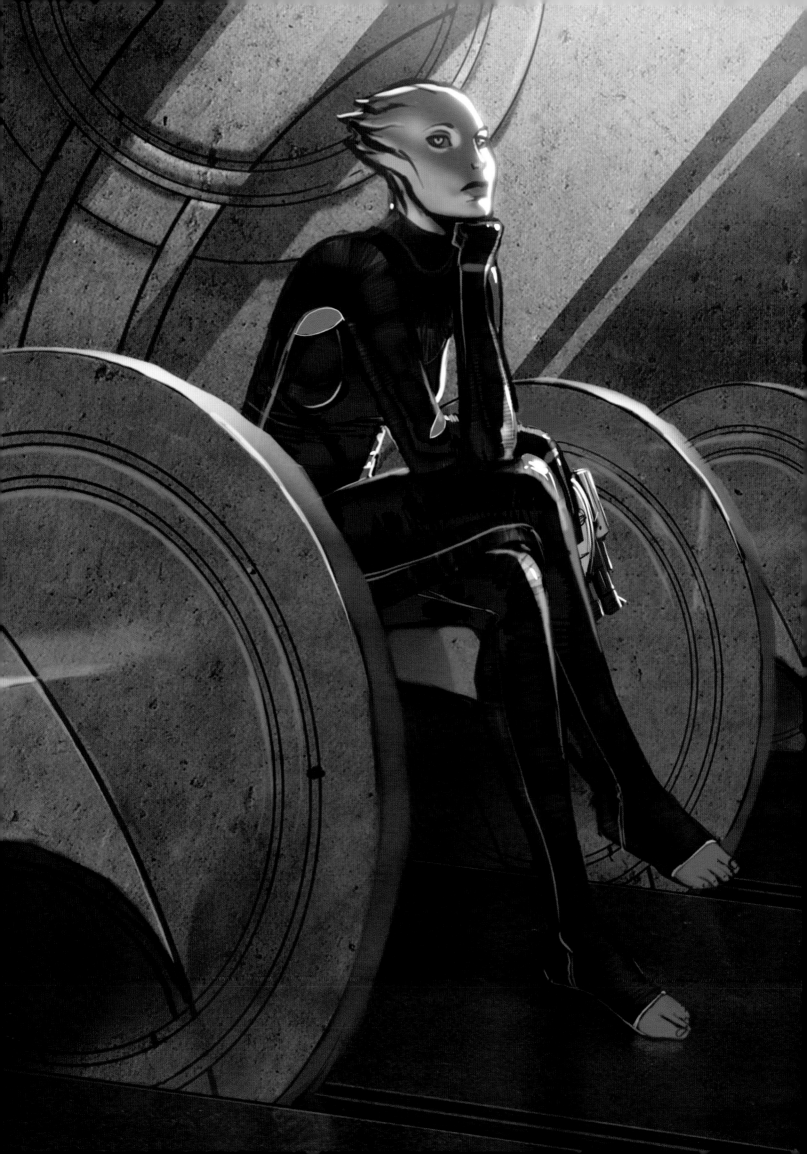

TURIANS

As Linus Pauling once said, "The best way to have a good idea is to have a lot of ideas." We had a lot of ideas for alien species! The writing department came up with an idea for a birdlike race, and we ran with it . . . in many directions. From this, the turians emerged with avian legs and an eagle-like head with the crest of a plumed bird. They have several decidedly unavian features to keep them alien, like the carapace that shields them from the radiation on their home planet.

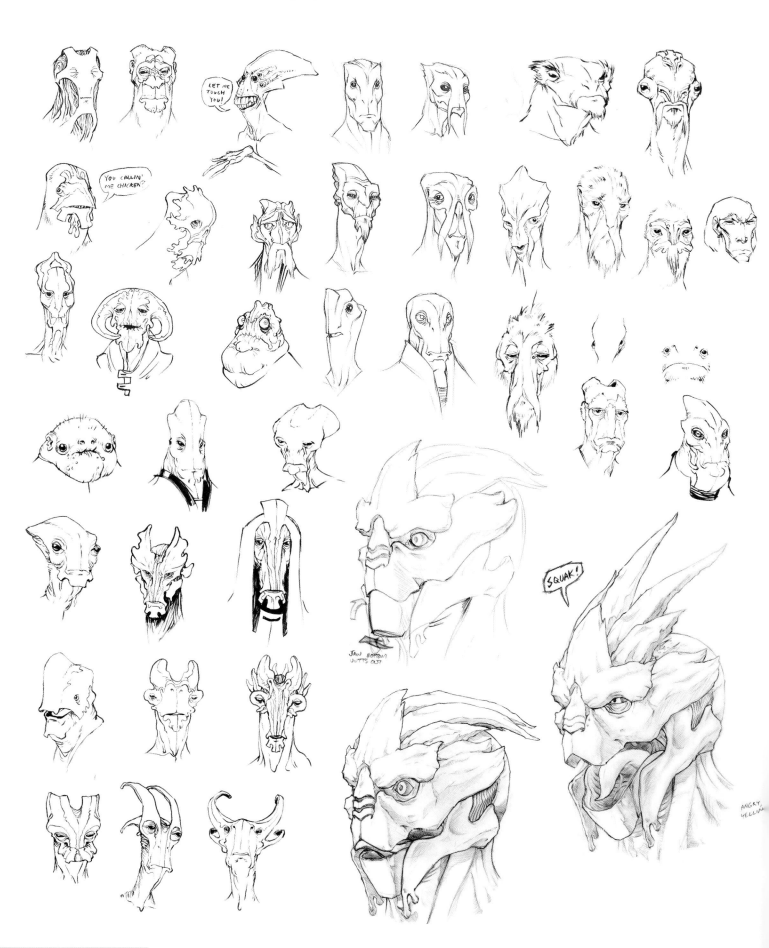

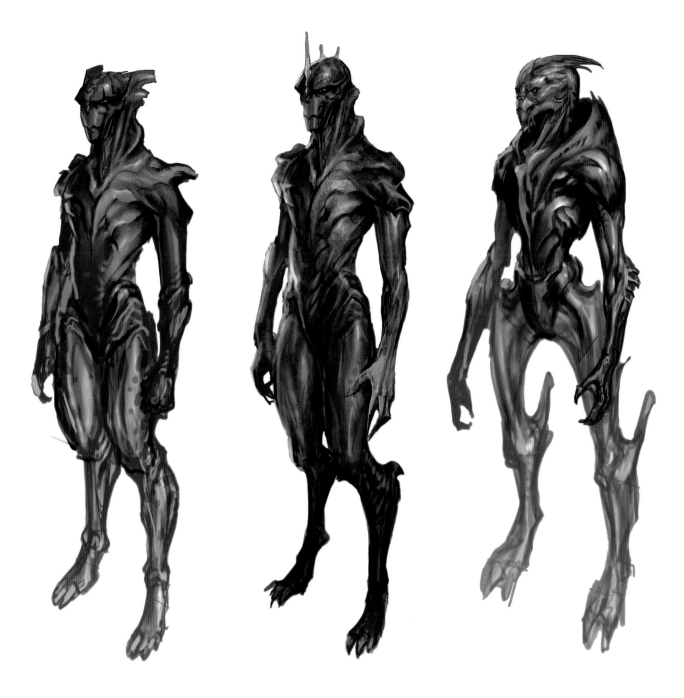

At the top are designs of turian bodies, including the final form. Most of the aliens in *Mass Effect* were designed without clothing or armor. Adding them later in the process forced us to keep designs consistent and complete to avoid having models with missing aspects hidden under clothing. Below are variations of turian heads. Once we had the head design, we tried to work out decorations to give each individual turian a unique look.

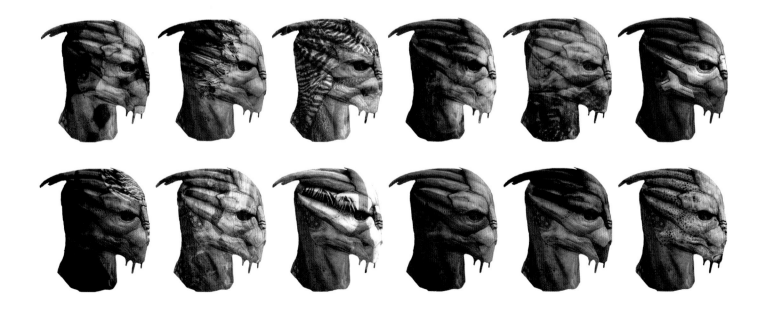

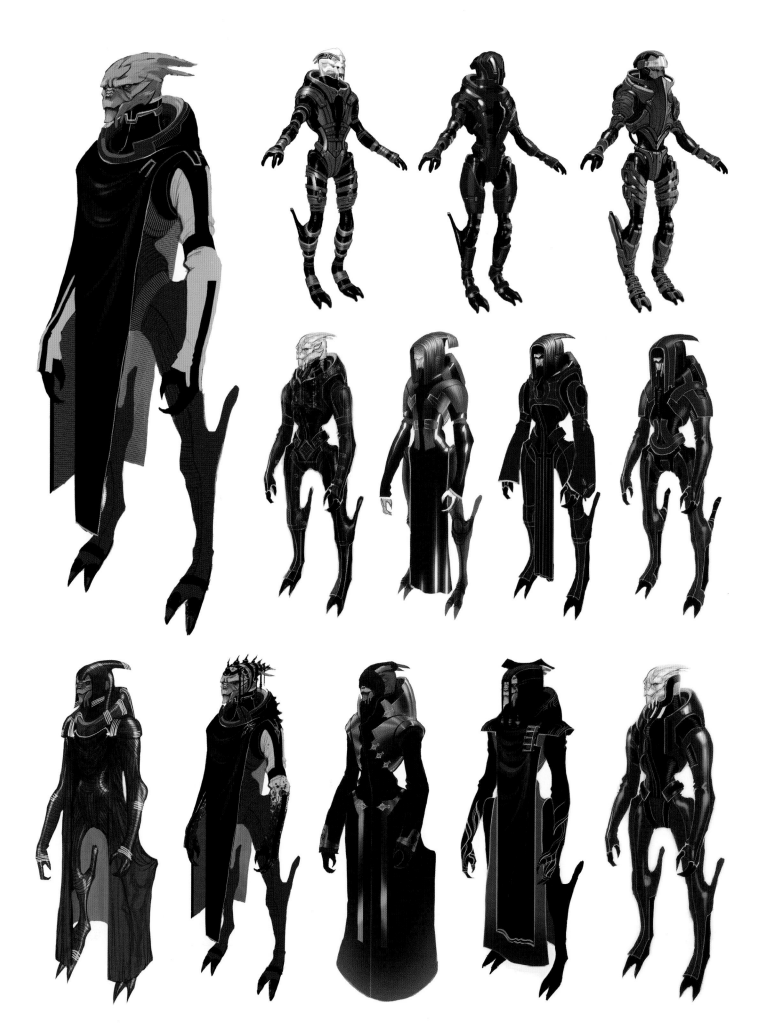

The top concepts are various styles of turian armor, including light and heavy versions. For their clothing, we balanced the design between human and alien, allowing space for turian head crests, the bones jutting from their calves, and the carapace on their shoulder blades.

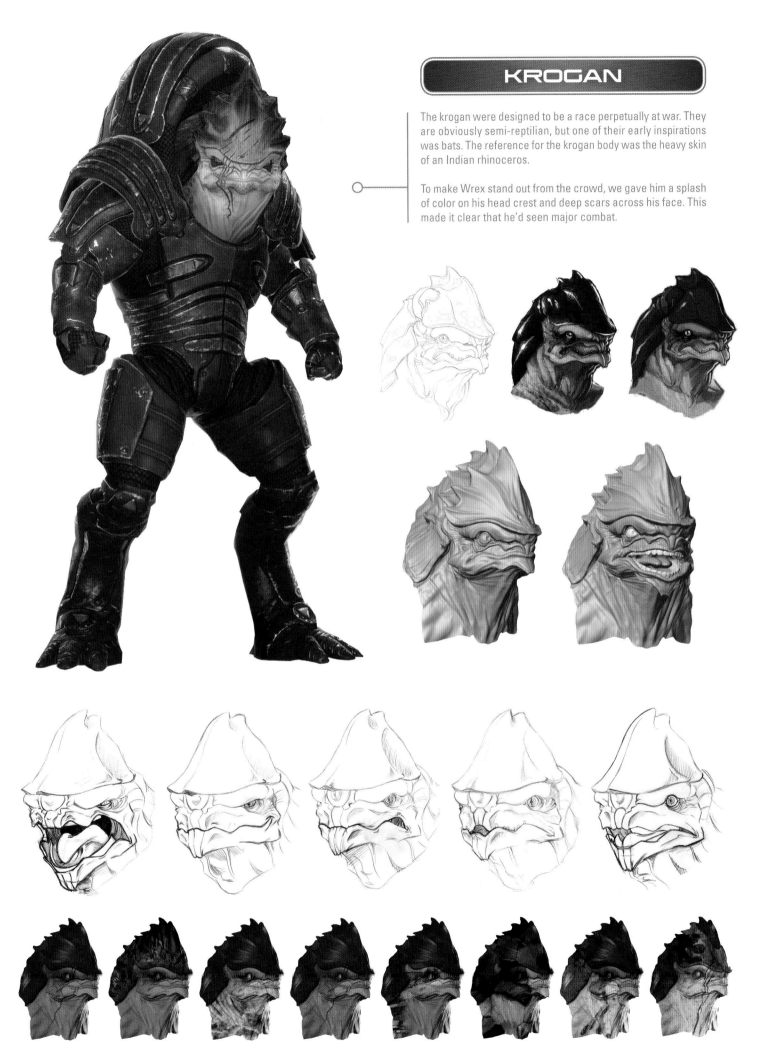

KROGAN

The krogan were designed to be a race perpetually at war. They are obviously semi-reptilian, but one of their early inspirations was bats. The reference for the krogan body was the heavy skin of an Indian rhinoceros.

To make Wrex stand out from the crowd, we gave him a splash of color on his head crest and deep scars across his face. This made it clear that he'd seen major combat.

The concepts above show facial expressions that helped animation. Below that are models used to figure out coloration, including the final model of Wrex.

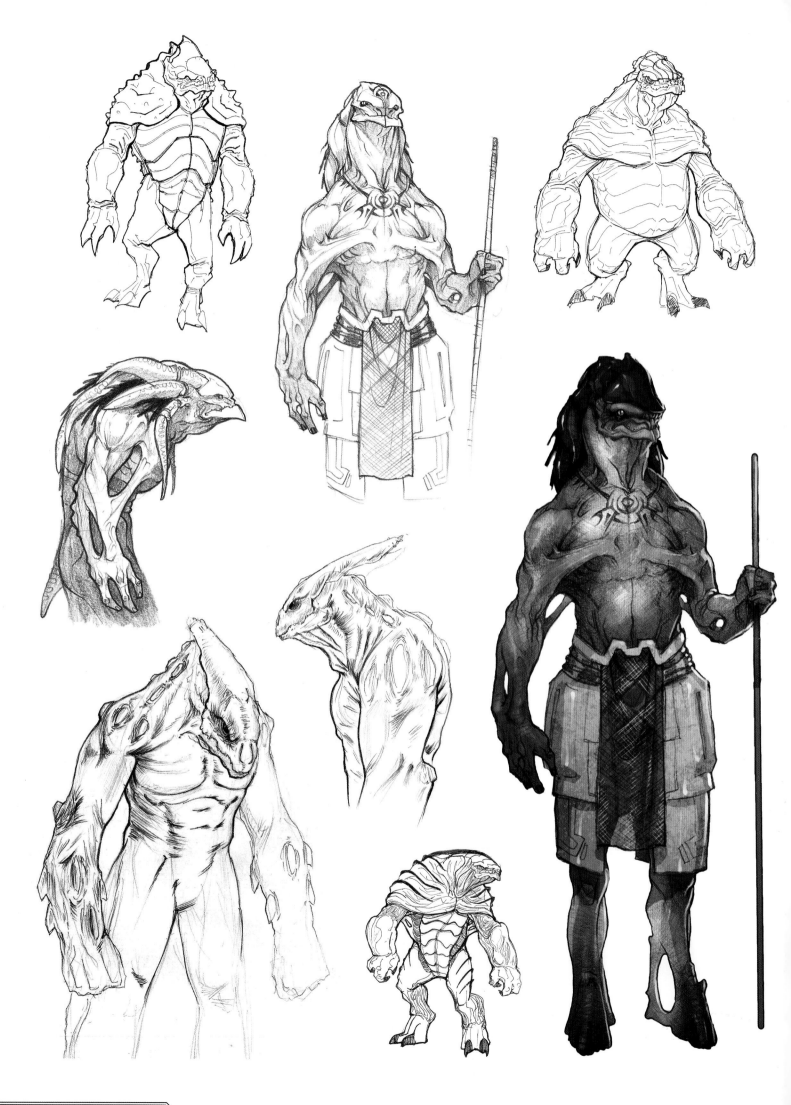

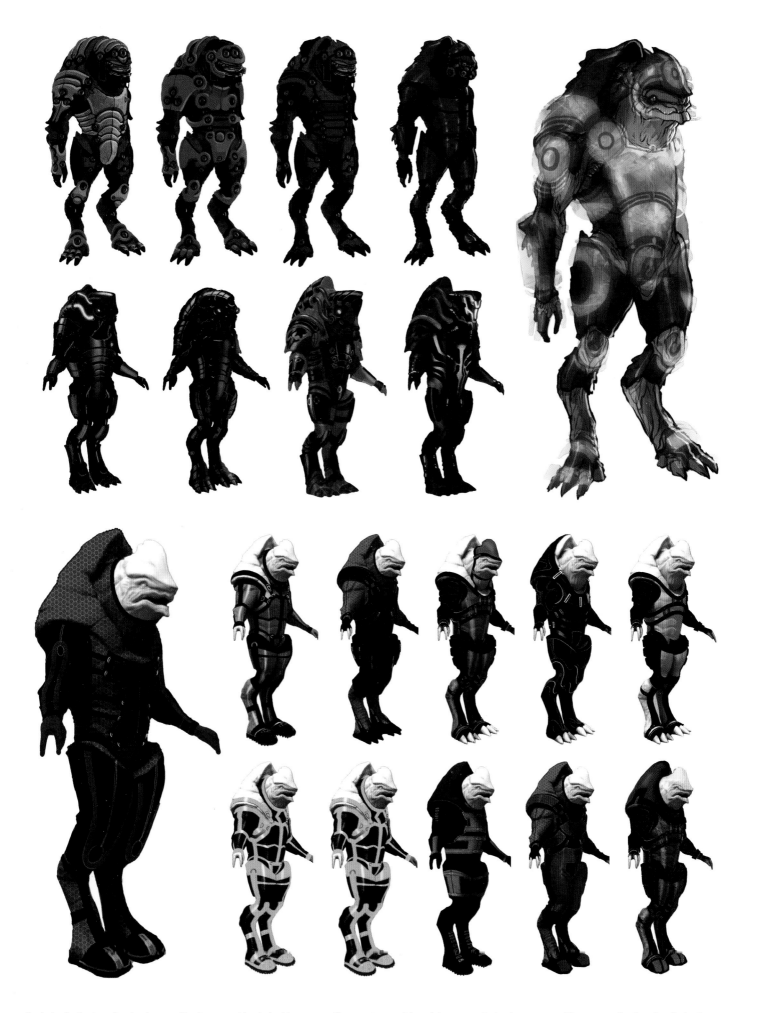

Early body designs for the krogan (facing page) included large, apelike creatures. A lot of these needed to be scrapped because of animation limitations. Above is a variety of krogan armor, including multiple helmet designs and versions for heavily armored bosses. Below that are variations of krogan clothing. Since krogan are almost never seen out of their armor, these were rarely used.

SALARIANS

The salarians were our version of "gray aliens," but with a nearly concave torso and doglike legs. These unique body features set the guidelines for all the clothing and armor to follow. The bottom collection represents the steps it took to reach final drawings of the salarian head as well as examples of how one of the variations might show emotion. We do drawings of expressions to help us figure out how the aliens will emote using our digital acting system.

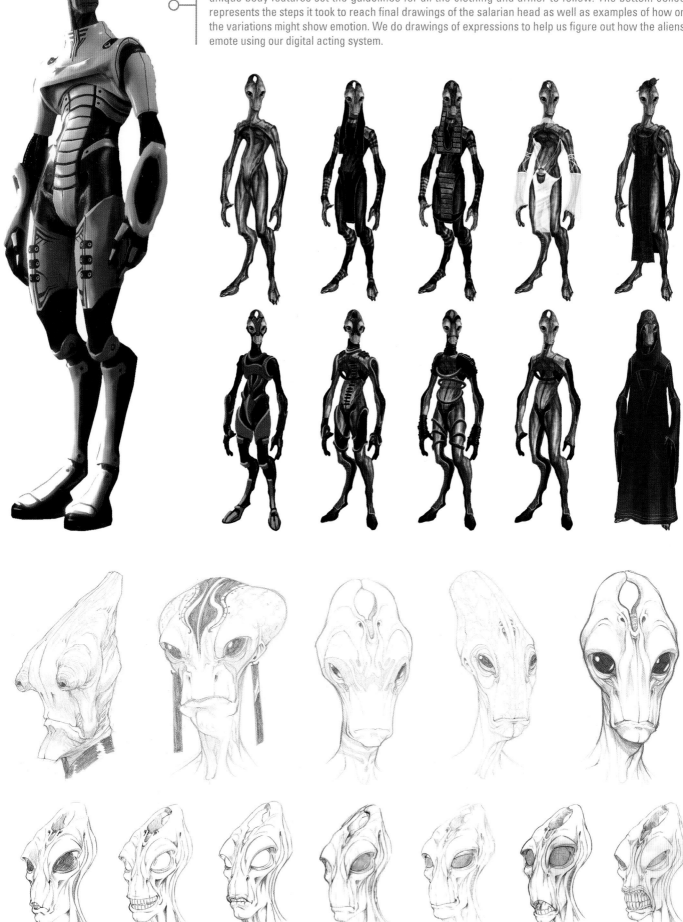

A wide variety of concept sketches of clothing for salarians. Except for a few of the drawings, most of them were too human to meet our needs.

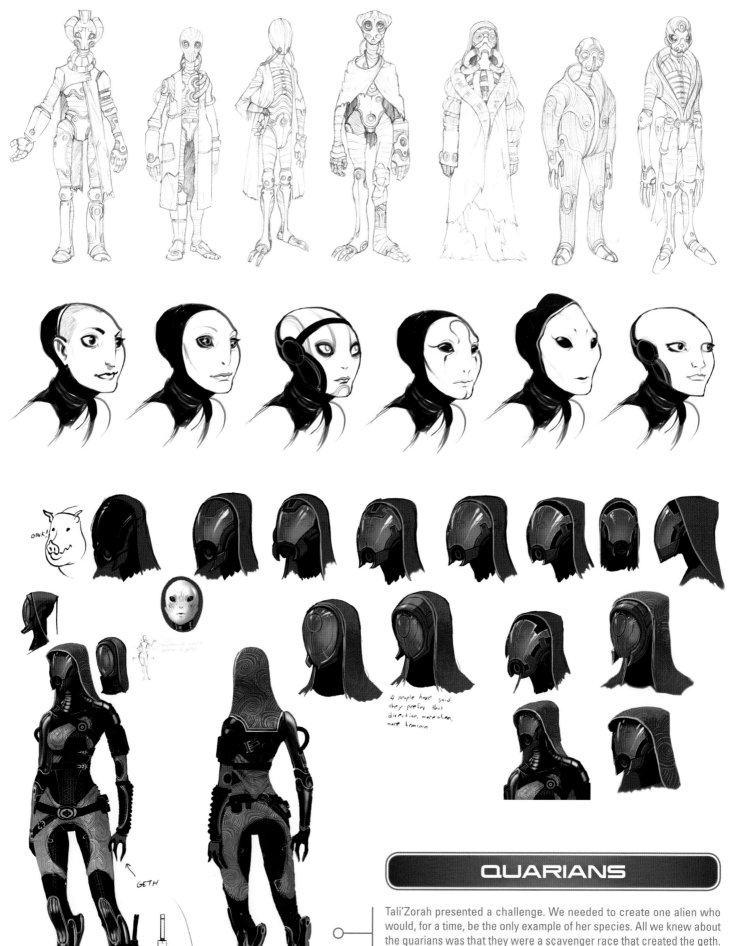

OINK!

GETH

SIDE

4 people have said they prefer this direction, more alien, more feminin

QUARIANS

Tali'Zorah presented a challenge. We needed to create one alien who would, for a time, be the only example of her species. All we knew about the quarians was that they were a scavenger race that created the geth. When some of these drawings were done, we didn't yet know what the geth actually looked like. Eventually, we decided on a look for the geth that influenced the (lower) quarian drawings. Tali was to have her face covered by a mask, tantalizing the player, who could barely make out the shape of her eyes, but no more.

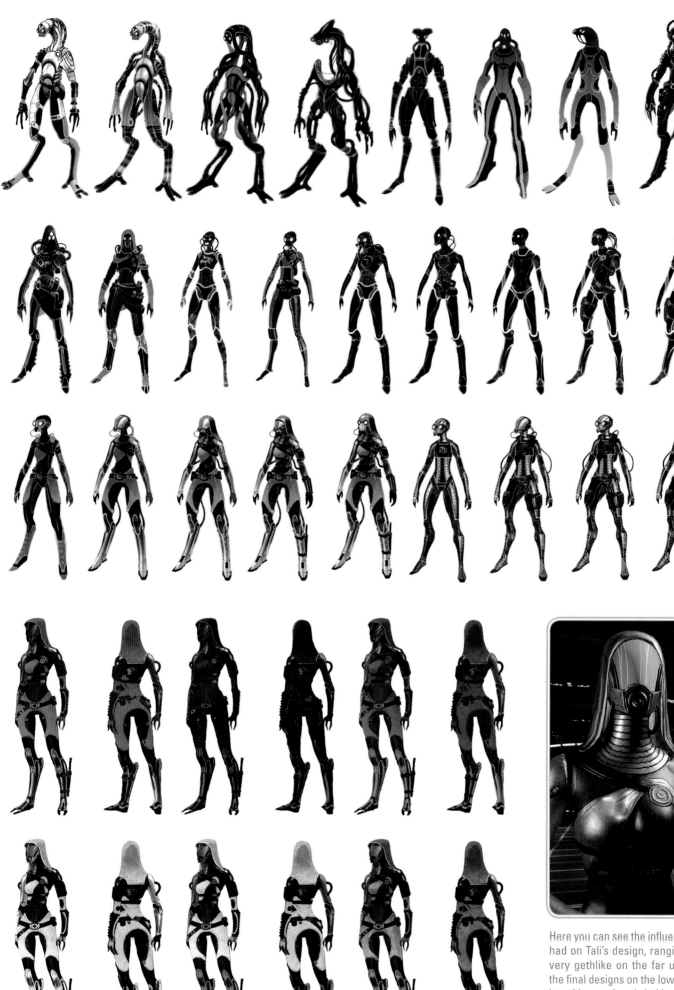

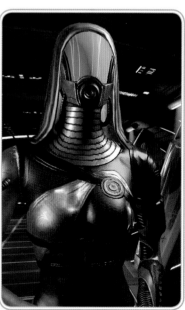

Here you can see the influence the geth had on Tali's design, ranging from the very gethlike on the far upper left to the final designs on the lower right. The breathing mask and clothing became the enviro-suit. The quarians, having a weak immune system, won't live long outside an enviro-suit.

ELCOR

In the early conception phase, anything and everything is possible. Some of the more outrageous original designs for the elcor are featured below. Eventually, modeling and animation constraints influenced the design.

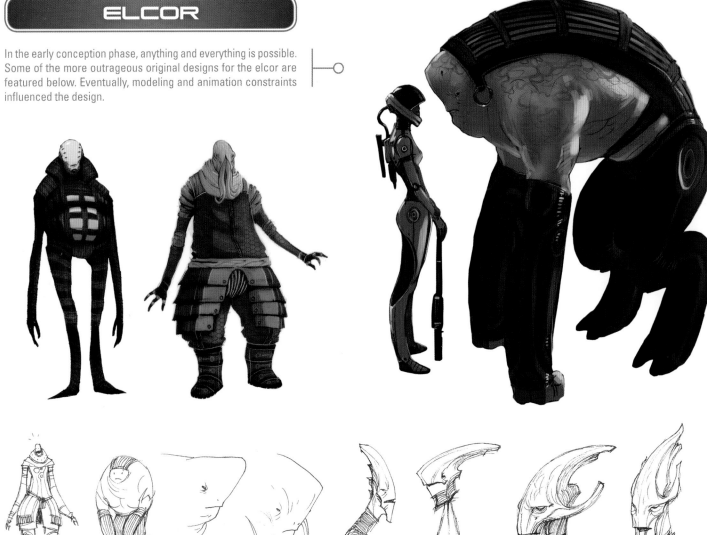

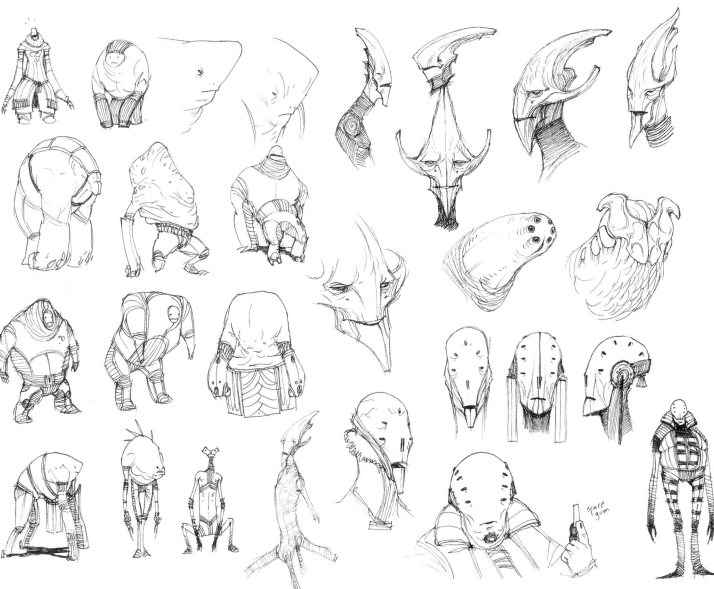

VOLUS

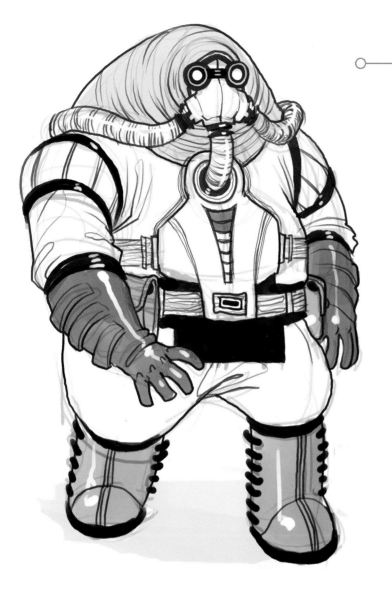

The volus are another race of aliens that need a full-body enviro-suit. Volus are from a planet with high air pressure, and to remove them from their suit anywhere else would cause them to rupture, much like a deep-sea fish brought to the surface. Some concepts for their species were relatively large. Ultimately, they became short and round, giving them a docile look.

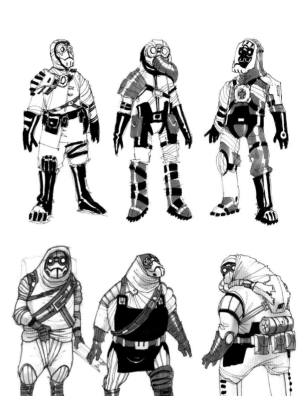

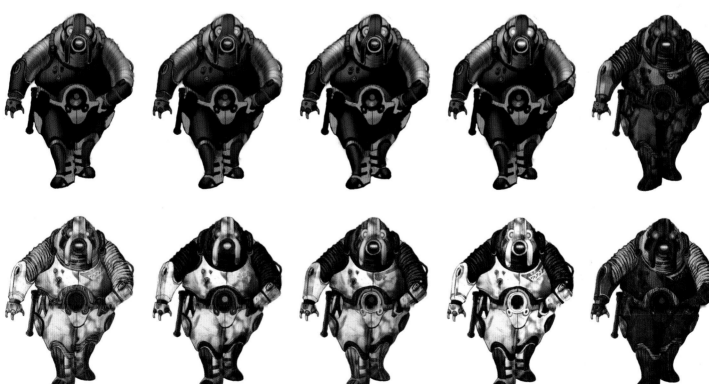

GETH

The geth are the most common enemy in the game, so they needed to stand out from enemies in other science-fiction universes. The head design was first nailed down for the geth armature, and this later became the basis for the geth's head design.

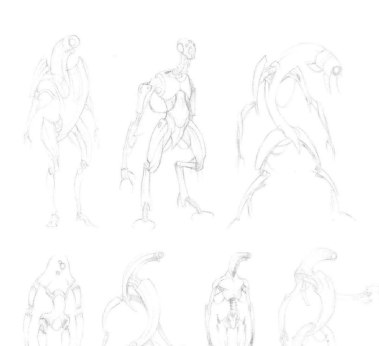

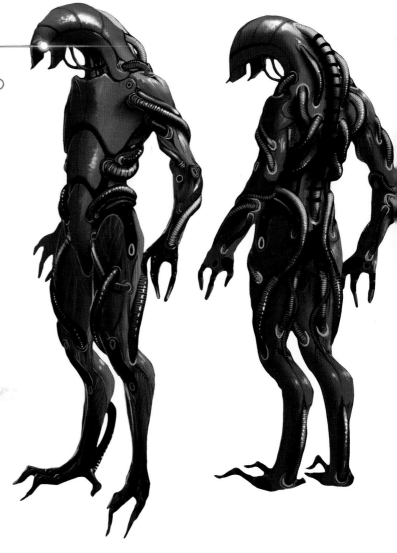

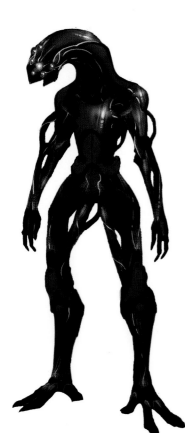

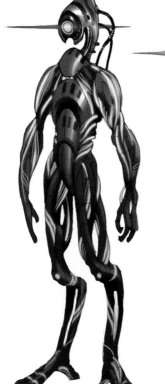

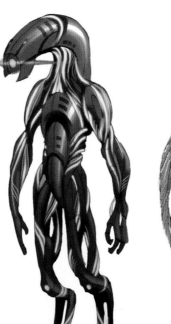

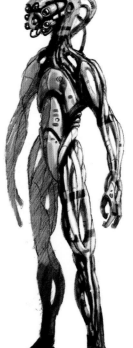

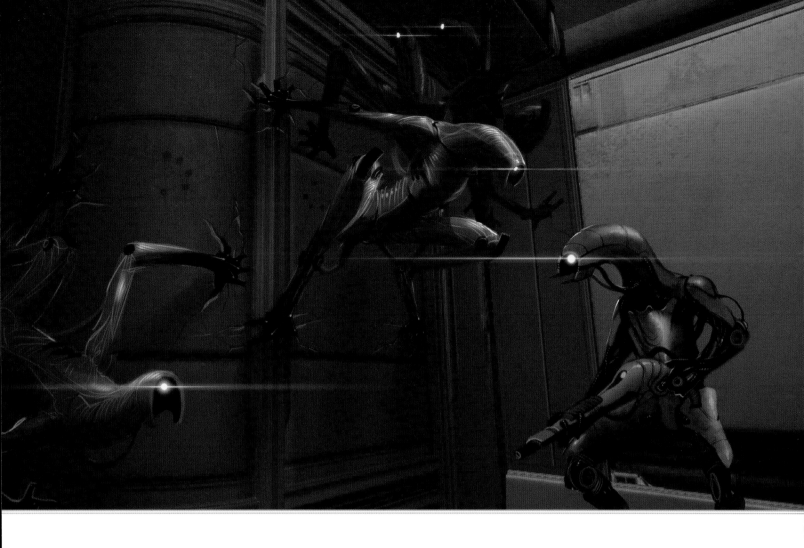

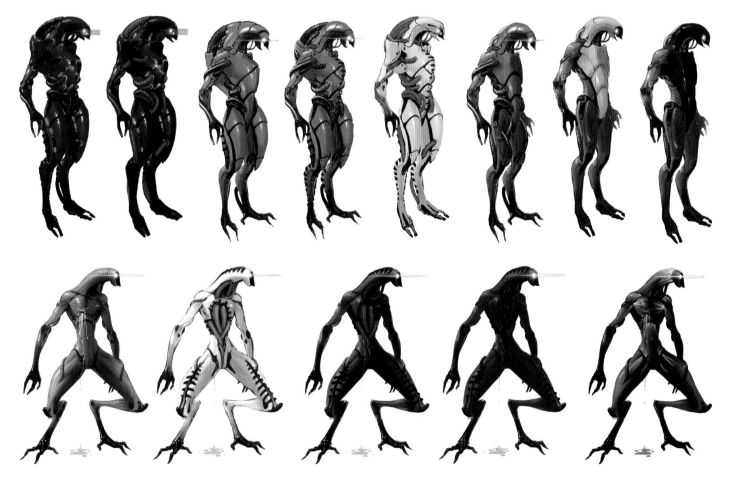

The production painting at the top shows how the geth hopper might attach itself to the wall, like Spider-Man clinging to a building. The middle images show variations refining the geth, such as the body plating and the shape of the head. The bottom images are variations on the final look of the geth hopper.

THE THORIAN

The thorian was lovingly referred to as the "grotesque sac" around the office. It developed into a fungal creature that was thousands of years old and able to infect humans with mind-affecting spores and to create clone duplicates of a creature it had absorbed.

you kill it

hell naw, I ain't touchin it.

well I sure as hell ain't touchin it

RACHNI

Early concepts for the rachni queen imagined what she would look like captured in a containment tank. We pictured her never being fully illuminated—a mysterious figure. Inspiration came from deep-sea creatures.

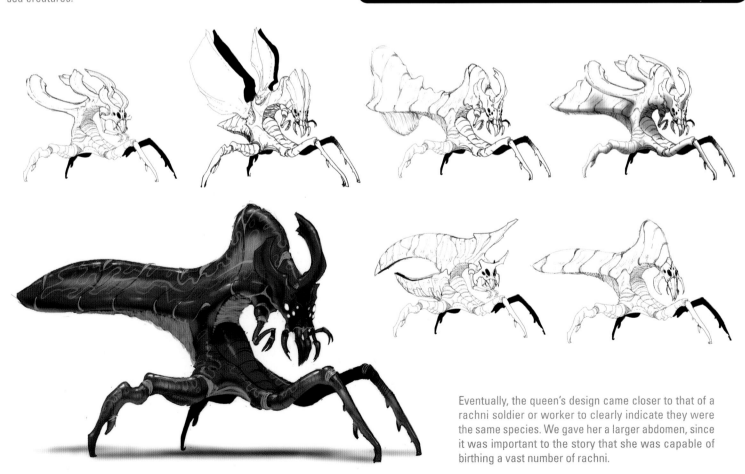

Eventually, the queen's design came closer to that of a rachni soldier or worker to clearly indicate they were the same species. We gave her a larger abdomen, since it was important to the story that she was capable of birthing a vast number of rachni.

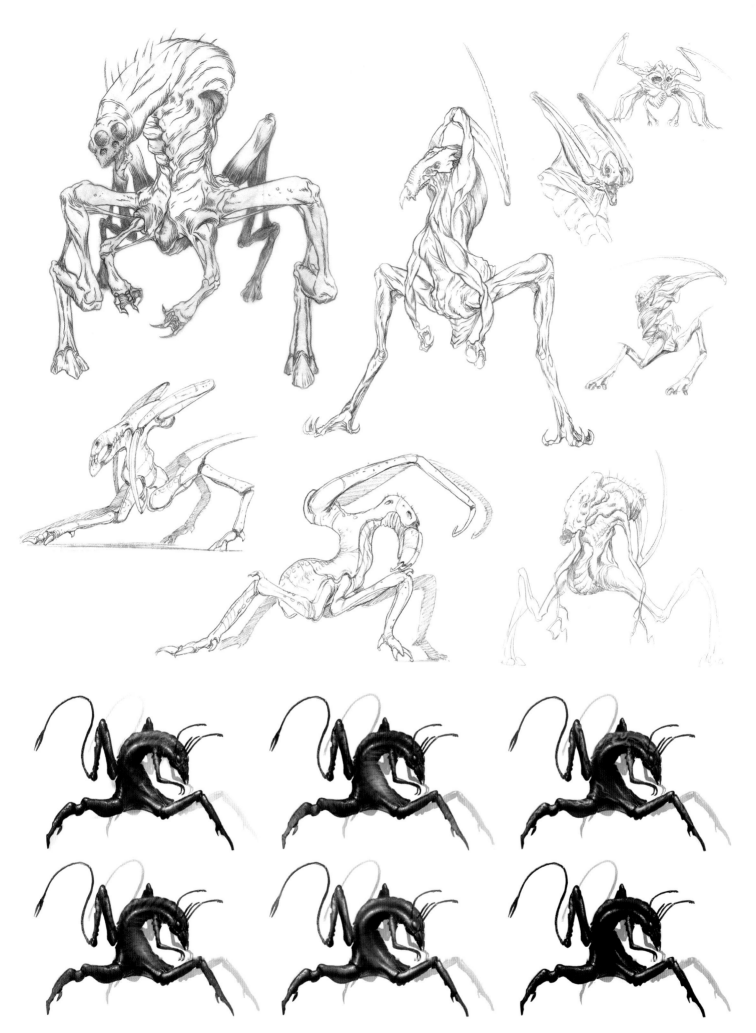

We toyed with a wide variety of ideas for the rachni. The original thought was to design a creature with long arms that could reach out and pierce the player. Eventually, these arms became something closer to whips.

THE CITADEL

The Citadel represents the seat of galactic government and thus was the level most representative of *Mass Effect's* architectural style. With large swooping curves cutting across vertical lines, it aimed to define *Mass Effect's* look.

The actual design was inspired by a sculpture that had five sides and a ring. The five sides became the ward arms, each one a city the size of Manhattan. The ring became the Presidium. Later, we attached the Citadel Tower, where the council members sit. We designed a 3-D model to help visualize the Citadel's ability to transform from an open station into an impenetrable shell.

The top images on the opposite page show early visualizations of the Citadel's interiors.

The bottom image on the opposite page is the Presidium's interior—the utopia of tomorrow—a perfect blend of nature and architecture. We referenced NASA concepts, including the Stanford torus design. Early Citadel concepts also had windows looking out into space, which were eventually discarded when the design confused testers.

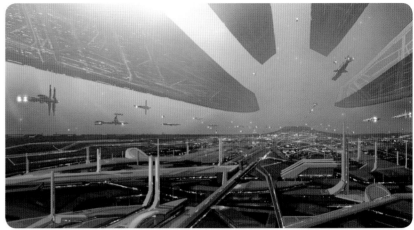

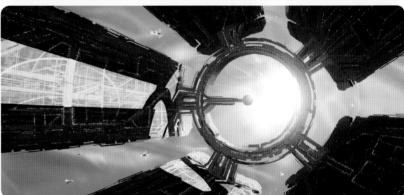

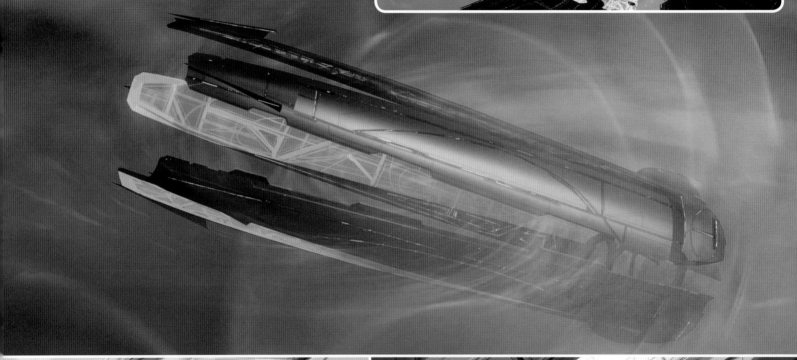

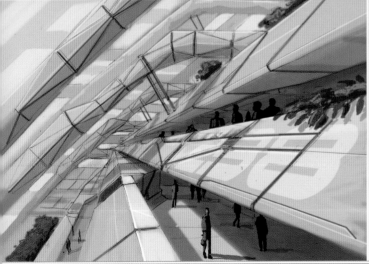

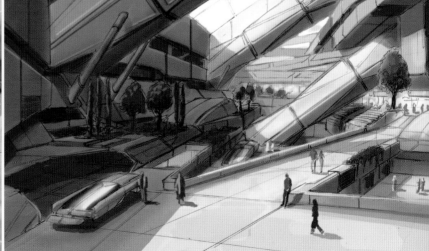

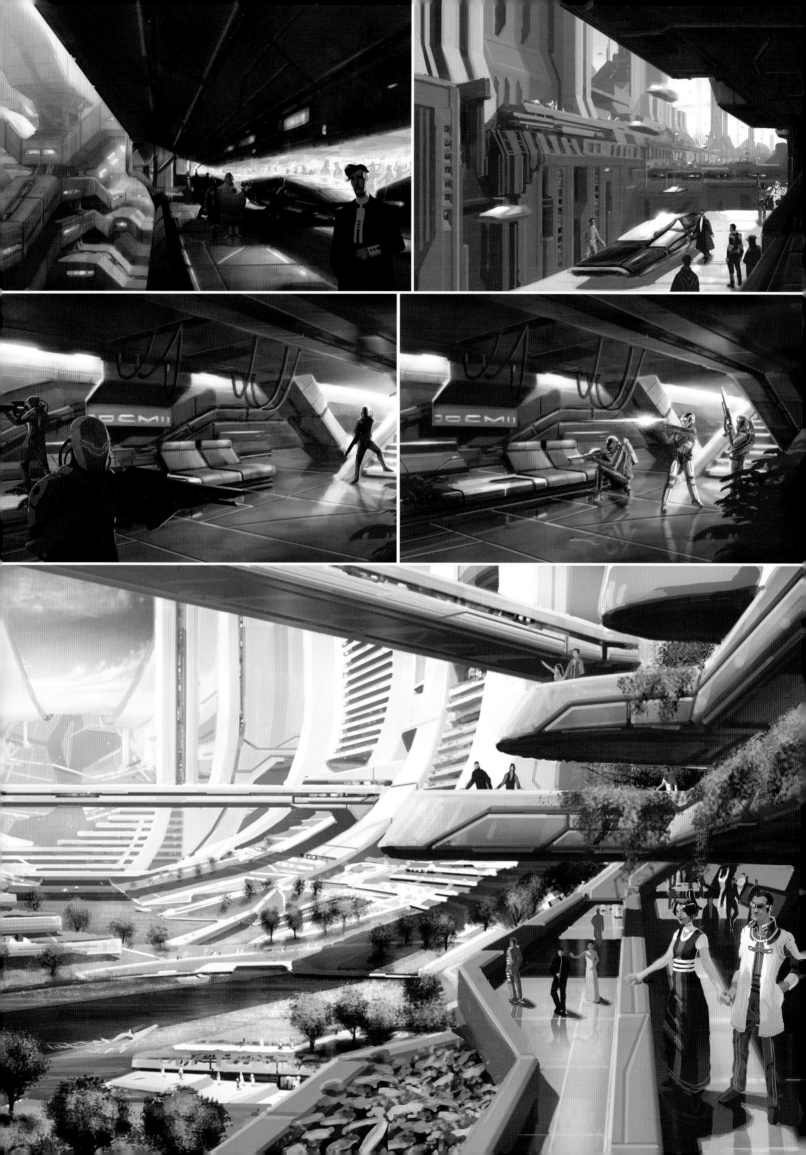

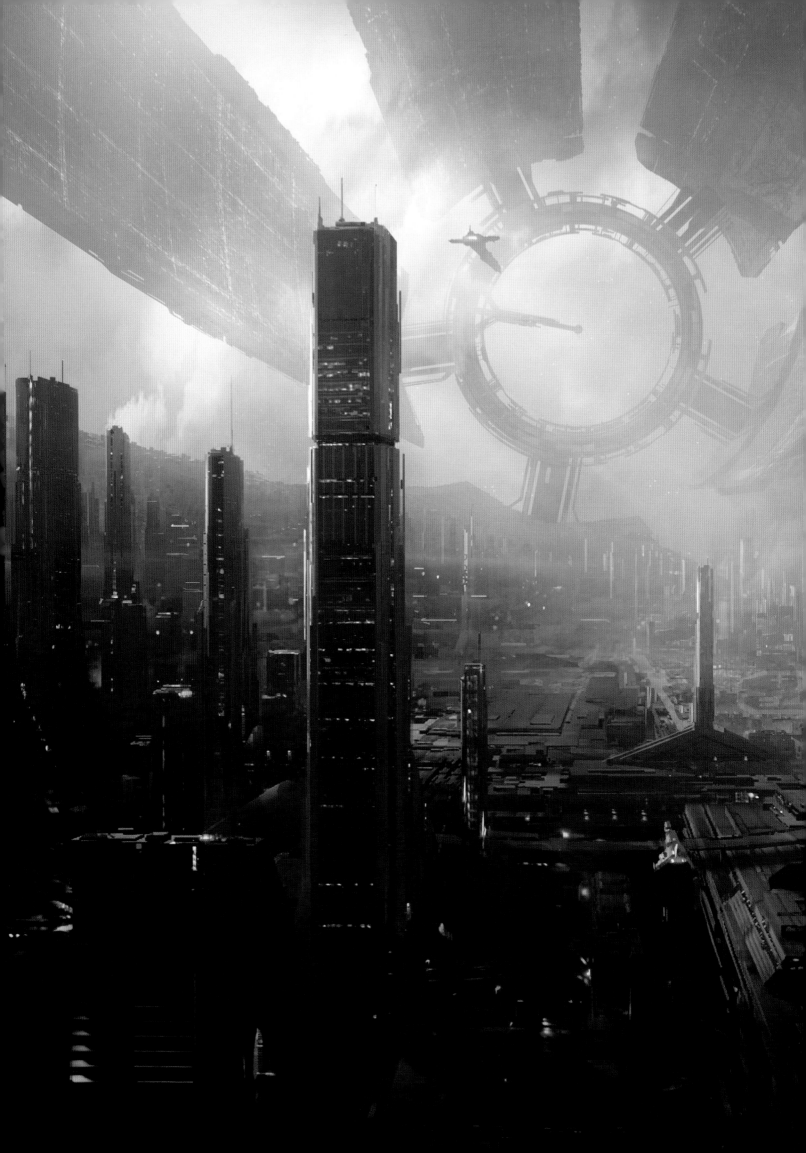

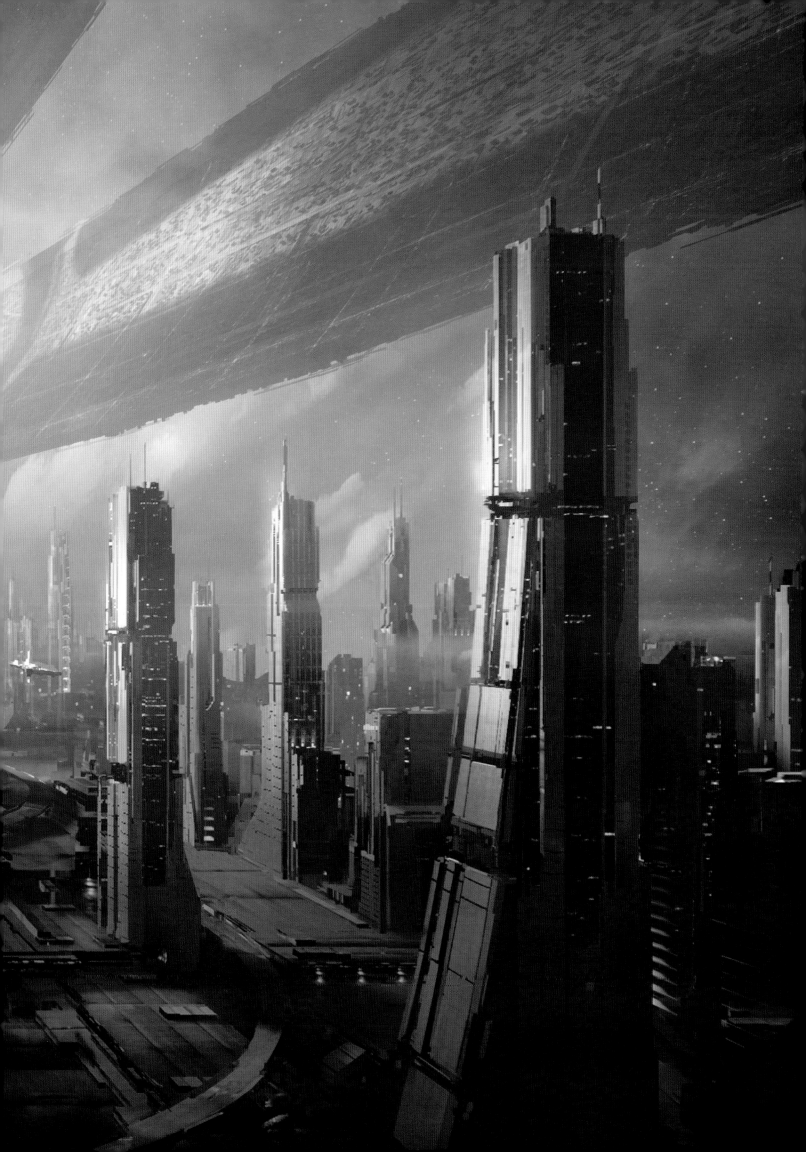

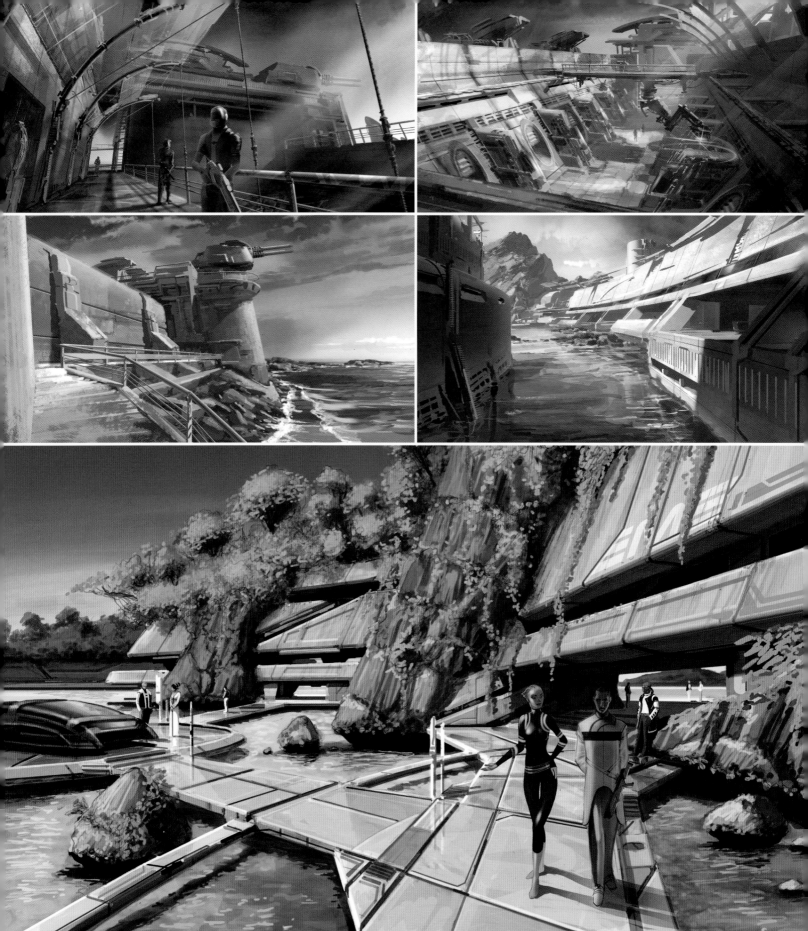

VIRMIRE

Originally, Virmire was to be a tropical paradise, a vacation spot for galactic travelers. The inspiration for the rock formation was the Phi Phi Islands in Thailand. The buildings were connected by floating walkways and attached by structures built into the rocks—nature and architecture working in harmony. This all changed radically. Virmire became Saren's base of operations, making the paradise theme unusable. The design shifted to "nautical fortress," complete with massive concrete walls and heavy gun batteries. Some of the original concepts remain in the level, such as the floating walkways and the open-air environment.

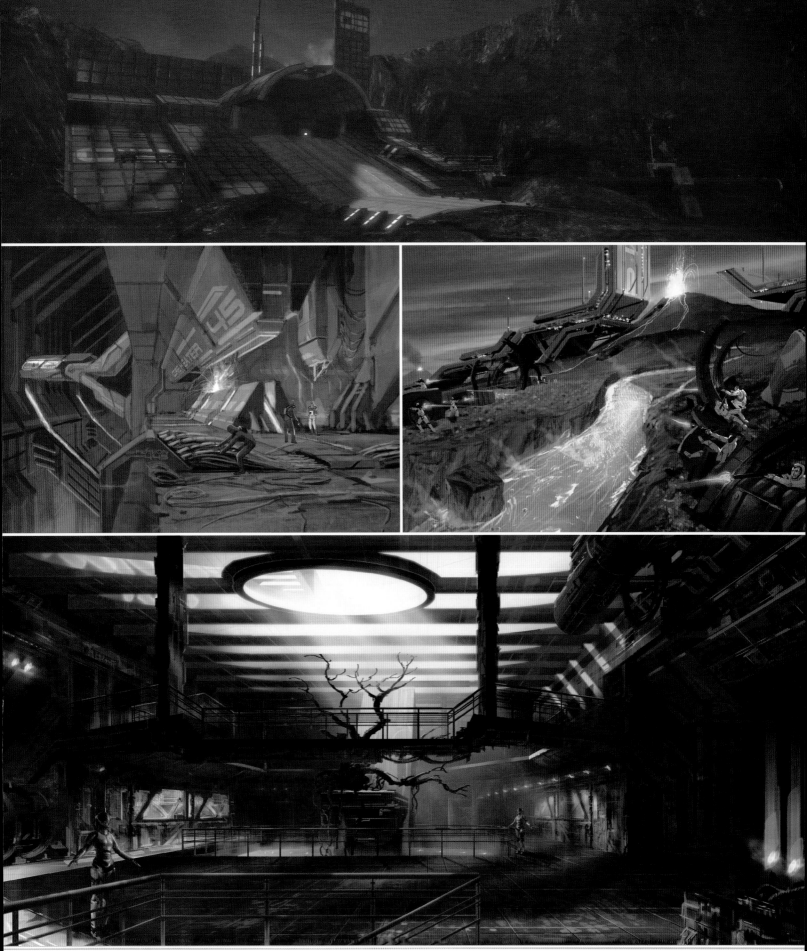

THERUM

Therum was originally a base built around the opening of a volcano. The base was going to be built up around the caldera, with heavy equipment mining the molten rock. Instead, the level was redesigned as an underground dig site.

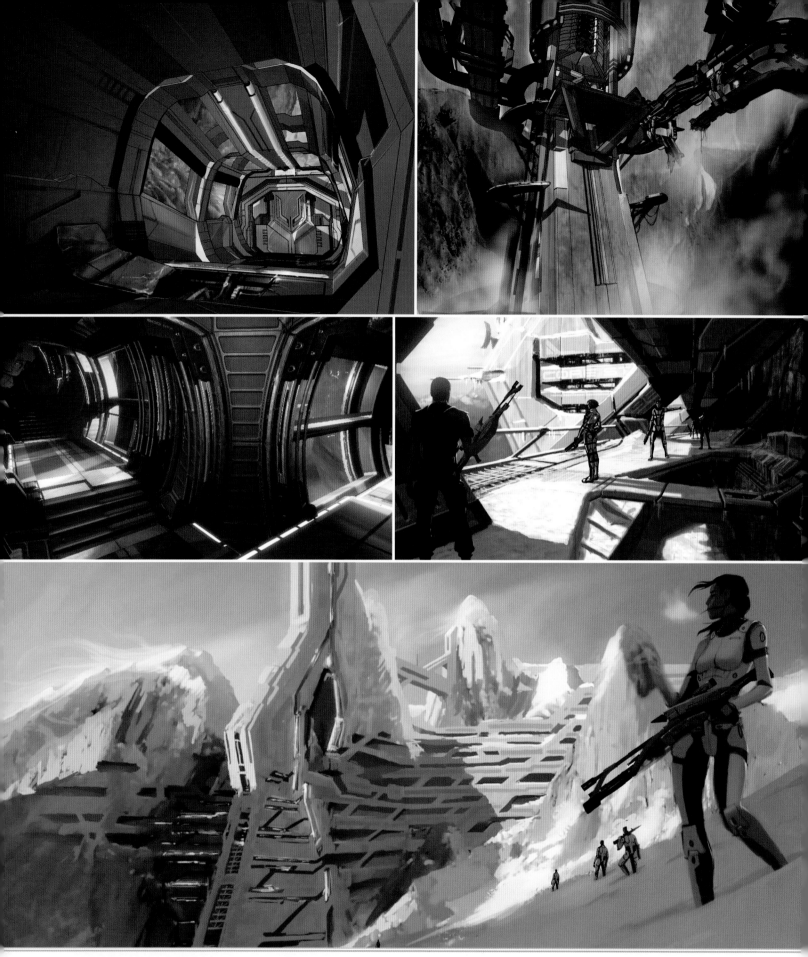

NOVERIA

What's a science-fiction game without an ice planet? Noveria originally had a lower alpine section, with the research stations high among the peaks. Eventually, we removed the lower section because it made players think they were on two different planets. The mountaintop station, Peak 15, was designed to look camouflaged. It was so massive that it blended right in with the other peaks. The top drawings are concepts of Peak 15's interior. The idea behind these was that encased tubes (affectionately called "hamster tubes") would be suspended within the ice and rock.

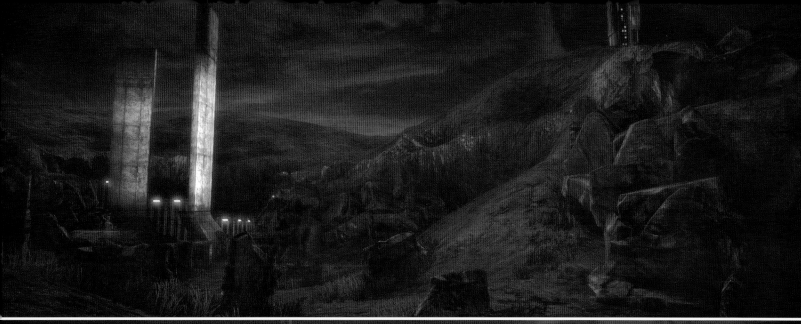

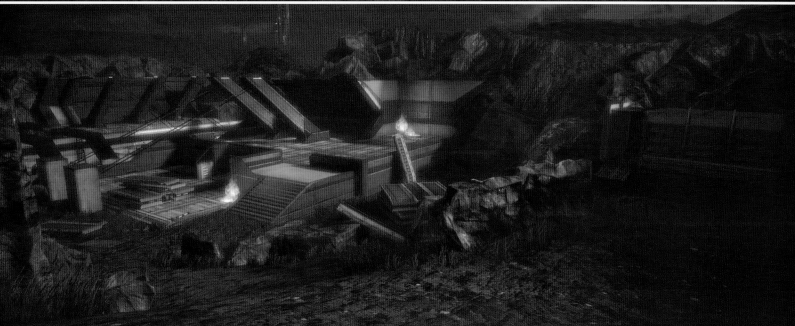

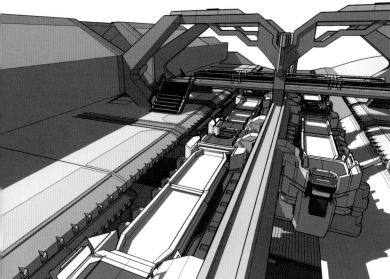

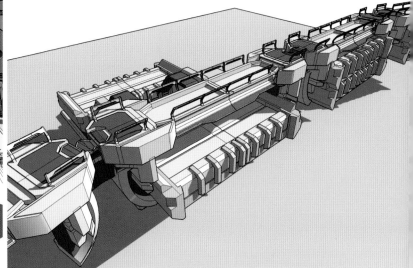

EDEN PRIME

The original idea for Eden Prime, inspired by England's Lake District National Park, had blue skies and rolling green hills. The Eden Prime colony farmed this area and created large towers with a suspended rail system for transporting crops. Later, we decided that Reapers had destroyed Eden Prime by the time Shepard arrived. The new design included battle damage and the "scorched sky" seen in the final game.

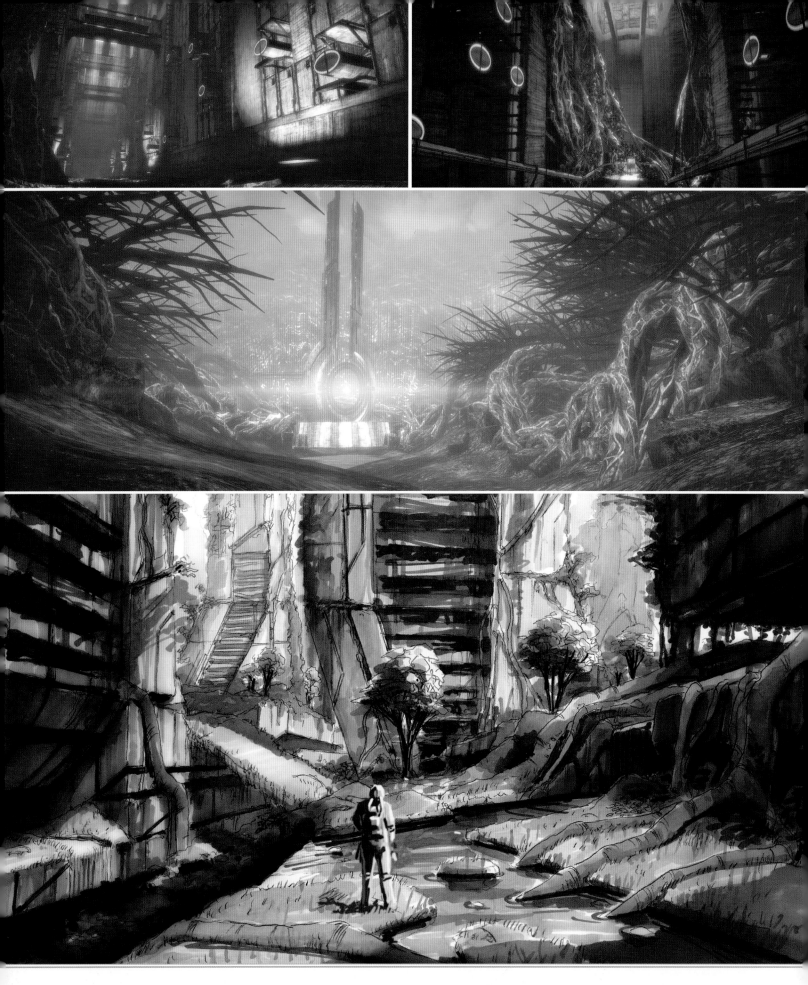

ILOS

Ilos originally felt like El Dorado or other legendary cities lost deep within a jungle, but having several tropical planets in the game, we decided to change the appearance of the level and to give it a more alien feel. We referenced Zdzislaw Beksinski when reimagining this world. The dried coral replaced the roots and vegetation covering the structures. We also relit the level to give it the feel that everything there was dying, just as the Protheans had.

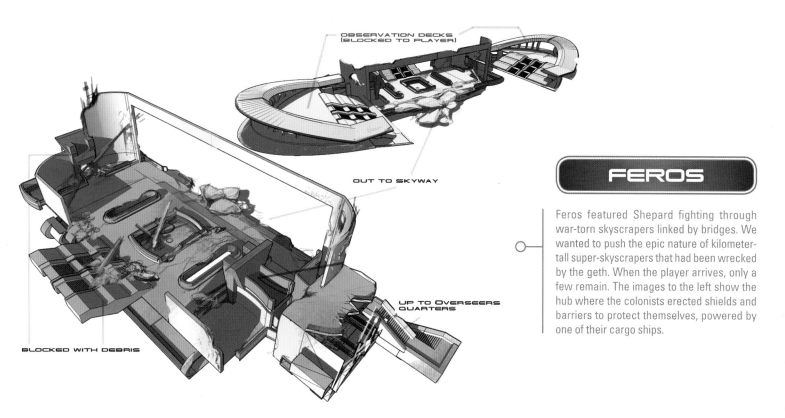

OBSERVATION DECKS
(BLOCKED TO PLAYER)

OUT TO SKYWAY

UP TO OVERSEERS
QUARTERS

BLOCKED WITH DEBRIS

FEROS

Feros featured Shepard fighting through war-torn skyscrapers linked by bridges. We wanted to push the epic nature of kilometer-tall super-skyscrapers that had been wrecked by the geth. When the player arrives, only a few remain. The images to the left show the hub where the colonists erected shields and barriers to protect themselves, powered by one of their cargo ships.

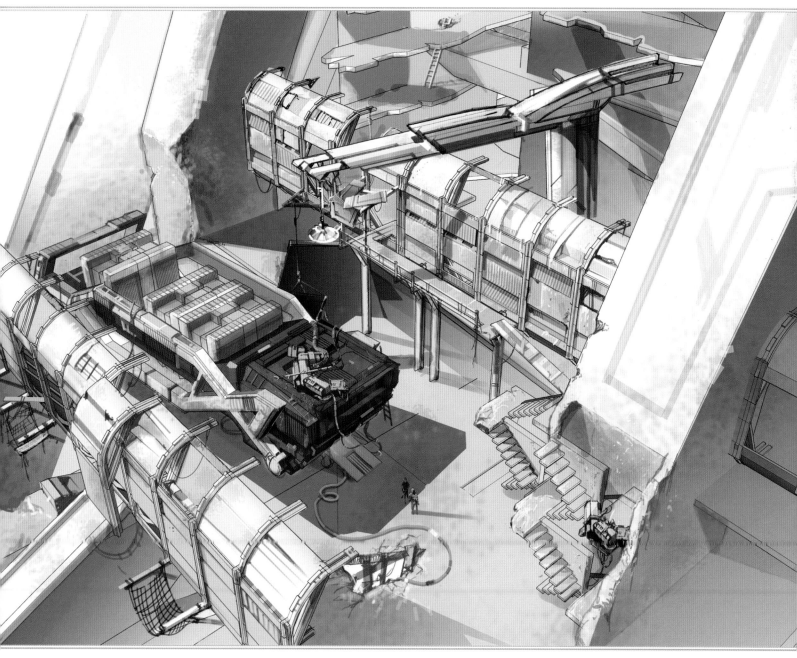

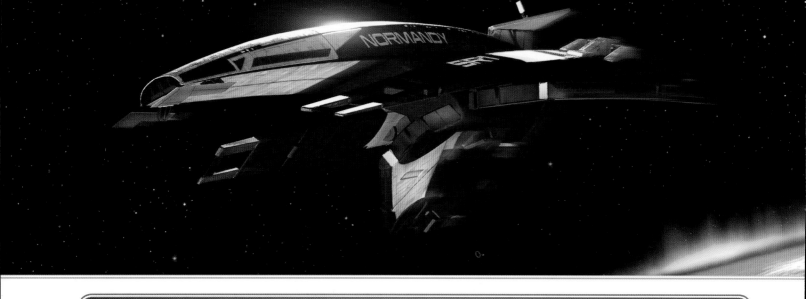

THE NORMANDY

Early concepts for the *Normandy* explored the ship as a fighter, a cruiser, a smuggler's ship, and a stealth vessel. Eventually it became a military prototype with a large crew and sufficient cargo space to store the Mako. Despite the fact that it lands on planets, we purposely never put visible landing gear on the *Normandy*—it hovers. When docking on stations like the Citadel, arms extend and attach to the ship. *Normandy's* final design referenced delta-wing fighters and the Concorde, giving it an aggressive, futuristic look.

The concepts below and to the right were made to visualize the wide variety of machinery on the *Normandy* and throughout the *Mass Effect* universe.

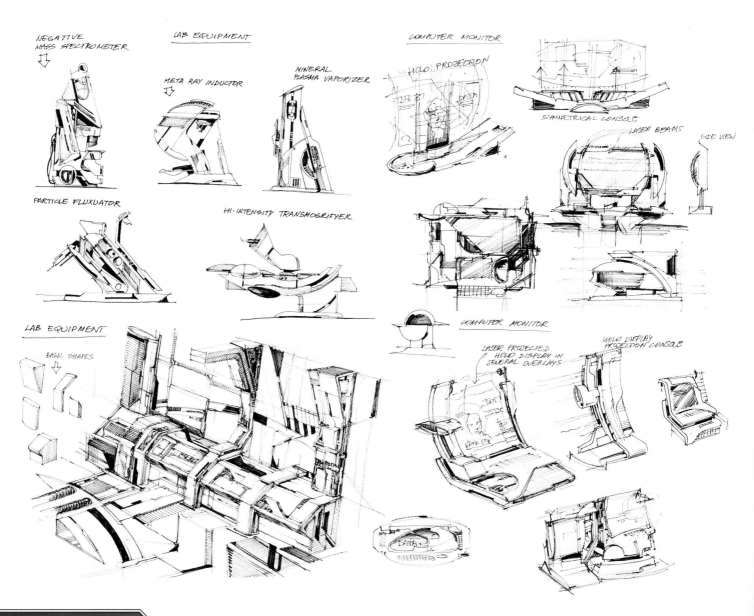

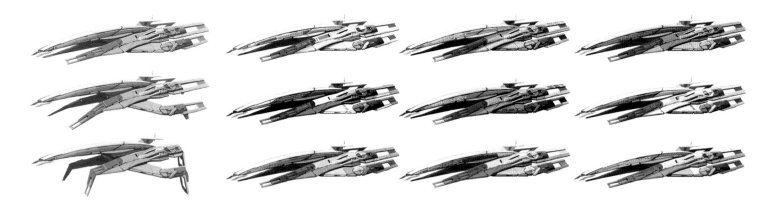

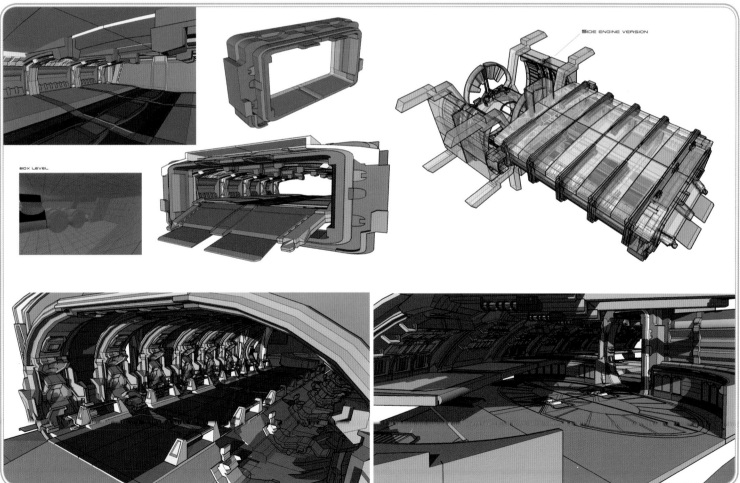

These images are concepts of the *Normandy*'s navigational and loading-bay areas. We needed to create a space where a large crew could live comfortably for months at a time.

VEHICLES

Our goal to create an expansive universe meant drafting concepts for the galaxy's many different ships and vehicles. The Alliance ships referenced the design style of the *Normandy*, with large, bi-directional thrusters. At the bottom are concepts that eventually became a krogan truck and an asari-designed skycar.

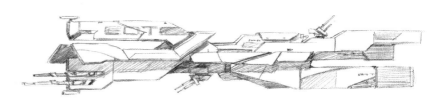

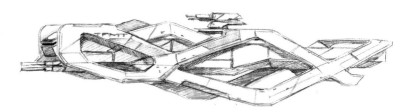

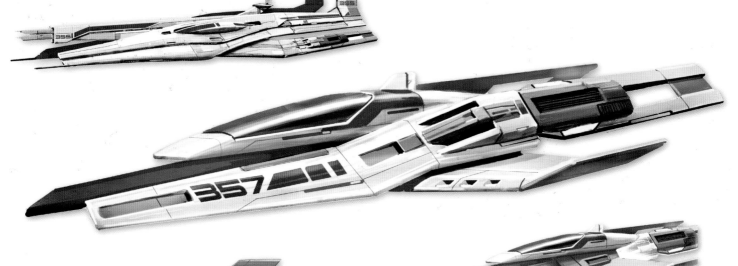

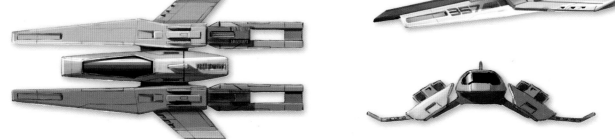

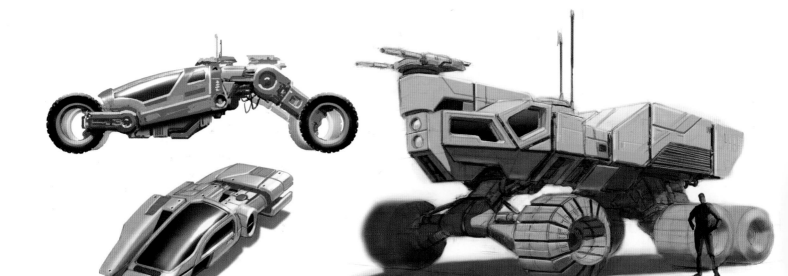

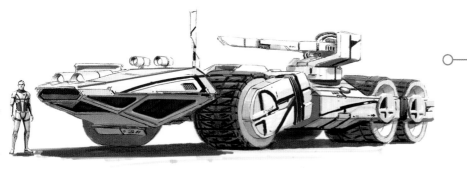

THE MAKO

We had many concepts for the Mako. We tried it as a rover, a tank, and a scout vehicle. In some concepts it even hovered, an idea that resurfaced with the Hammerhead in *Mass Effect 2*. Eventually, we decided to reference a modern armored personnel carrier. We gave it a darkened, armored-glass front and six wheels, which became the standard for *Mass Effect*'s heavy vehicles.

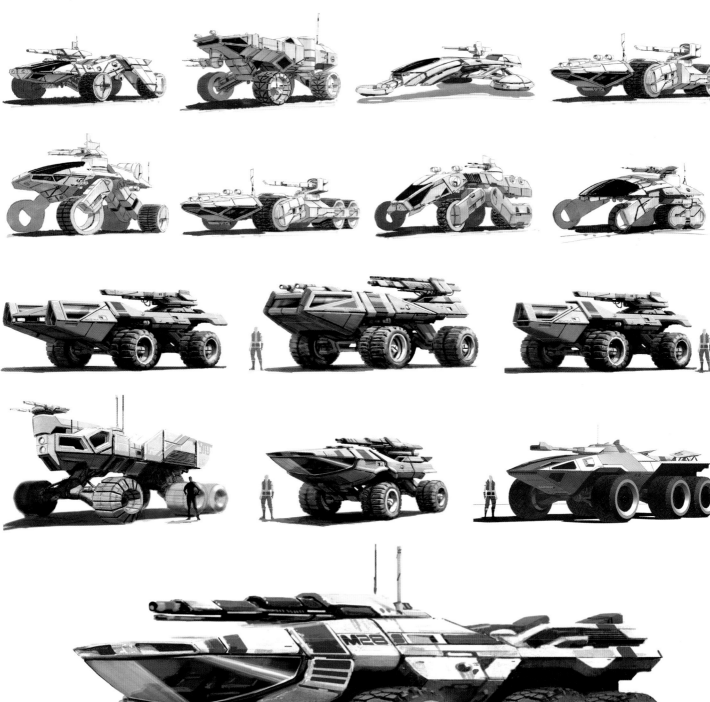

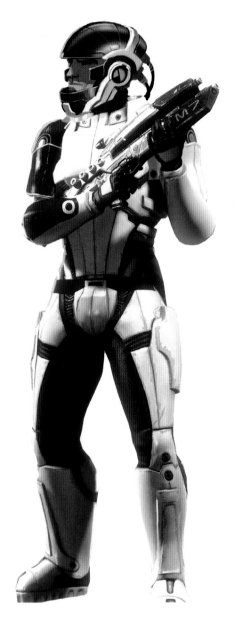

HELMETS

We had more concepts for helmets, of all things, than anything else in the *Mass Effect* universe. We made over 200 types in trying to figure out what Shepard's helmet should look like. We went back and forth between a closed-face helmet, for a more futuristic feel, and an open-faced helmet, similar to those in use by militaries today. We decided to go with the open-faced helmet so that players could see characters' expressions during the game's conversations.

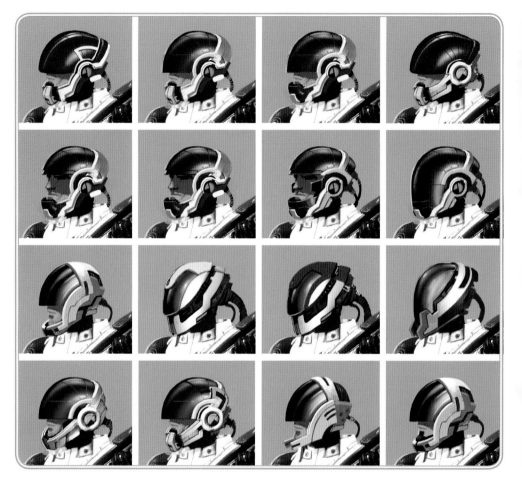

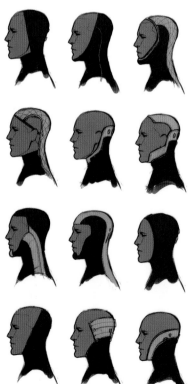

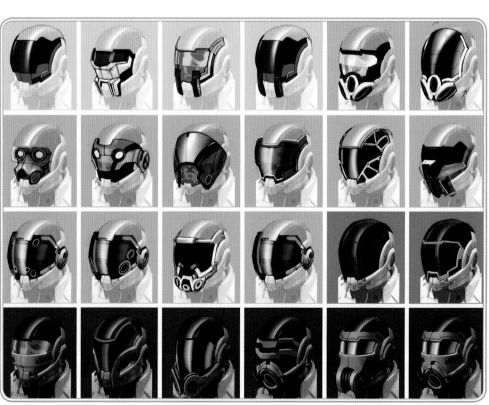

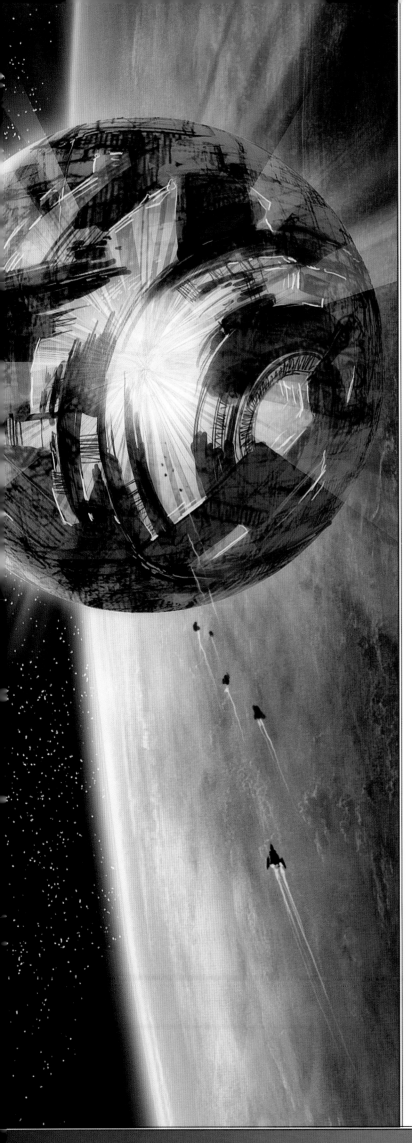

MASS RELAYS

We were cognizant of the fact that giving ships faster-than-light travel wasn't necessarily enough to account for a galaxy-spanning civilization. To address this, we came up with mass relays, which used superior alien technology. The early designs varied wildly, but we eventually settled on an unused concept for the Citadel, fitting since the Citadel and the mass relays had a common designer.

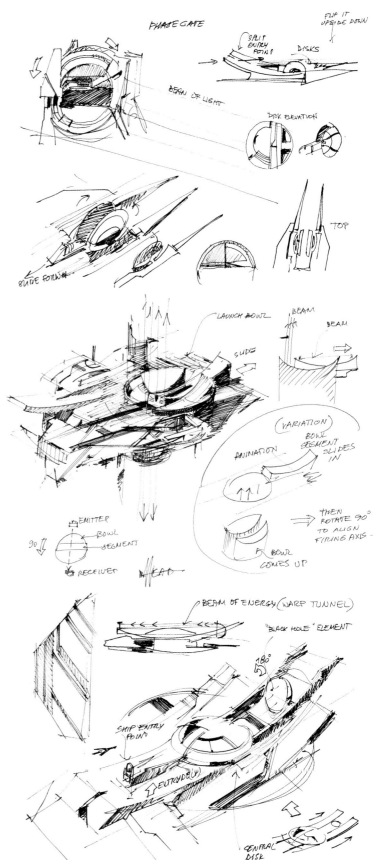

SYMBOLS

There is an expansive array of corporate logos, military insignias, and other symbols in the *Mass Effect* universe. Some images above were adopted for the Citadel or the Alliance. Others were stamped on the ubiquitous crates as logos for shipping companies.

Aldrin Labs

Kassa Fabrication

Serrice Council

ExoGeni Corporation

Binary Helix

Cerberus Skunkworks

Devlon Industries

Elanus Risk Control

Geth Armory

Hahne-Kedar

Haliat Armory

Ariake Technologies

Nashan Stellar Dynamics

Armali Council

Noveria Development Corp.

Elkoss Combine

Sirta Foundation

Rosenkov Materials

Armax Arsenal

Batarian State Arms

Jormangund Technologies

Spectre Rank 1

Spectre Rank 2

Spectre Rank 3

WEAPONRY

Mass Effect's guns had to be collapsible so that the player could store several on Shepard's back. The concepts on top were the weapons the player would have at the beginning of the game, and all have the strong *Mass Effect* arch. The original guns were chrome, later changed to make them more practical for military use. The guns were all designed with two barrels, mainly for appearance rather than functionality.

The four holes on the original assault rifle were for slotting in modifications. This was later altered in favor of color variations, but the slots remained in the weapon's design.

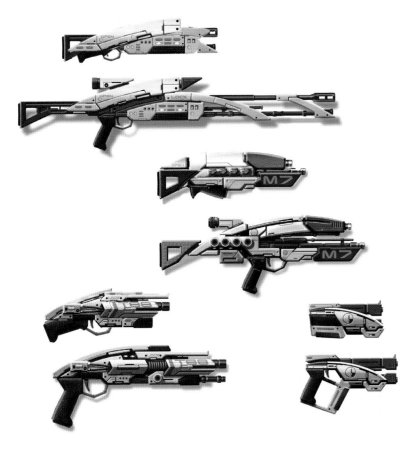

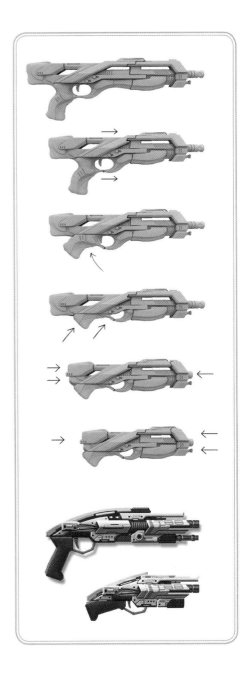

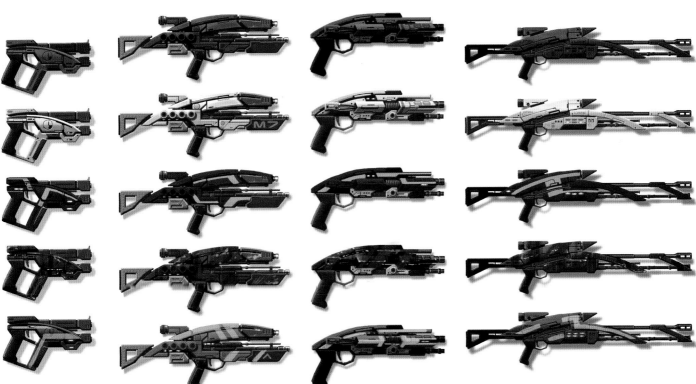

GETH TECHNOLOGY

The geth ships looked like metallic insects. The bottom images were concepts for the geth cruiser, dropship, and fighter, showing how it might be animated while flying. Small arms were attached to the geth vehicles to give them the look of a fly rubbing its legs together.

Since the geth were the most common enemy in the game, we tried a wide variety of weapons and machinery for them. One original concept was a cyborg with dolphin-like skin, as seen on the facing page's top-left armature, but we felt this would be difficult to present convincingly. The idea was scrapped in favor of a metal appearance.

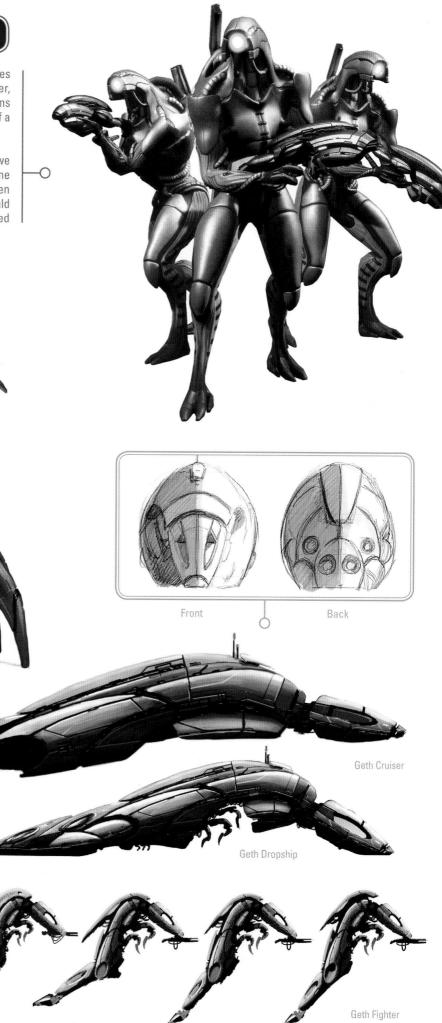

Geth Turret

Geth Tower

2M

1.2 M

Front

Back

Geth Cruiser

Geth Dropship

Geth Fighter

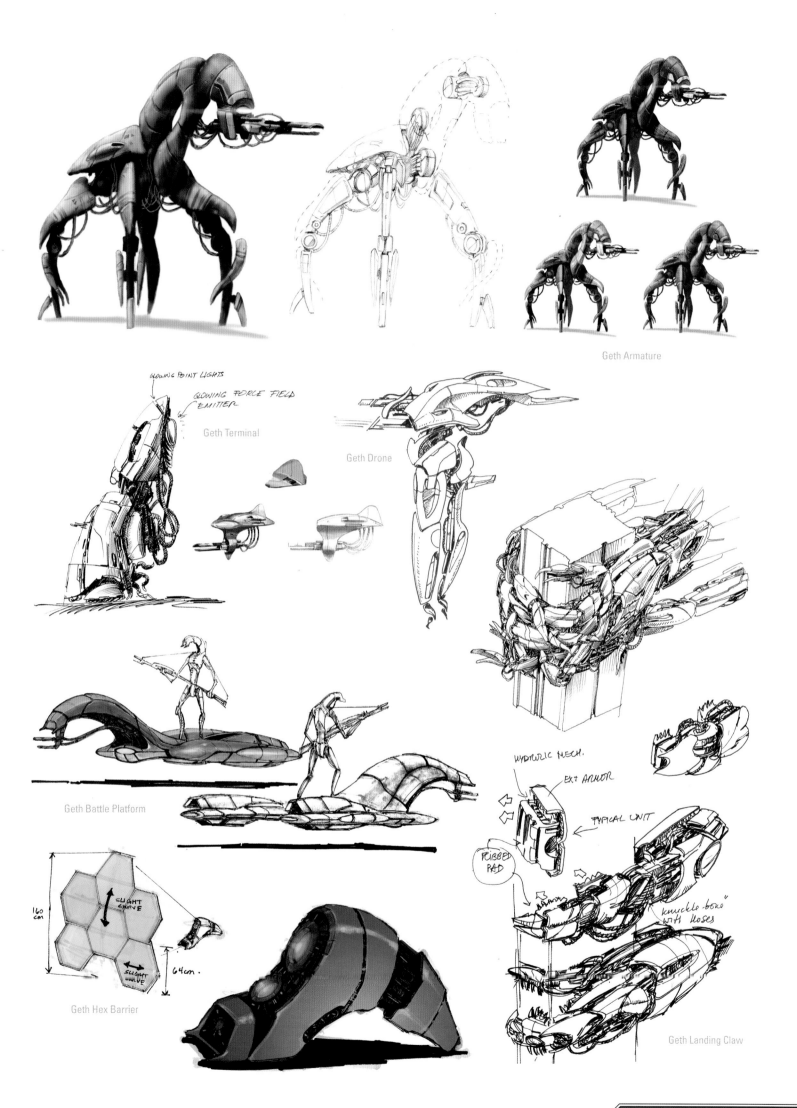

Geth Armature

Geth Terminal

GLOWING POINT LIGHTS

GLOWING FORCE FIELD EMITTER

Geth Drone

Geth Battle Platform

Geth Hex Barrier

160 cm

SLIGHT CURVE

SLIGHT CURVE

64cm.

HYDRAULIC MECH.

EXT ARMOR

TYPICAL UNIT

RIBBED PAD

knuckle-bone with hoses

Geth Landing Claw

MISC. TECHNOLOGY

Some concepts for machinery were used on the main worlds as set dressing, while others were made for the uncharted worlds where Shepard retrieves technology lost on the surface of the planet.

Given the size of the *Mass Effect* universe, we needed an enormous amount of set dressing and ambient machinery like chairs, beds, storage, and medical equipment to make the areas look lived in and believable. They aren't the most glamorous pieces, but if they didn't exist, players would feel something was missing.

Alarm Sensor

FRONT GLOWING CAMERA 'EYES' SIDE 1

SIDE 1

Gun rotates 360

Barrels move up and down

Hinge

Hinge Turret Gun

Legs pivot

Keeper Console

Downed Satellite

HATCH OPENS Escape Pod

BEAMS OF LIGHT

CENTER CORE HAS ROTATING GLOWING ANIMATION

POWER REGULATOR (DESTRUCTIBLE)

Cargo Container

POWER TUBES

POWER TUBES

POWER TUBES

Generator

ANIMATED GLOWING BLUE LIGHTS SIGNAL GENERATOR IS OPERATIONAL LATERAL LASER BEAMS 'MOVE' DOWN WHEN ANIMATED

BACK

FRONT

Pleasure Pod

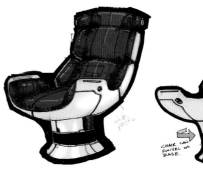

Comfortable Chair

1.7M
1.2M
3M

Mantlet

2.5M

Truck Jack

Mechanical Arm

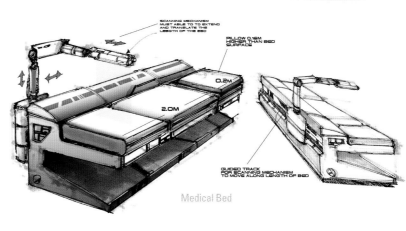

SCANNING MECHANISM MUST ABLE TO TO EXTEND AND TRANSLATE THE LENGTH OF THE BED

PILLOW 0.15M HIGHER THAN BED SURFACE

0.2M

2.0M

GUIDED TRACK FOR SCANNING MECHANISM TO MOVE ALONG LENGTH OF BED

Medical Bed

1.3 m

First-Aid Station

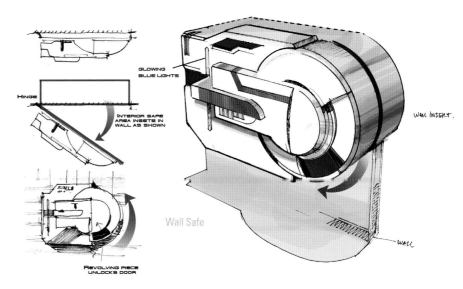

GLOWING BLUE LIGHTS

Hinge

INTERIOR SAFE AREA INSETS IN WALL AS SHOWN

WALL INSERT.

Wall Safe

WALL

REVOLVING PIECE UNLOCKS DOOR

» MASS EFFECT 2

COMMANDER SHEPARD

The middle images are concepts for the customization system for Shepard. Shepard's armor system became piece-based in *Mass Effect 2*. The looks emphasized Shepard's silhouette, making the commander appear stronger and able to take more punishment. Below are early attempts at visors and helmets, including a variation on Thane's helmet.

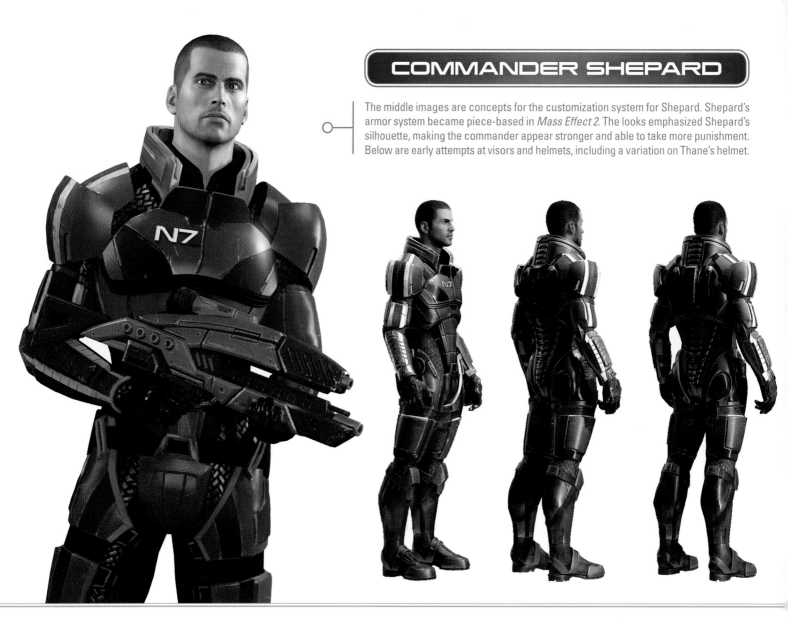

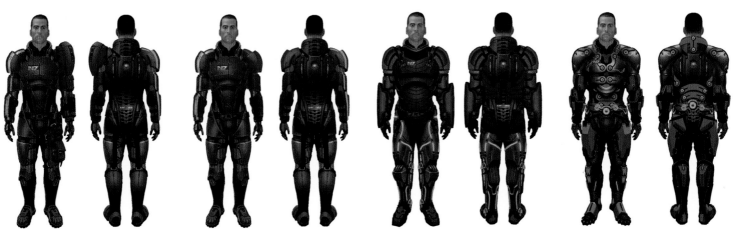

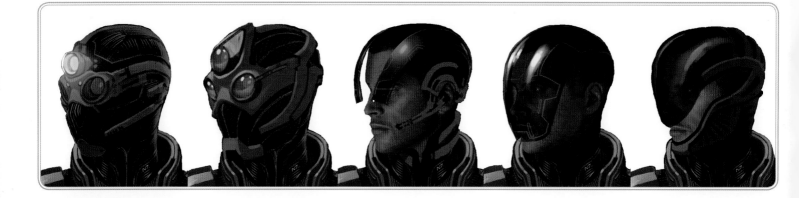

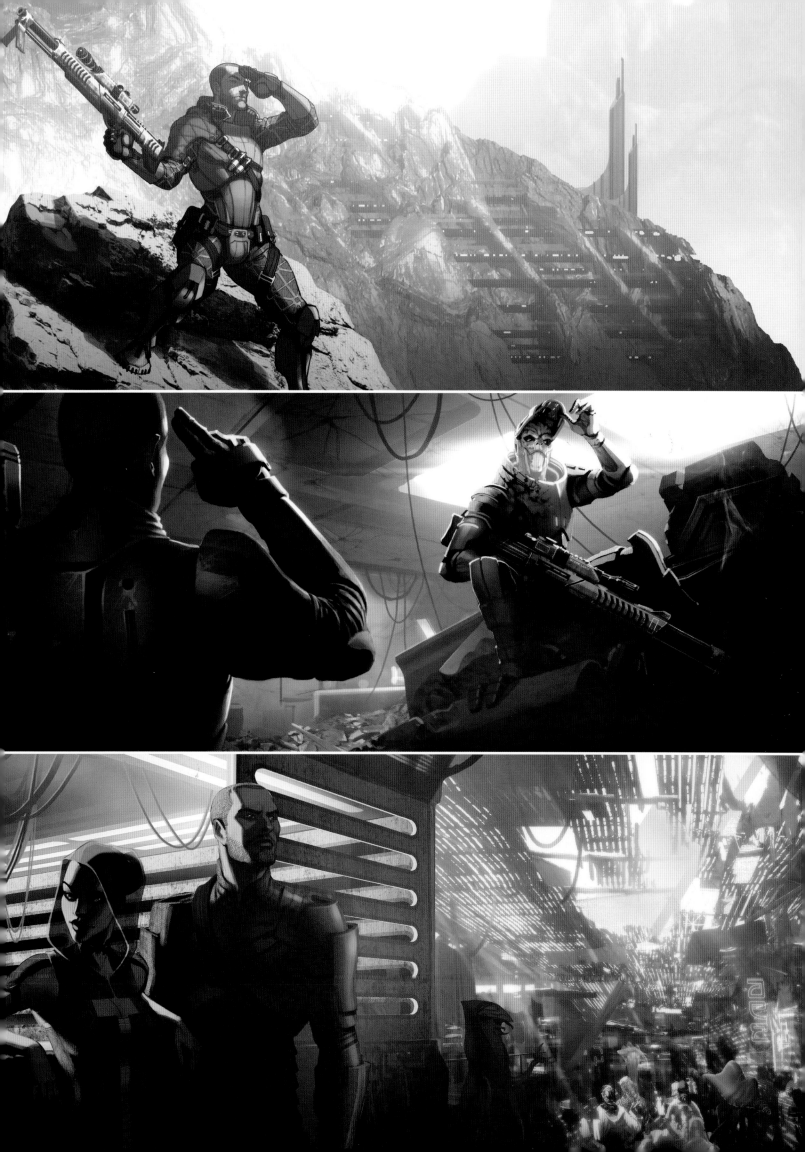

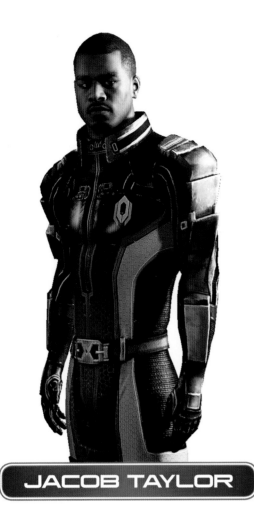

JACOB TAYLOR

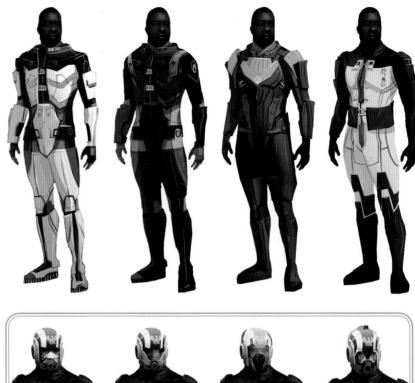

Jacob's armor and clothing helped define the iconic look of all Cerberus clothing. Some concepts were fully armored, while some were cloth or a mixture of cloth and armor. Helmets and breathers would be mandatory on airless or toxic planets. Ultimately, a small respirator was chosen to allow for greater expressivity from the digital actor.

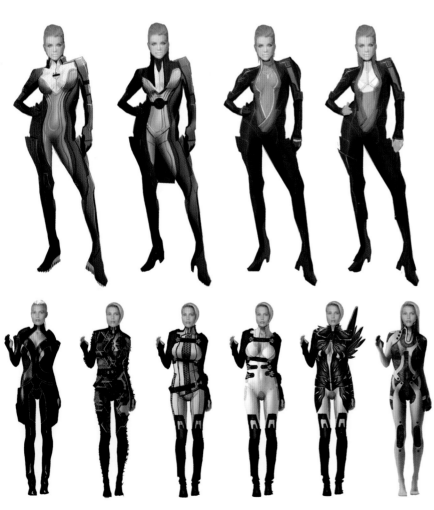

Concepts for Miranda's body and clothing tried to balance sex appeal with a uniform befitting a Cerberus officer.

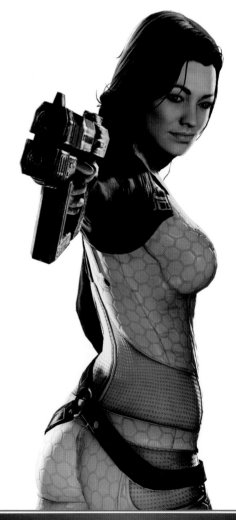

MIRANDA LAWSON

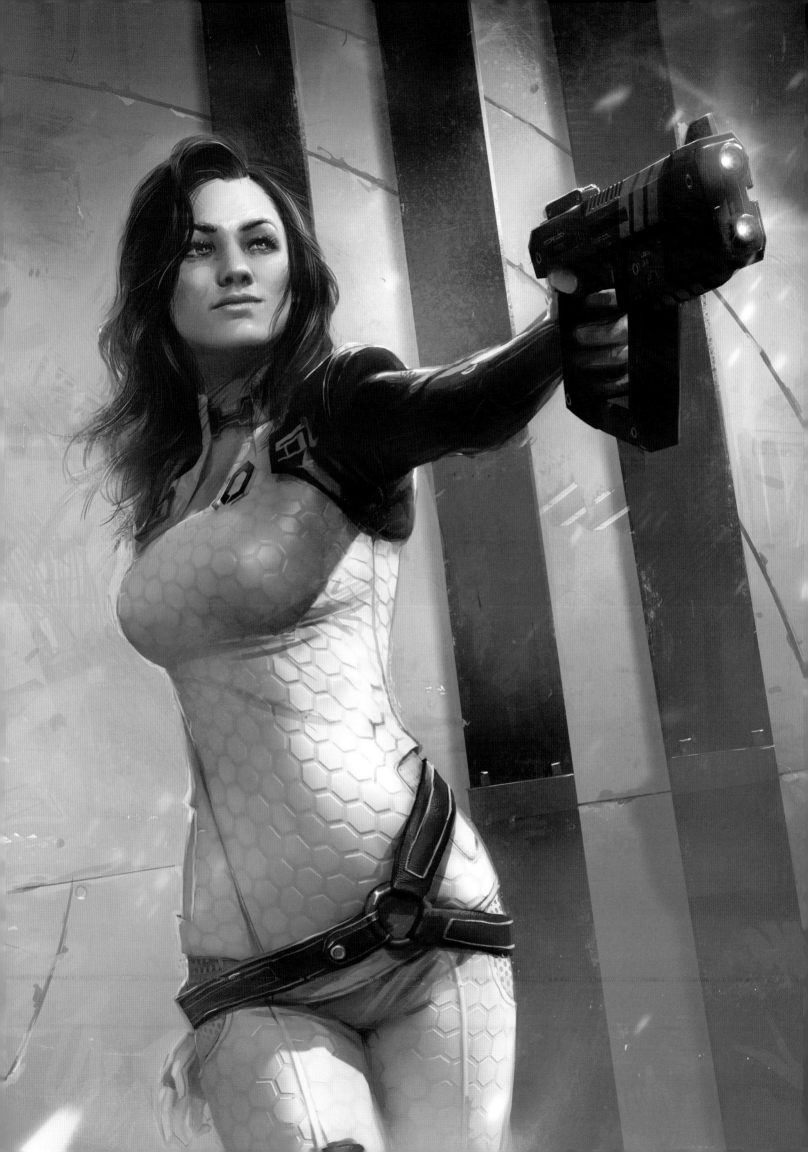

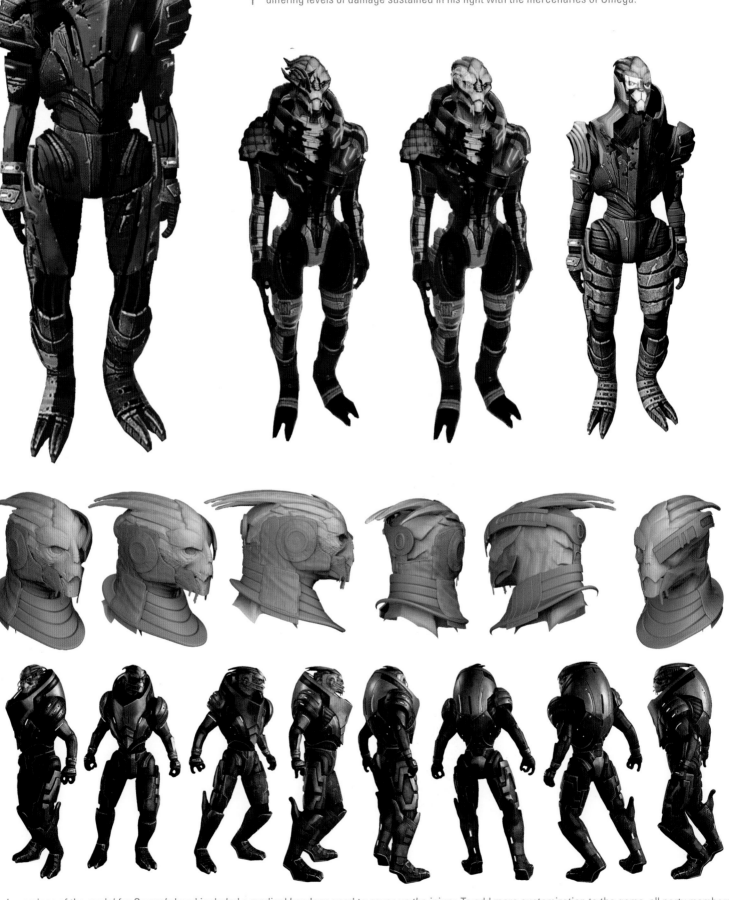

GARRUS VAKARIAN

Garrus was a popular character among fans, so his design kept pieces of his iconic uniform, such as the eye visor and his signature blue-and-black armor. The variations above show differing levels of damage sustained in his fight with the mercenaries of Omega.

Early versions of the model for Garrus's head included a medical bandage used to cover up the injury. To add more customization to the game, all party members eventually received alternate appearances. Garrus's had undamaged armor and a slight color variation to make him seem more unique.

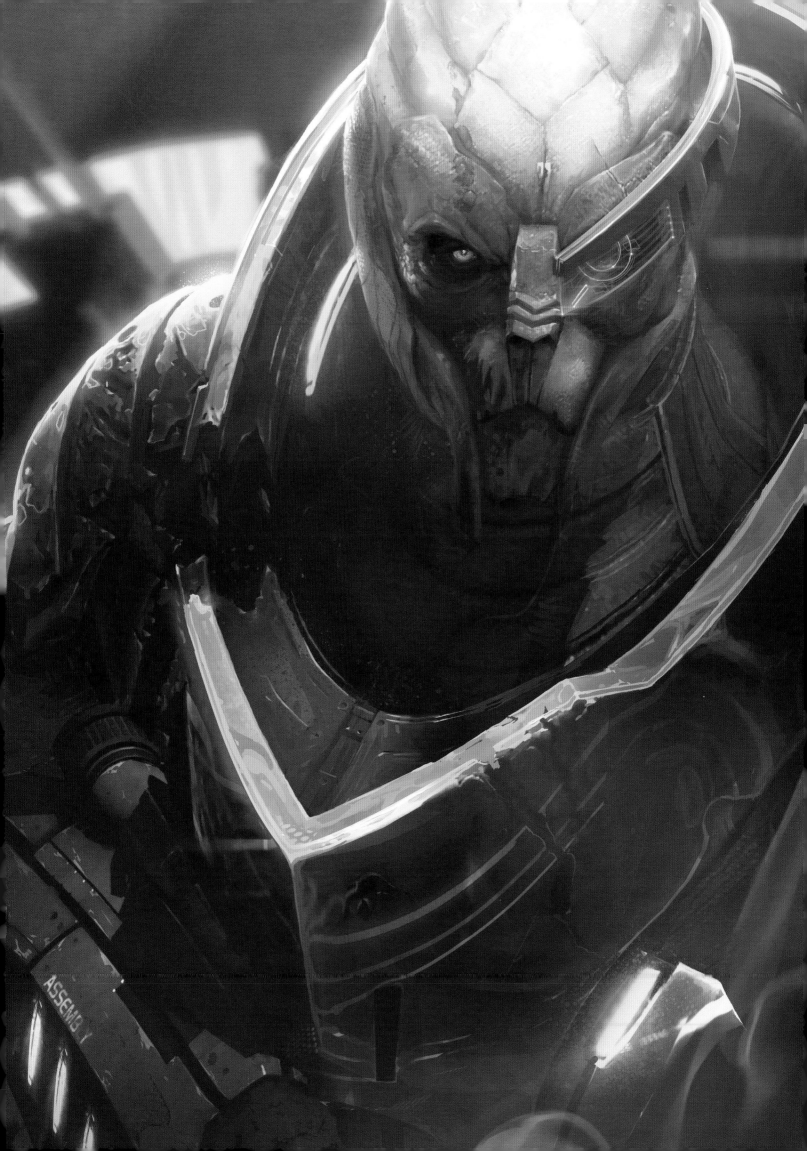

TALI'ZORAH

Tali'Zorah also proved more popular than expected, and early concepts exploring more extreme variations of her hood and uniform were shelved in favor of one that kept her iconic appearance. Tali's final art was a more polished version of the original *Mass Effect* character, with a slightly refined hood. This appearance was chosen because it stood out against the many other quarians seen for the first time in *Mass Effect 2*.

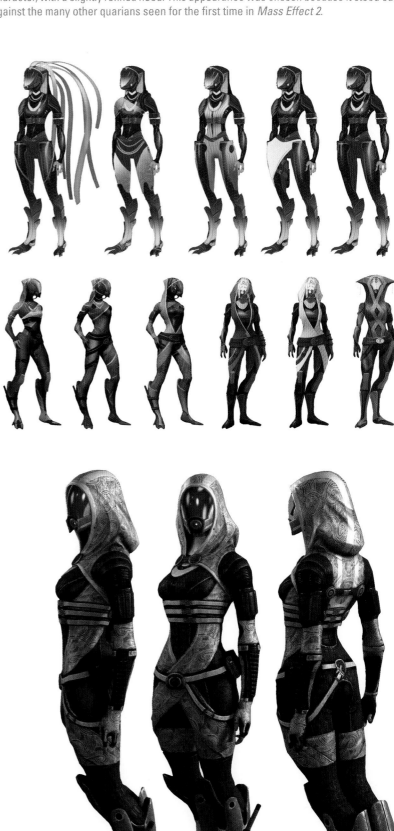

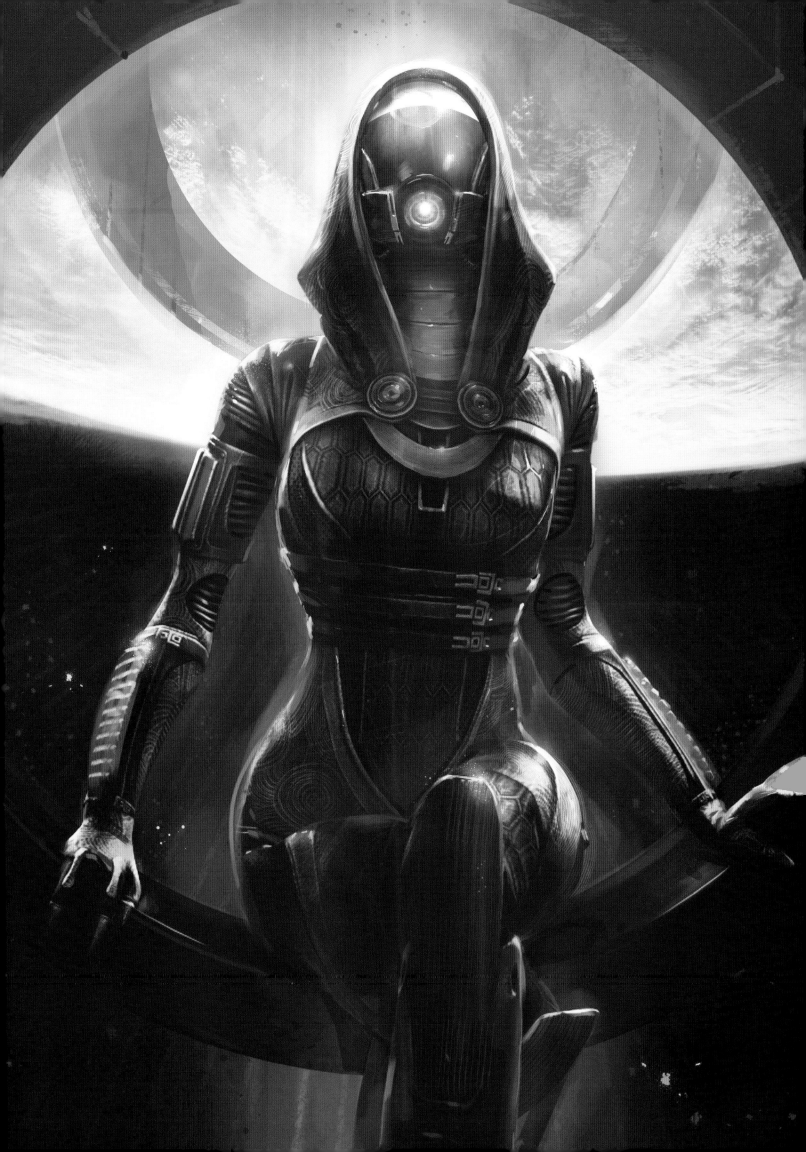

GRUNT

Grunt had to be young, but also tough, so we designed the krogan's crests to grow as they age. Grunt's crest is smaller than Wrex's and hasn't fully covered his entire skull. His armor evolved into large shoulder pads and exposed muscular arms, reminiscent of a linebacker.

Early materials for Grunt's armor varied widely. In contrast to the old, battle-scarred Wrex, Grunt looked youthful. His armor could be likened to the "show-room finish" on a brand-new vehicle.

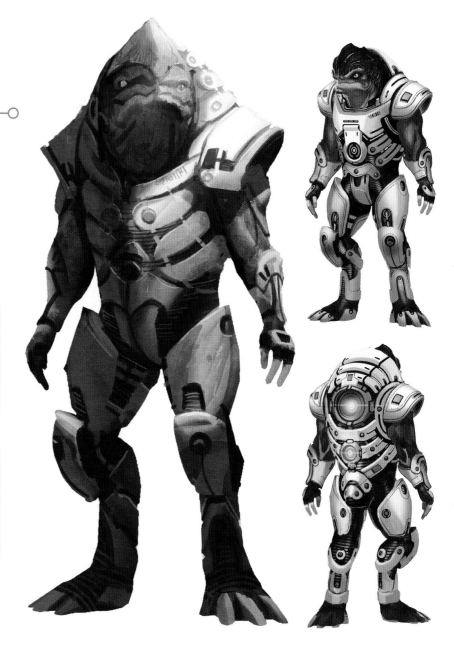

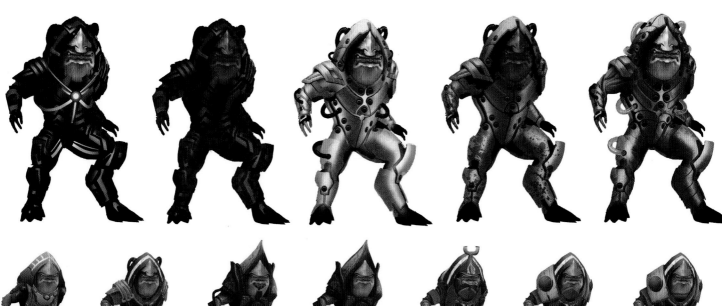

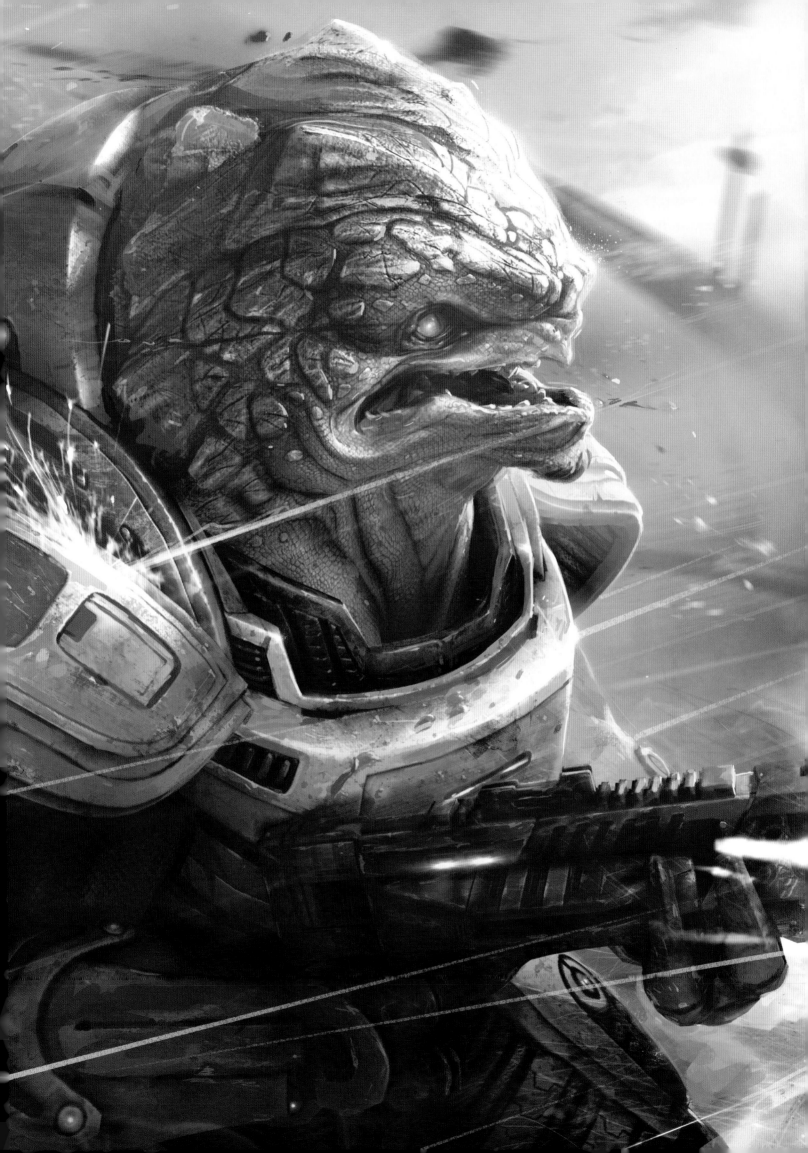

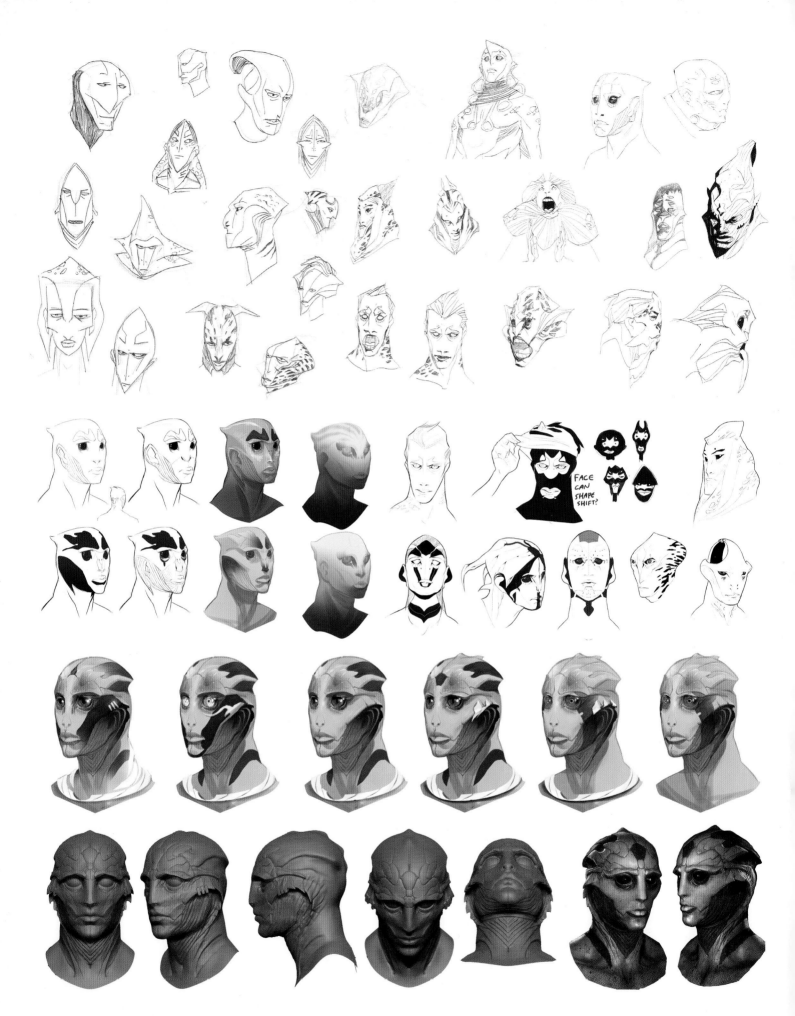

THANE KRIOS

We made many thumbnail drawings for early Thane concepts. Early in development, concept artists are given as much freedom as possible. For Thane, some drew upon lizards or birds of paradise for inspiration. Later refinements led to a mixture of aquatic and reptilian characteristics. Also included are some concepts for jewelry on his face and neck. Only his necklace made it into the final game.

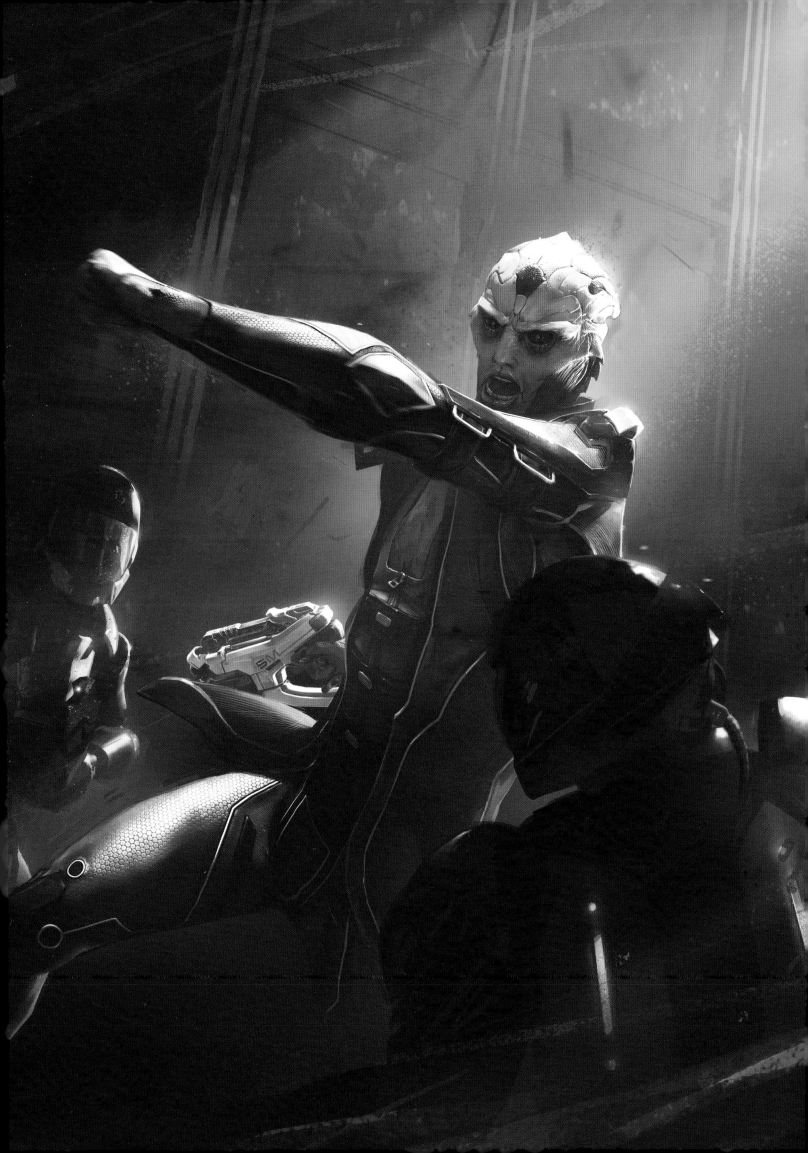

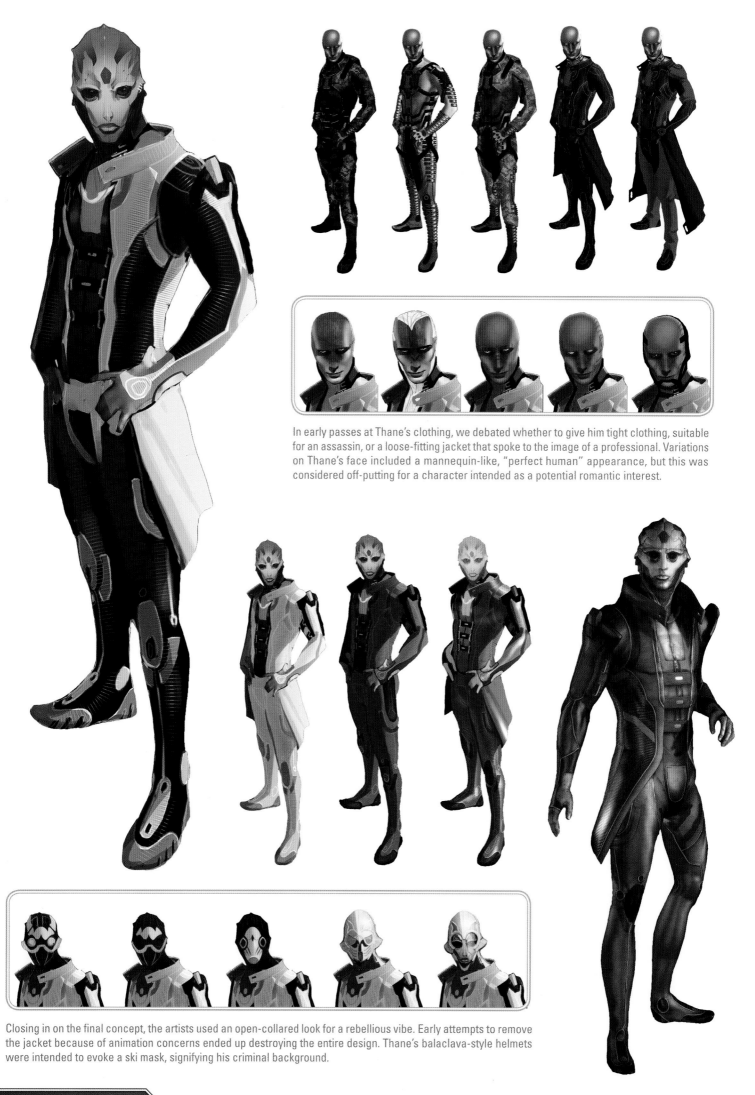

In early passes at Thane's clothing, we debated whether to give him tight clothing, suitable for an assassin, or a loose-fitting jacket that spoke to the image of a professional. Variations on Thane's face included a mannequin-like, "perfect human" appearance, but this was considered off-putting for a character intended as a potential romantic interest.

Closing in on the final concept, the artists used an open-collared look for a rebellious vibe. Early attempts to remove the jacket because of animation concerns ended up destroying the entire design. Thane's balaclava-style helmets were intended to evoke a ski mask, signifying his criminal background.

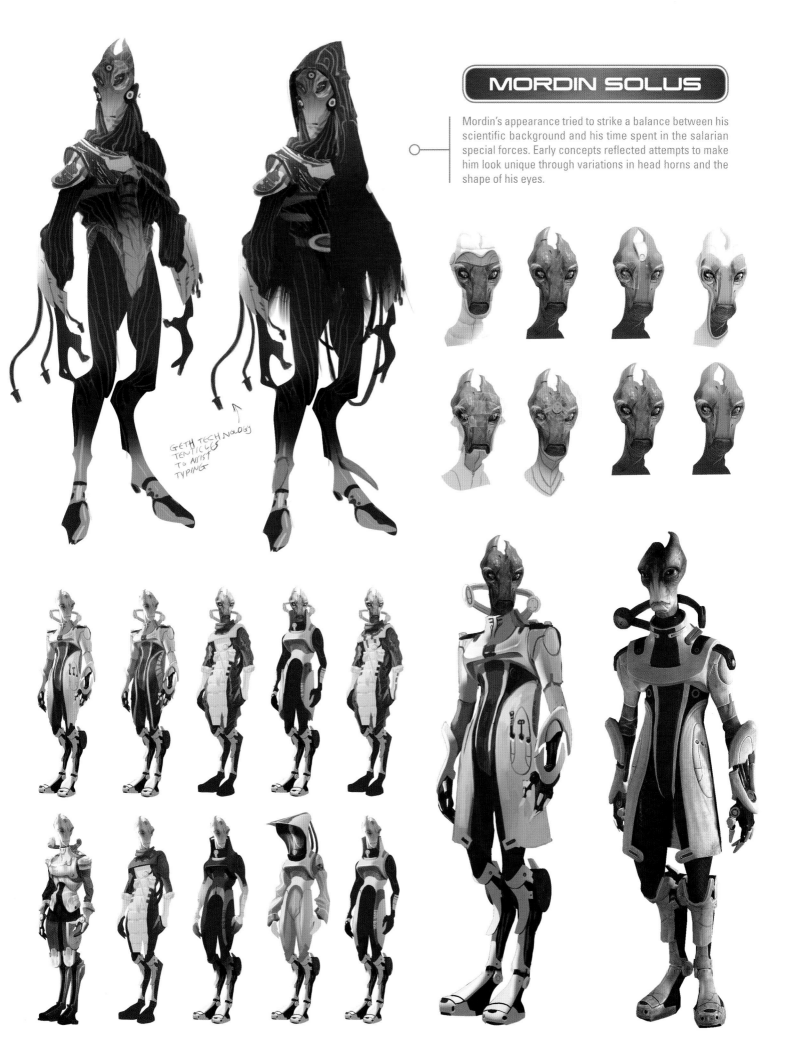

MORDIN SOLUS

Mordin's appearance tried to strike a balance between his scientific background and his time spent in the salarian special forces. Early concepts reflected attempts to make him look unique through variations in head horns and the shape of his eyes.

GETH TECHNOLOGY TENTICLES TO ASSIST TYPING

Mordin's appearance hinted at a lab coat and was similar to the outfits chosen for medical characters in the *Mass Effect* universe. The metal collar was added to break up his silhouette—its purpose was never actually explored in the game's dialogue or lore.

LEGION

The goal of Legion's early concepts was to distinguish him from other geth. Eventually, this direction was reined in. In the later stages, it was decided that Legion had ripped off a section of Shepard's armor to cover the battle damage in his chest.

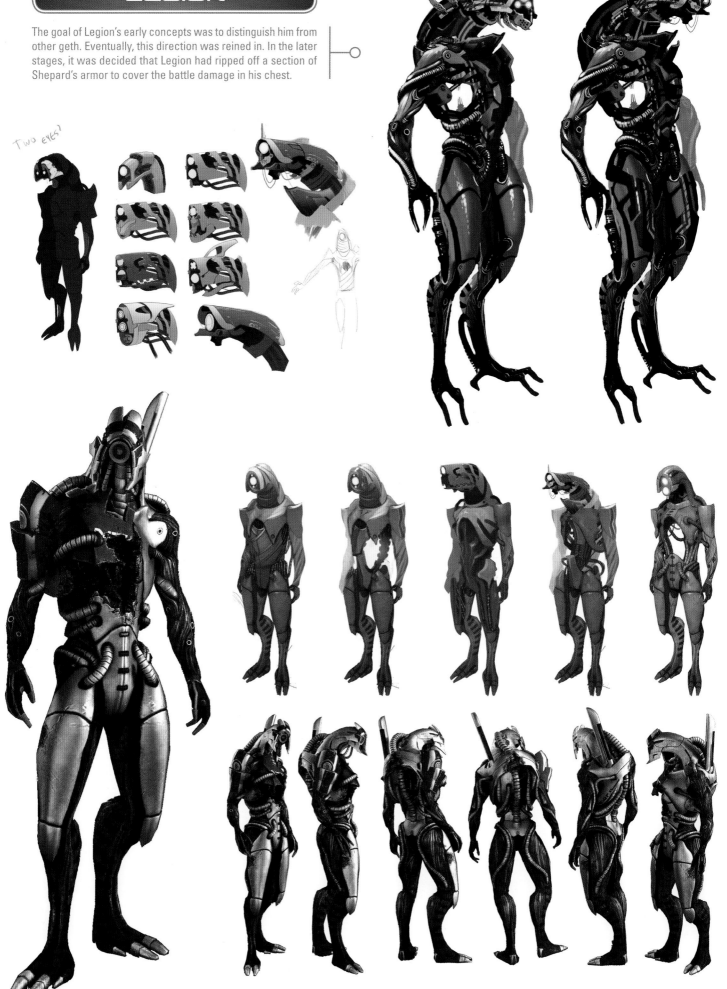

Two eyes?

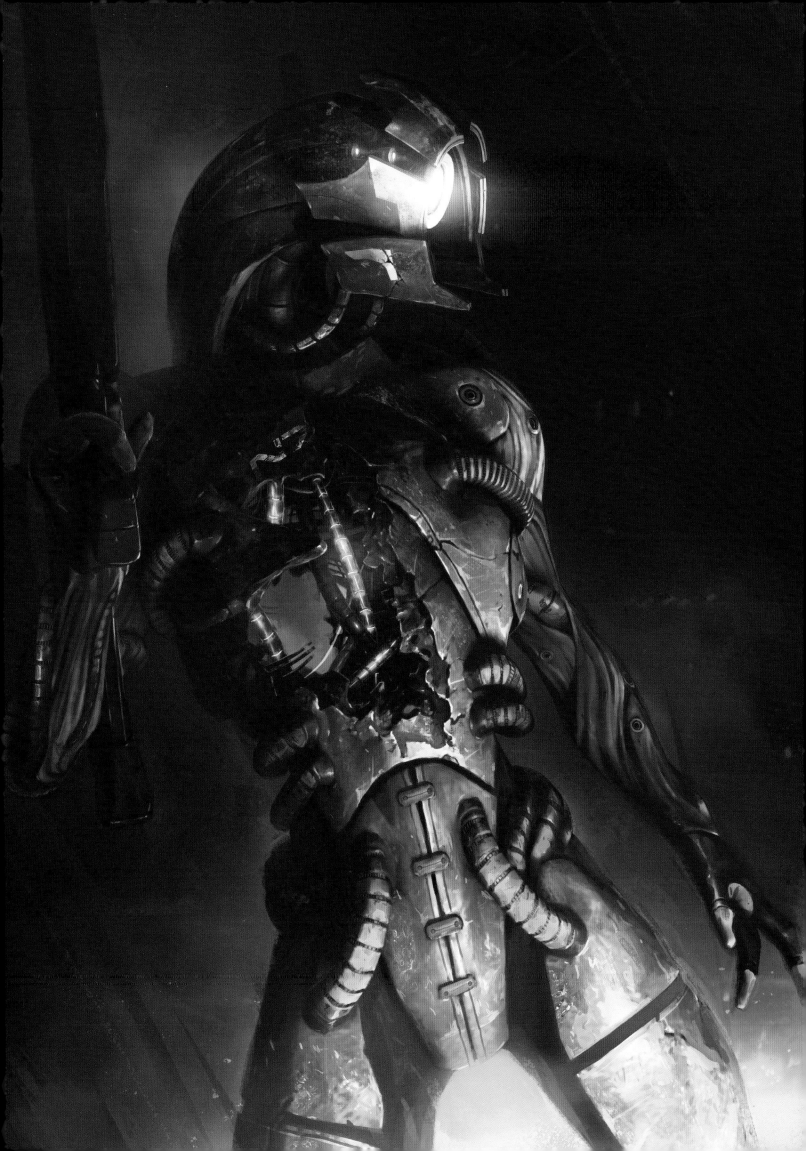

JACK

These images are production paintings showing Jack in her element, giving a feel for what she can do when she breaks out of *Purgatory*.

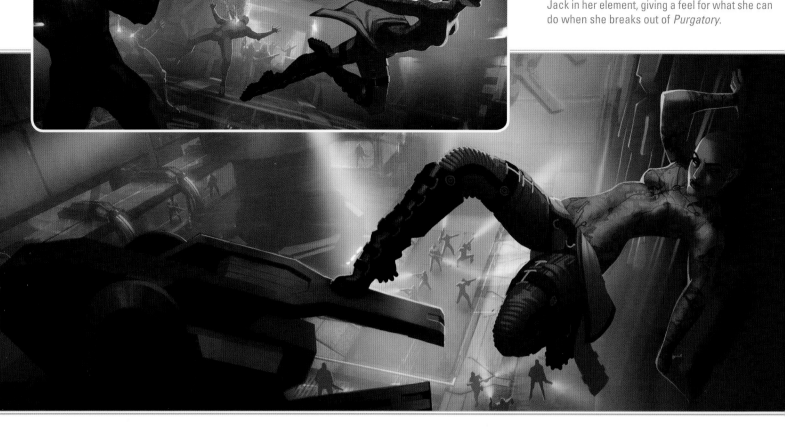

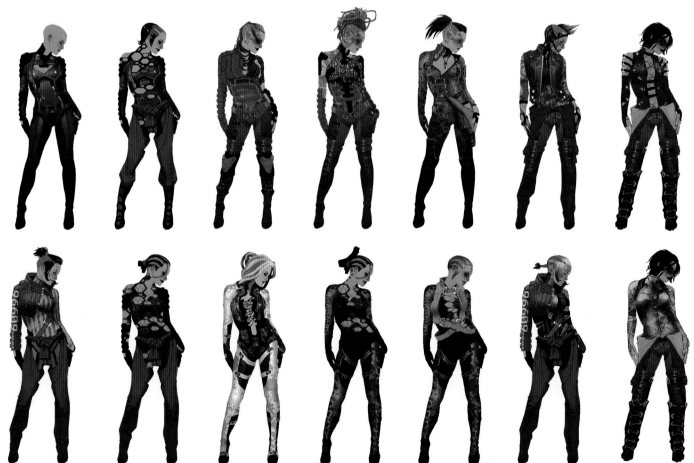

Jack is a punk, and early variations focused on that. Her pants, which were part of her prison uniform, were pulled down to reflect Jack's unique sense of style. Her tattoos cover her scars in a deliberate attempt to write her own story, erasing the pain of her past.

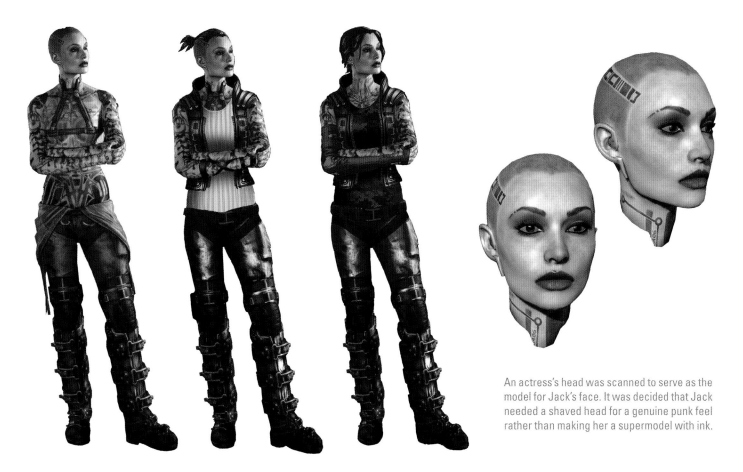

An actress's head was scanned to serve as the model for Jack's face. It was decided that Jack needed a shaved head for a genuine punk feel rather than making her a supermodel with ink.

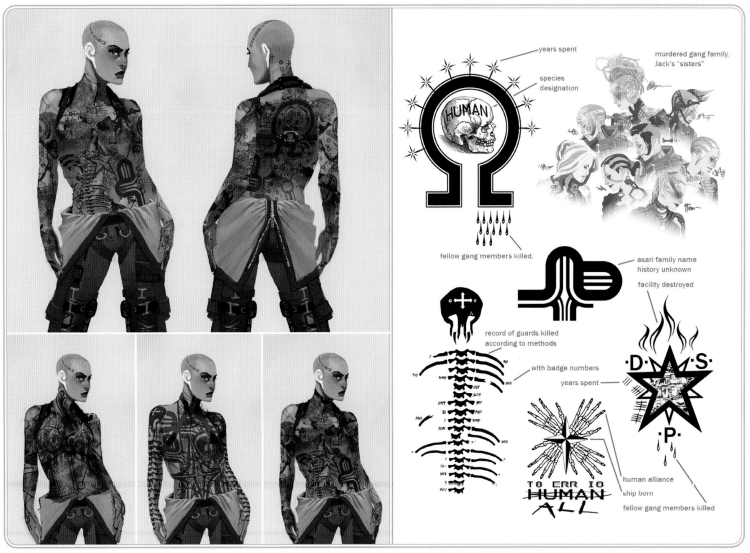

years spent

species designation

HUMAN

fellow gang members killed.

murdered gang family. Jack's "sisters"

asari family name history unknown

facility destroyed

record of guards killed according to methods

with badge numbers

years spent

·D·S·

·P·

TO ERR IO
HUMAN
ALL

human alliance

ship born

fellow gang members killed

Once it was decided that Jack would be clothed in tattoos, various directions were explored for how to tell her backstory through them. We also sought ways to best show off her tattoos while covering her chest to some degree. Concerns about how exposed she was led to some of these changes.

SAMARA

Samara was one of the more difficult characters to nail down. Her mystic-warrior concept led to variations including religious headgear or crownlike adornments to imply royalty. It was ultimately decided that it would be acceptable to have some skin showing due to her armor's near-invisible kinetic-barrier technology, which was her primary method of defense.

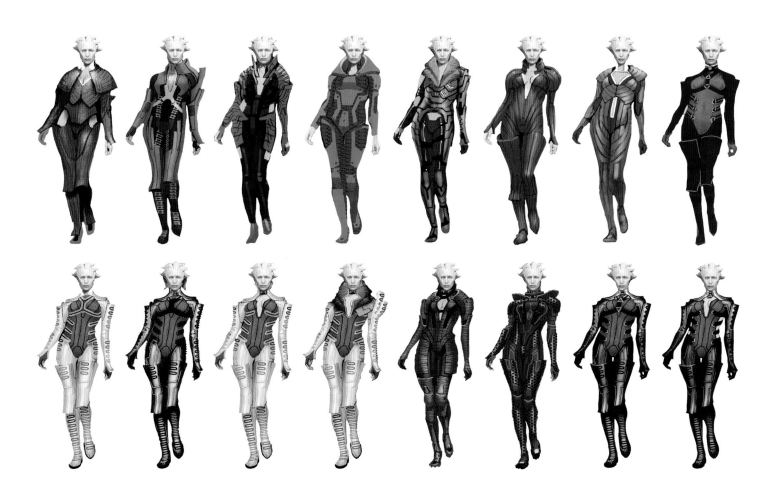

The images above are good examples of our phase one concept work, in which we try to get as many ideas as possible onto the page. This provides us the chance to figure out what stands out about a character and what makes her iconic. Here it is pretty obvious which outfit drew our eye. In phase two, we polished the design until we were all in agreement. Various designs were tried for Samara's breather. As with Jacob, we eventually decided on a small breather to allow for more facial expression.

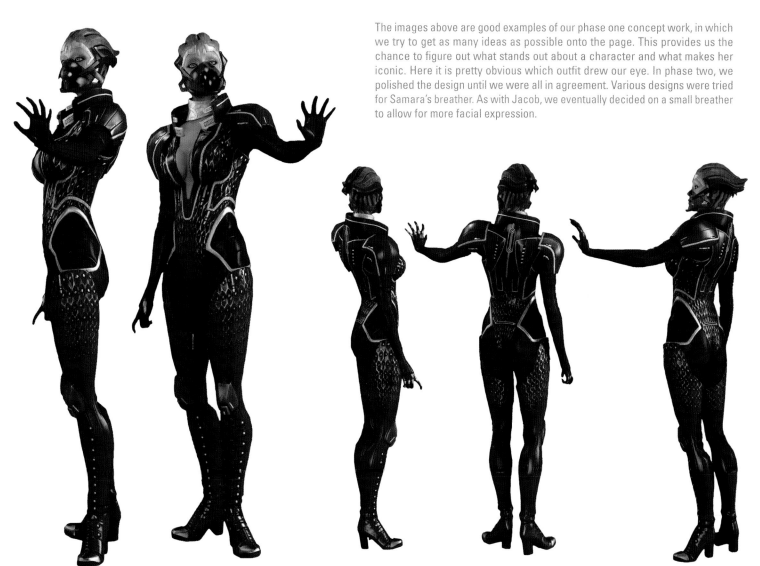

ZAEED MASSANI

Early concepts toyed with giving Zaeed an artificial leg as part of his battle injuries, as well as a dog companion. Neither concept was taken past phase one. Potential breathers were inspired by a welding helmet and a hockey mask for intimidation purposes. Head models of Zaeed went through several iterations, adding scarring and a Blue Suns tattoo to show his history with that group.

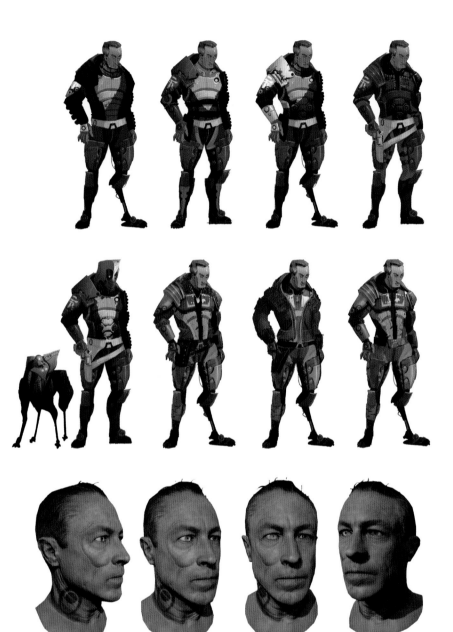

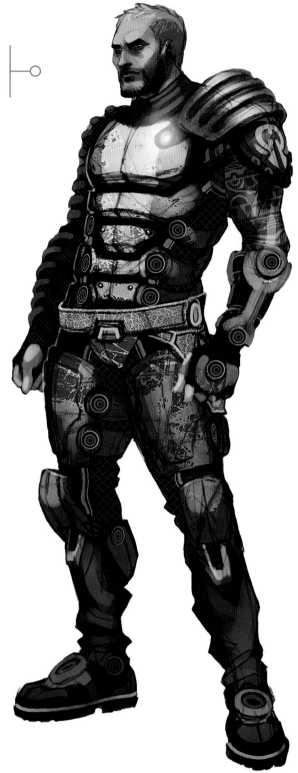

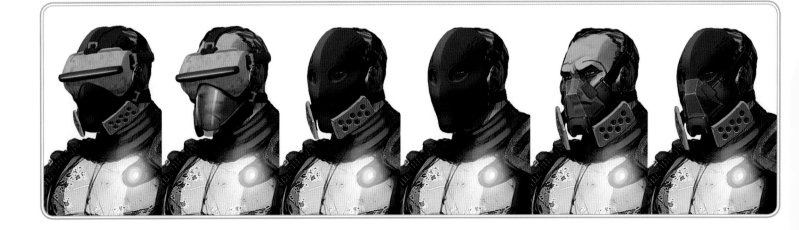

KASUMI GOTO

Kasumi's concepts ventured into Middle Eastern styles, since Earth societies in the *Mass Effect* universe are a pastiche of modern cultures. Eventually, her outfit came to echo that of a medieval thief; the hood was adopted to give her a more mysterious, stealthy look.

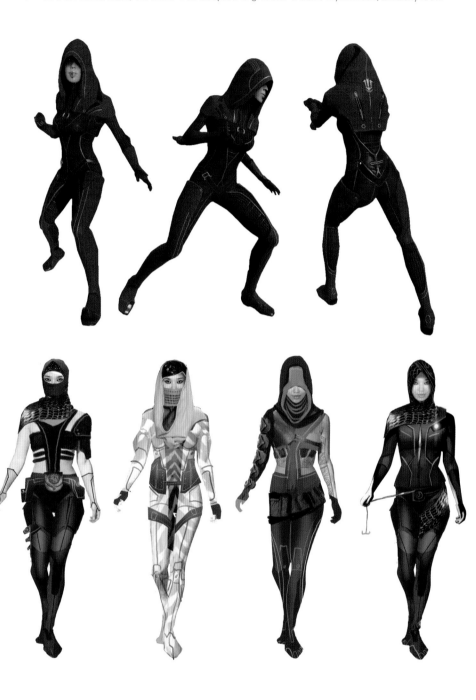

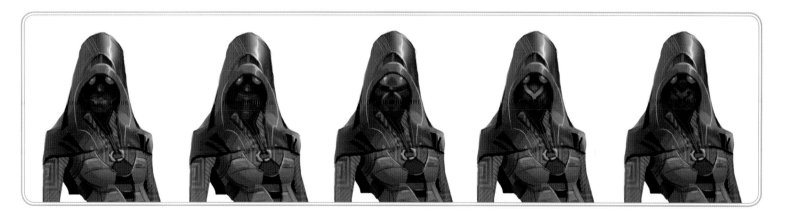

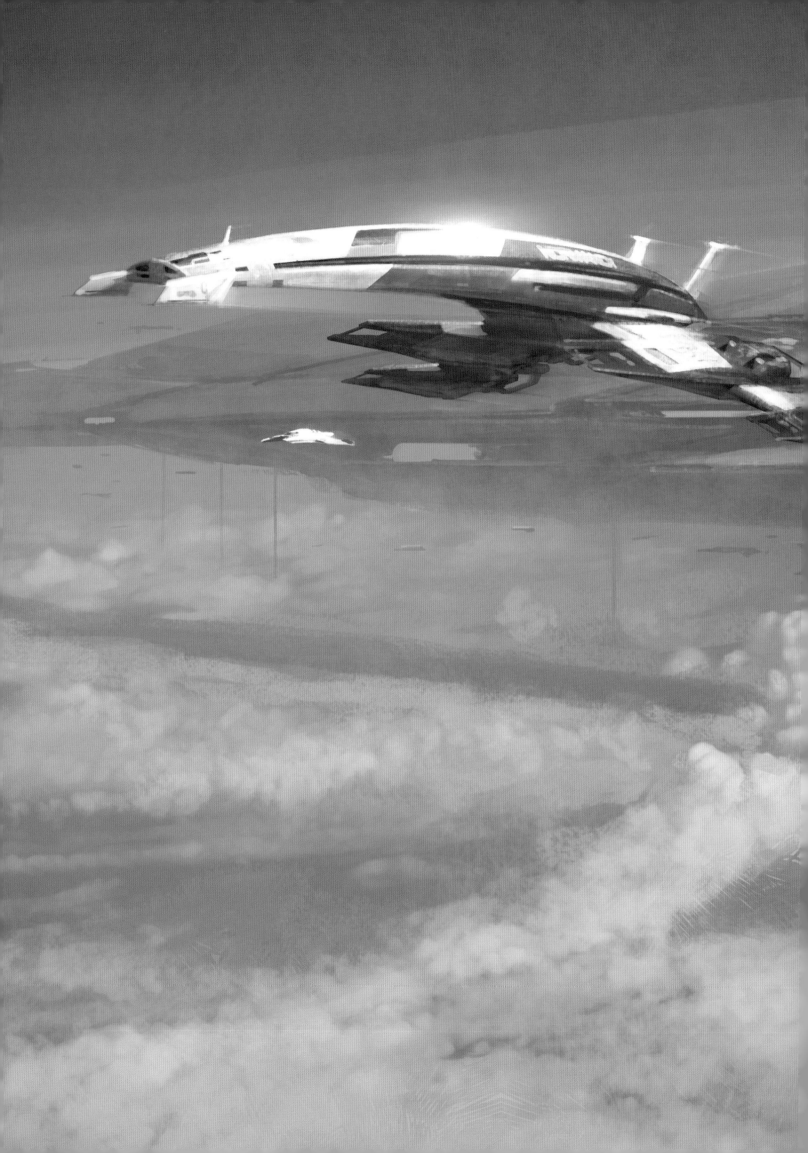

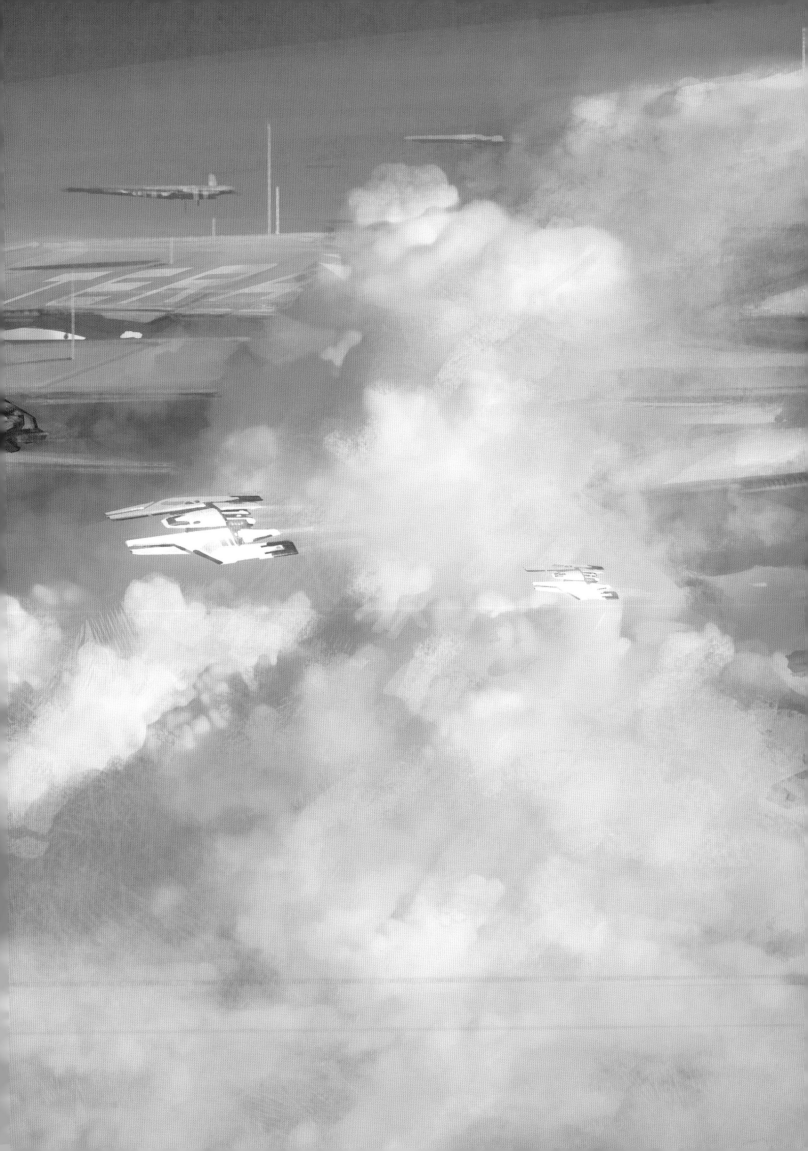

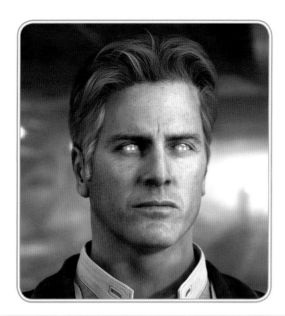

THE ILLUSIVE MAN

It was decided early on that the Illusive Man's face would be based on a "catalog model." Though in his fifties, the Illusive Man doesn't show many signs of age, as improvements in medical technology mean that even a hard-drinking smoker would still look fairly fit. A lot of attention was paid to the implants in his eyes, the intent being to give him a subtly inhuman look.

The challenge with the Illusive Man's suit was to create a futuristic outfit recognizable as a suit, but not confined by any particular decade's fashion. We wanted to give his appearance a timeless feel. His open shirt was included to strike an informal note that said, "I can do what I please."

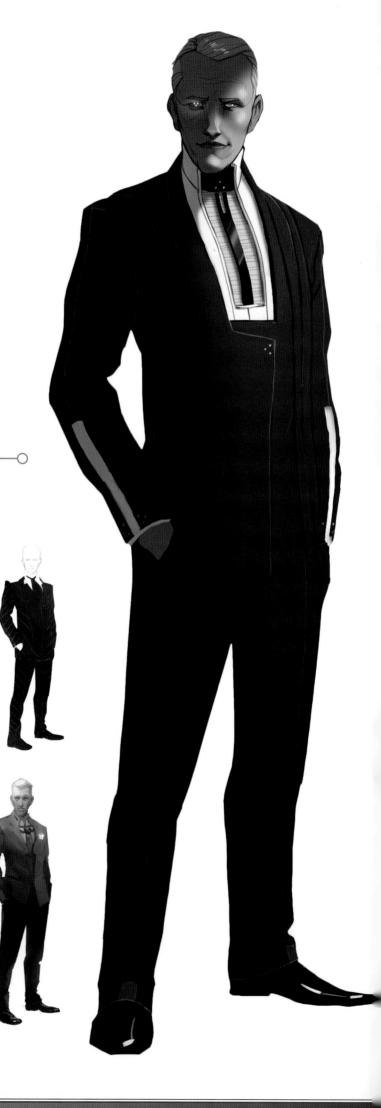

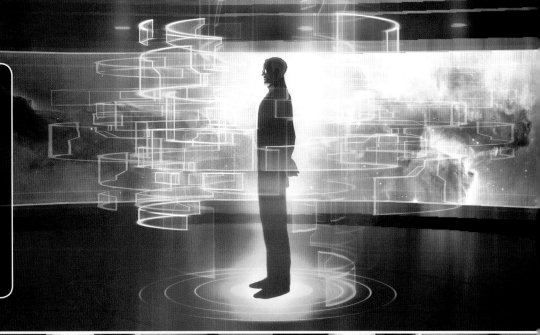

Only a few concept pieces were created for the Illusive Man's room. The artist created a piece with him watching a dying star, giving him the feel of completely controlling his environment. The room is empty, giving no hint of where the Illusive Man actually physically lives.

Instead of phones or monitors, the Illusive Man is surrounded by holograms, showing that he is connected to a vast web of information. The fact that he only communicates to Shepard through these holograms again gives a subtly inhuman feel—he sees facsimiles of people rather than the genuine articles.

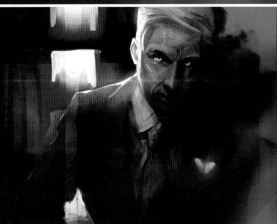
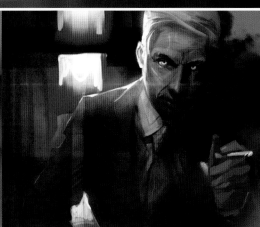

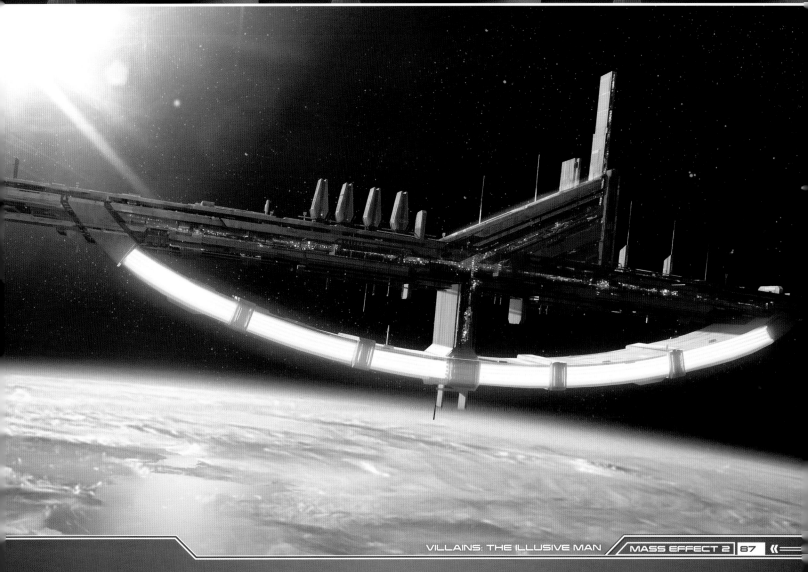

THE SHADOW BROKER

The challenge in creating the Shadow Broker was to put together two disparate concepts: that of the galaxy's greatest information broker, who is clearly part of the galactic society, but also something inhuman and alien that would be a new and frightening challenge for Shepard.

His suit said mob boss, while his exposed face was more alien than anything we had done in the past. The existing digital-acting system could not handle the stresses of the new face, so custom work had to be done to animate his multiple eyes and triangular mouth.

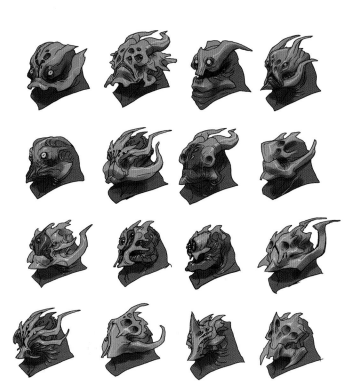

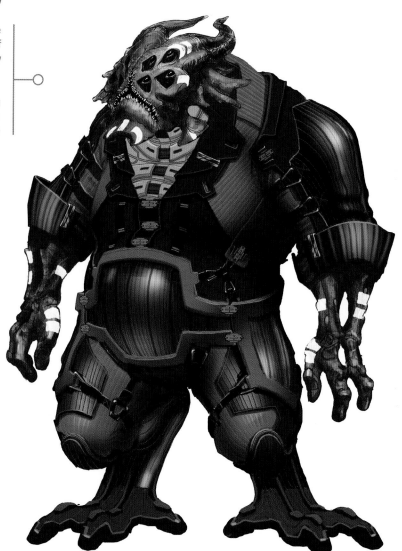

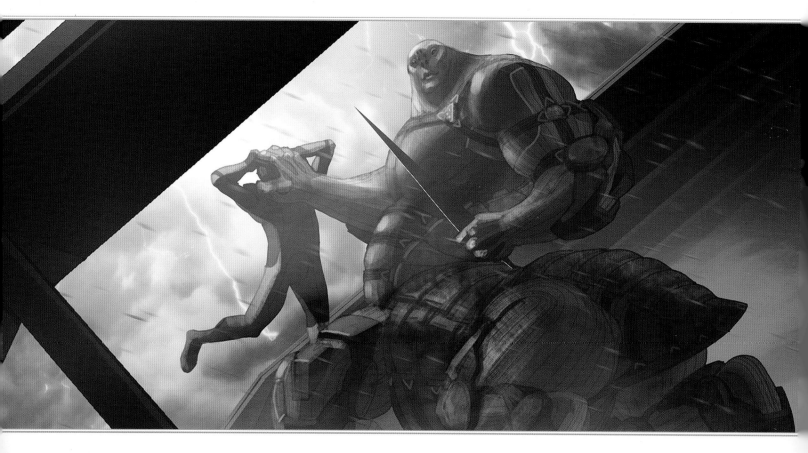

THE SCION

Ideas for the scion varied widely, and the criteria were vague at first. We knew that the scion was made up of multiple husks strung together in a grotesque manner, but the challenge of creating a unique look brought out a wide variety of concept pieces.

Many of these concepts were scrapped because of animation concerns. The final design had one arm turned into a weapon. The sac on the scion's back was added as a weak point for combat.

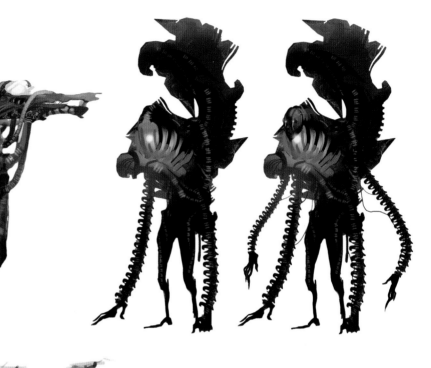

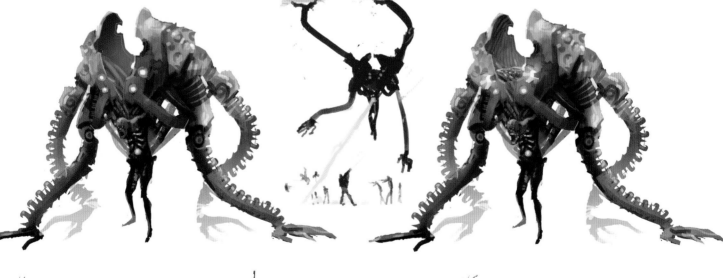

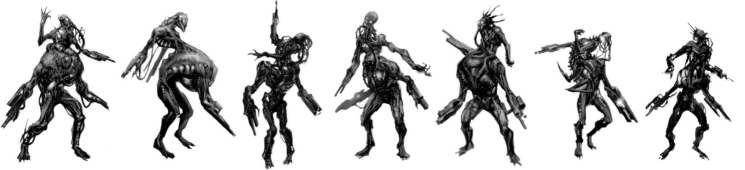

THE PRAETORIAN

The Praetorian was another example of an enemy that didn't come with details on how it looked or how it fought. Some original concepts had it walking, but the Praetorian needed to be inserted into combat levels where he could float above players taking cover.

Eventually, it was decided that he could float, using internal mass-effect generators. The final concept included numerous husk heads inside his chest cavity to add a more horrific and menacing feel.

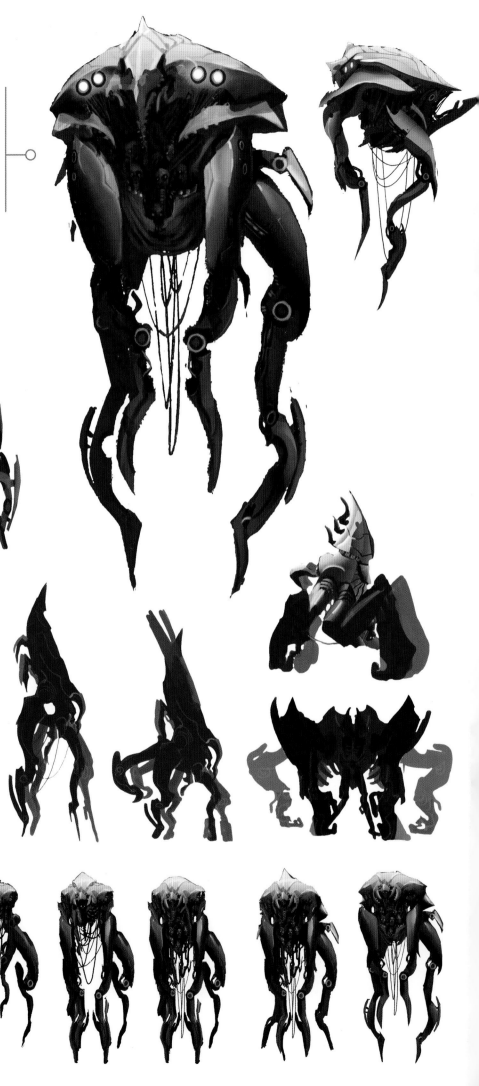

THE PROTO-REAPER

The Proto-Reaper, made from harvested human DNA, had several early concepts that resembled a human fetus. Ultimately, this was not deemed threatening enough, and a version closer to the "skeleton" at the bottom was adopted. Many iterations followed, including several adjustments to the final model to make it look more menacing and fulfill more of the combat requirements.

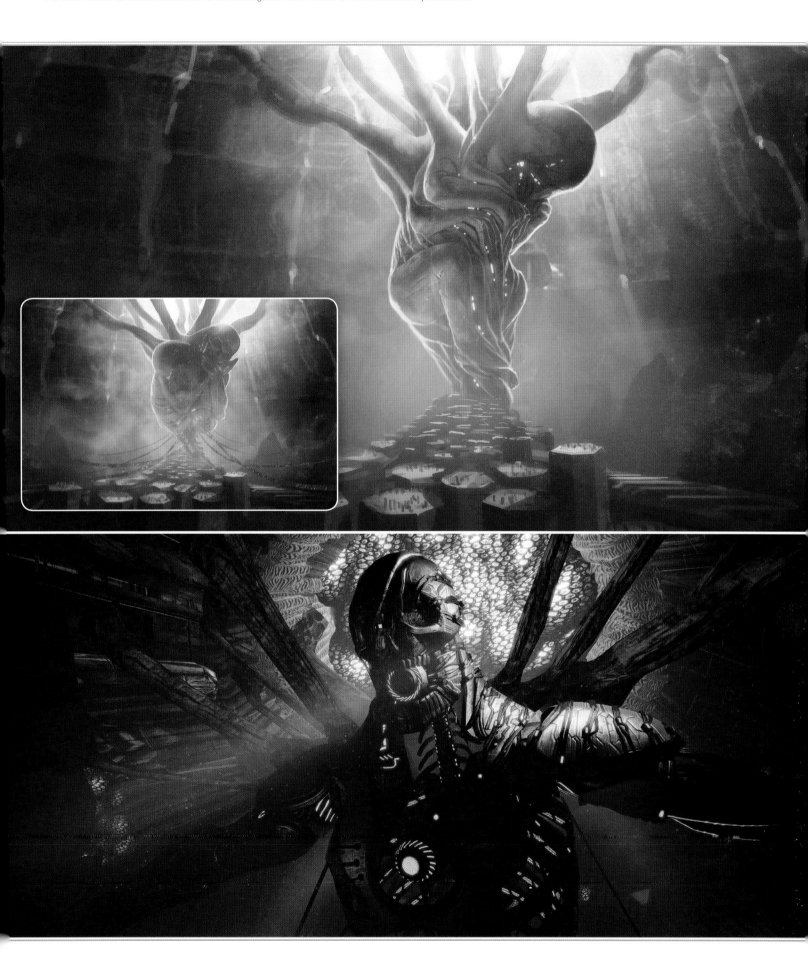

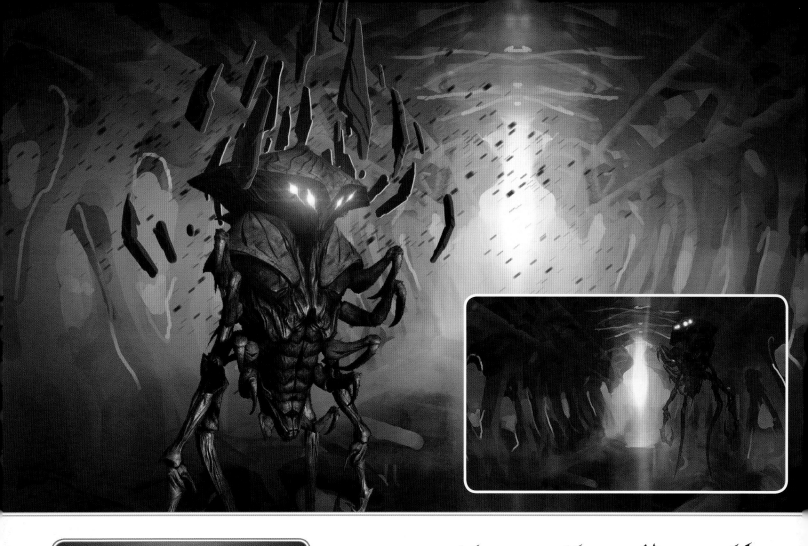

COLLECTORS

The Collectors' look was based on microscopic close-ups of insects, particularly beetles and mosquitoes, for an unsettling, horrifying feel. Early versions included robed walking bipeds for a dark, cultlike appearance. Eventually, it was decided to have the Collector General look more alien, with multiple limbs.

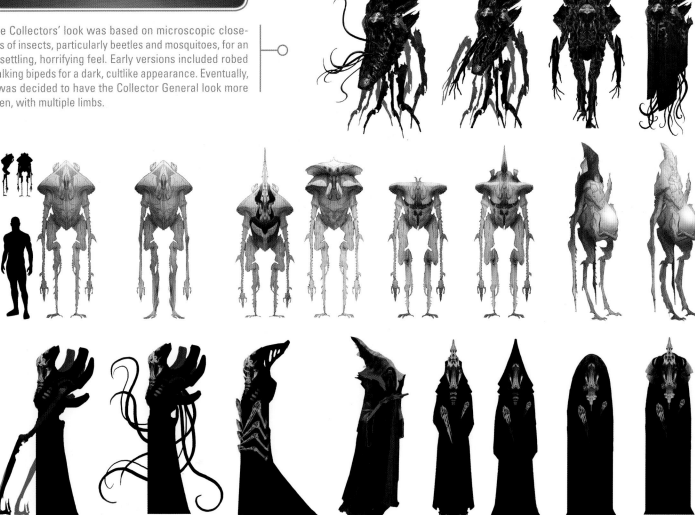

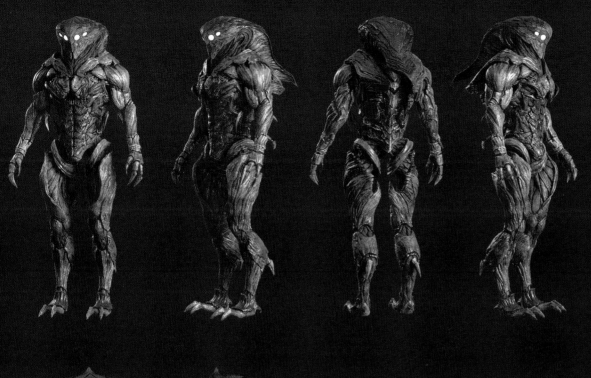

Collector soldiers had to fulfill a number of combat requirements, including taking cover and firing weapons, which led to a design that was more humanoid than the Collector General.

The extra limbs were retained in shrunken, vestigial form on the soldier's chest. The chitinous shell covered the outside of the body, while soft flesh could be seen on inner areas, such as the thighs. The glowing eyes became useful to visually show the player when Harbinger assumed direct control of an enemy.

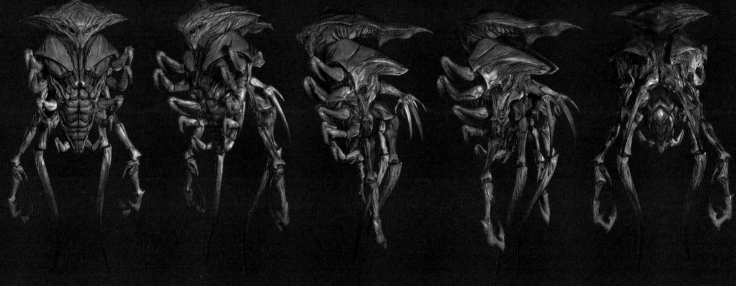

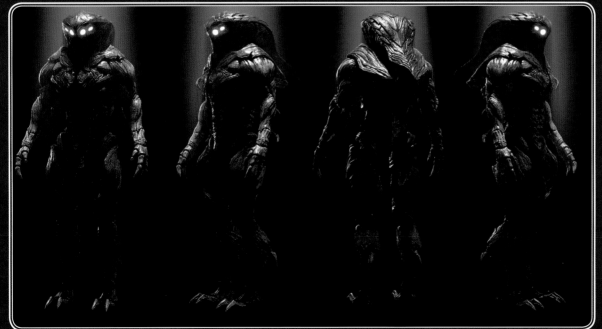

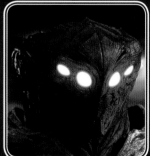

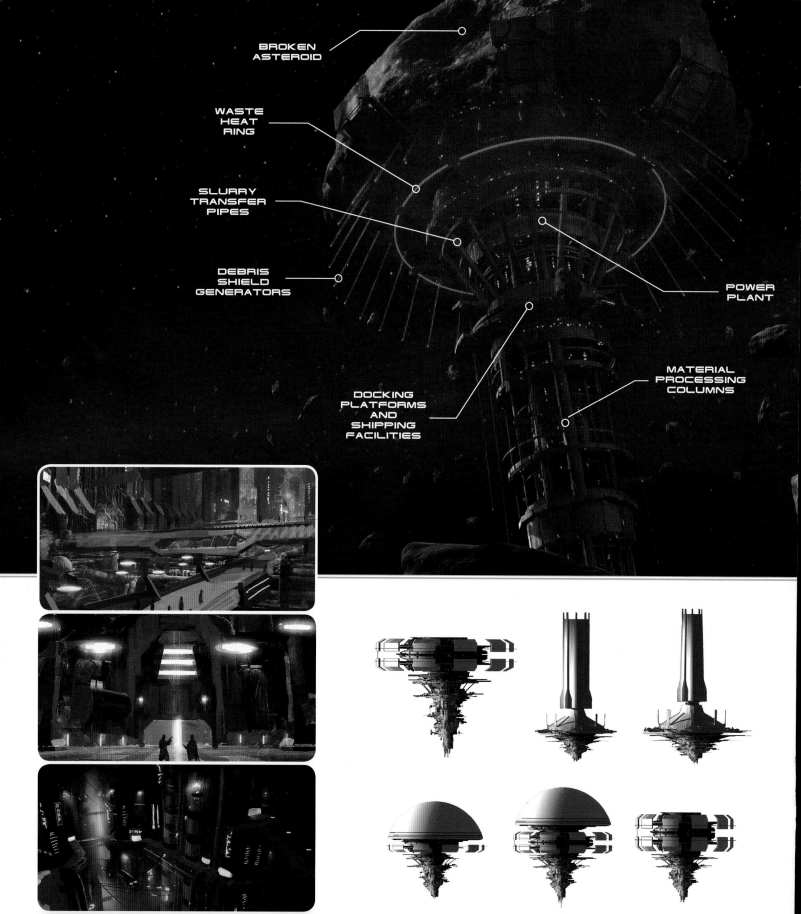

BROKEN ASTEROID

WASTE HEAT RING

SLURRY TRANSFER PIPES

DEBRIS SHIELD GENERATORS

POWER PLANT

MATERIAL PROCESSING COLUMNS

DOCKING PLATFORMS AND SHIPPING FACILITIES

OMEGA

Omega's initial concept was a dark version of the Citadel, grimy and crime ridden. The shape of Omega was based on that of a mushroom cloud—the hollowed-out asteroid portion forms the cloud and the metallic construction creates the plume.

Some of the ideas for the interior included large shafts connected by bridges for an industrial feel. Early versions that relied too heavily on bridges were then scrapped in order to create more walkable areas.

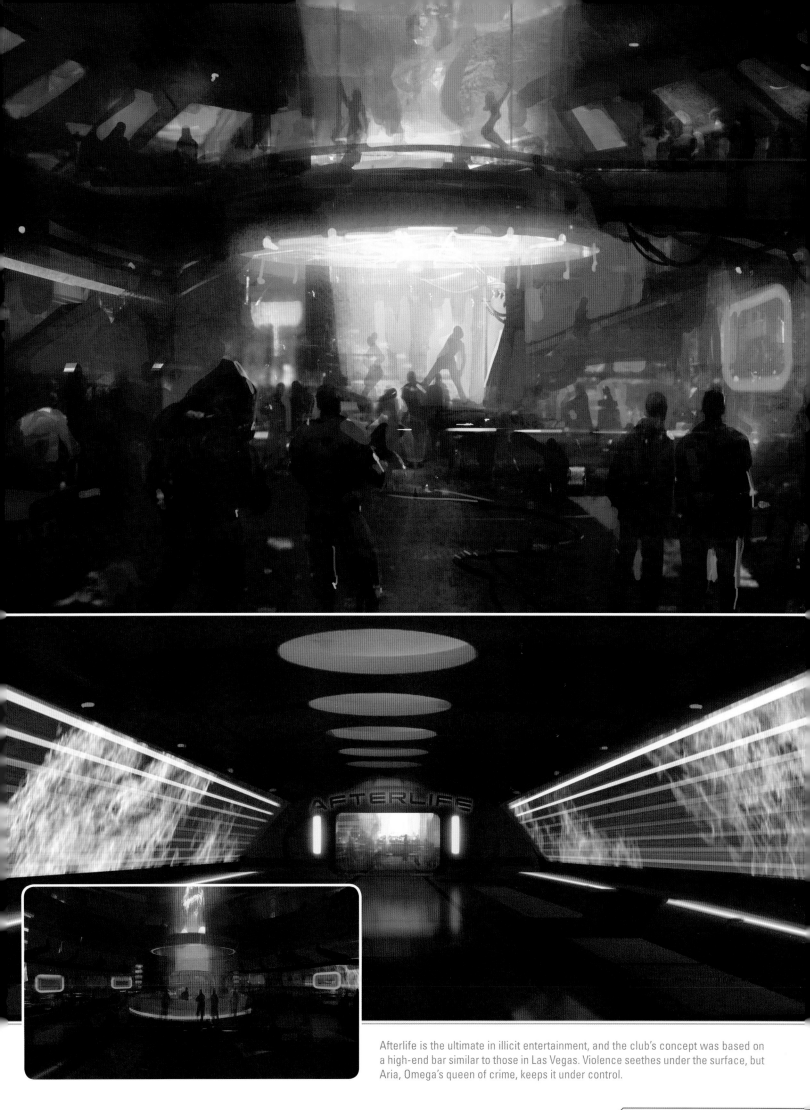

Afterlife is the ultimate in illicit entertainment, and the club's concept was based on a high-end bar similar to those in Las Vegas. Violence seethes under the surface, but Aria, Omega's queen of crime, keeps it under control.

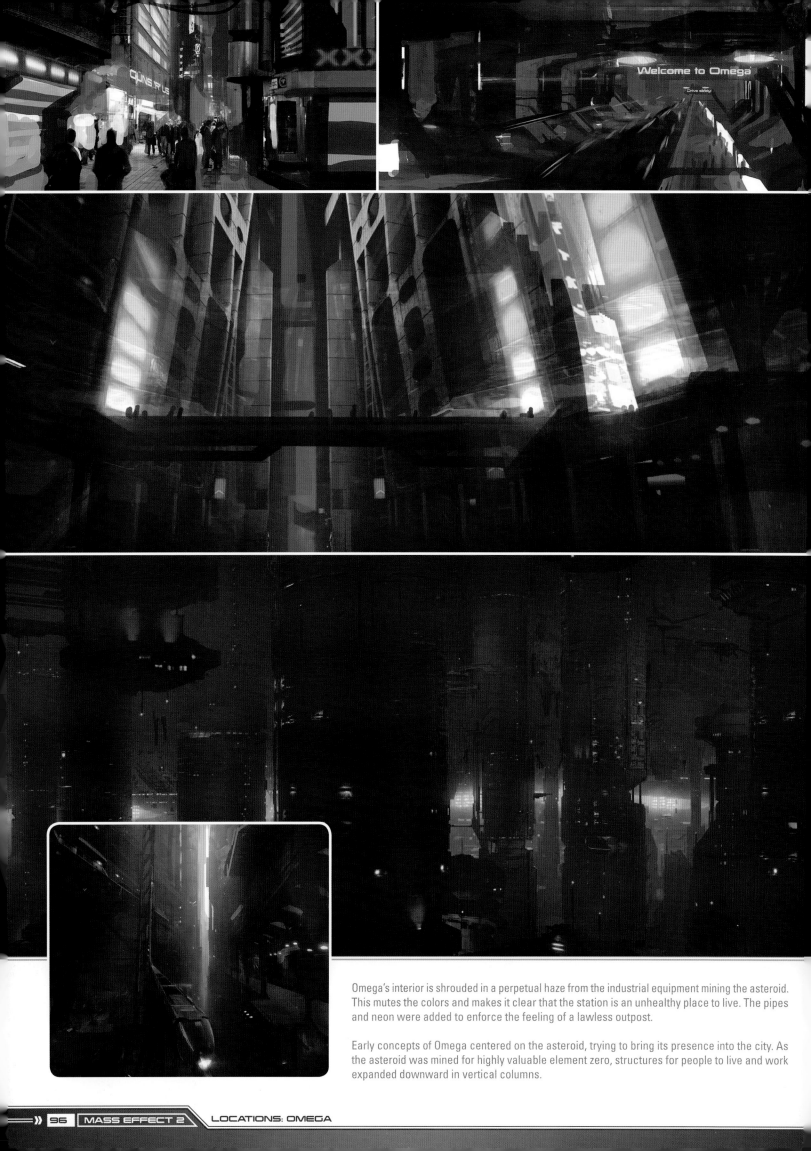

Omega's interior is shrouded in a perpetual haze from the industrial equipment mining the asteroid. This mutes the colors and makes it clear that the station is an unhealthy place to live. The pipes and neon were added to enforce the feeling of a lawless outpost.

Early concepts of Omega centered on the asteroid, trying to bring its presence into the city. As the asteroid was mined for highly valuable element zero, structures for people to live and work expanded downward in vertical columns.

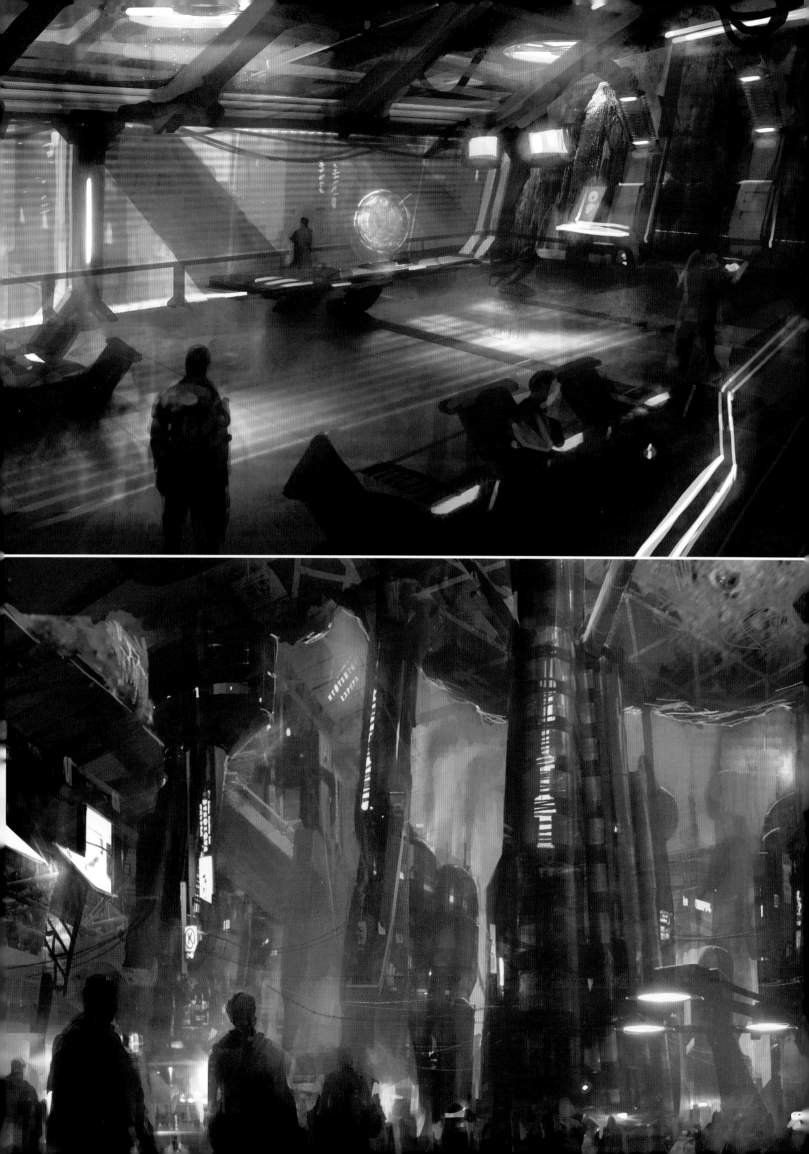

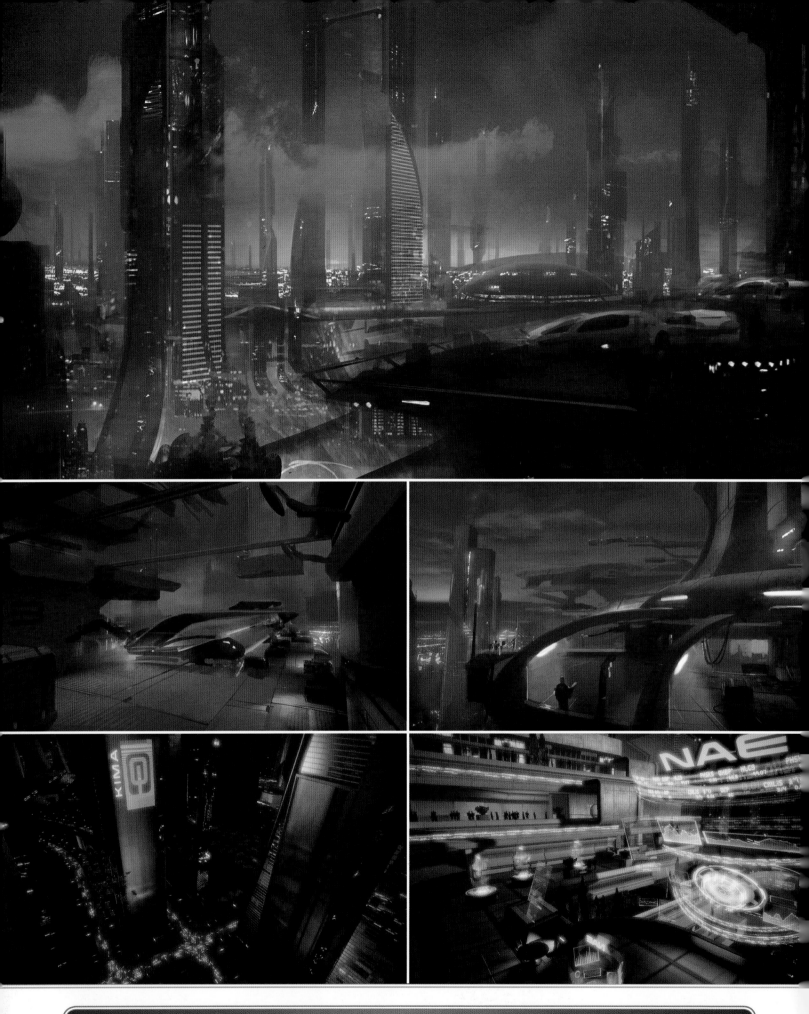

ILLIUM

Illium's capital of Nos Astra was conceived as the ideal city of the future, the place where everyone wanted to live. Clean architecture, no garbage, and flying cars reflected a more utopian, 1950s view of the future. Illium's smooth curves and horizontal lines reinforced the *Mass Effect* style.

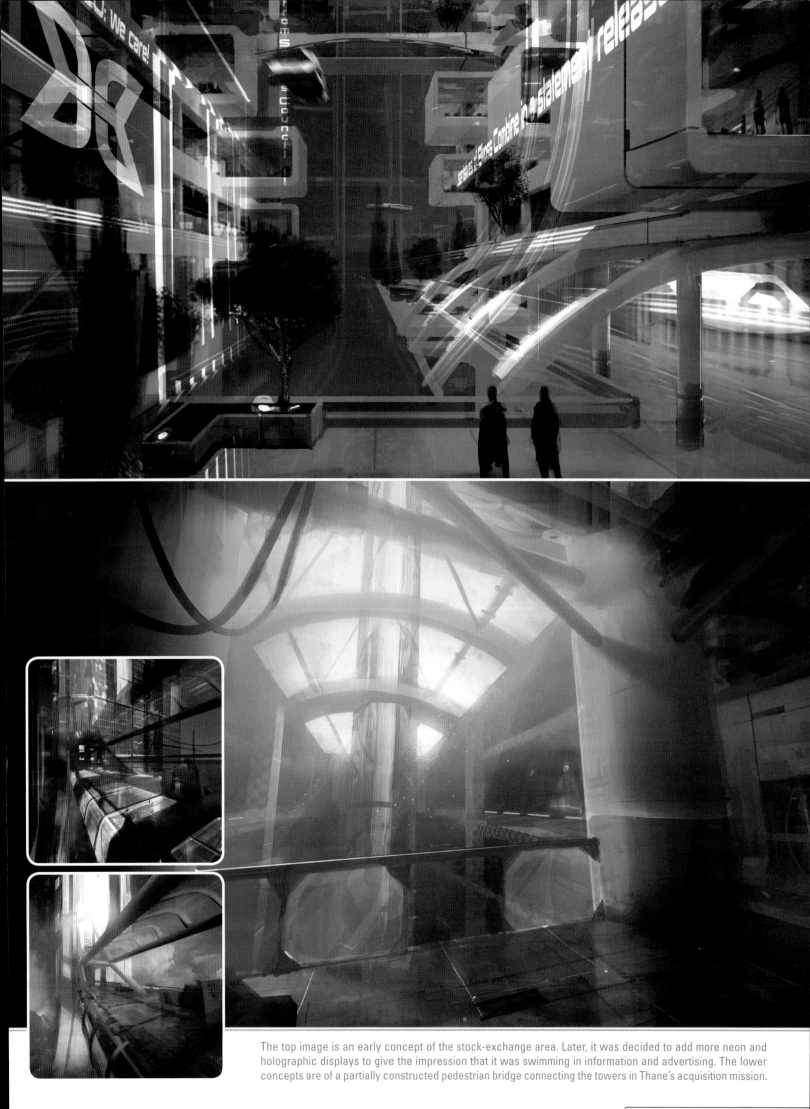

The top image is an early concept of the stock-exchange area. Later, it was decided to add more neon and holographic displays to give the impression that it was swimming in information and advertising. The lower concepts are of a partially constructed pedestrian bridge connecting the towers in Thane's acquisition mission.

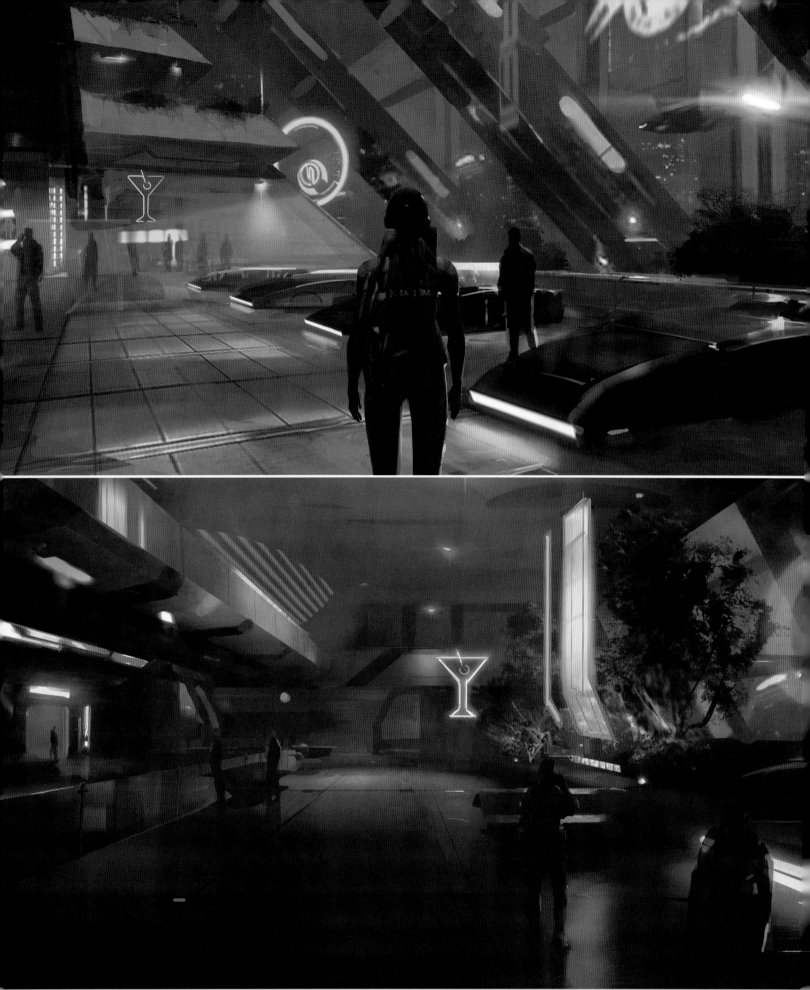

THE CITADEL

The Citadel Wards conveyed a more cosmopolitan vibe than on Illium, with a safer and more vibrant street life than that on Omega. Inspiration was drawn from cities such as Dubai and Tokyo.

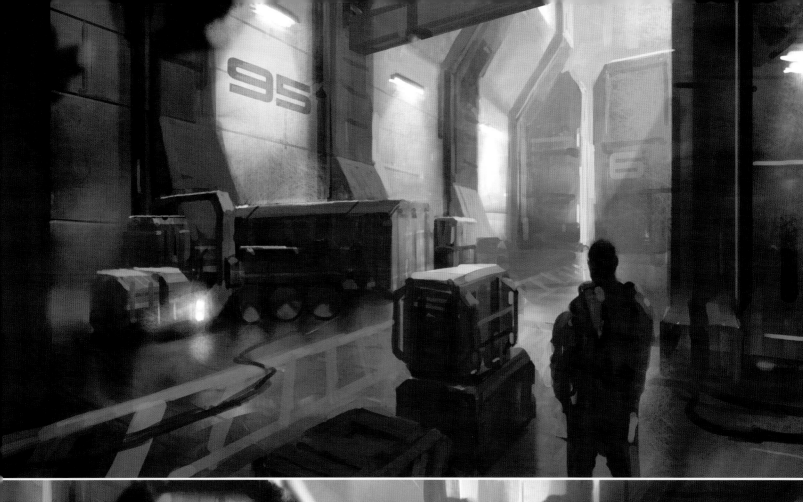

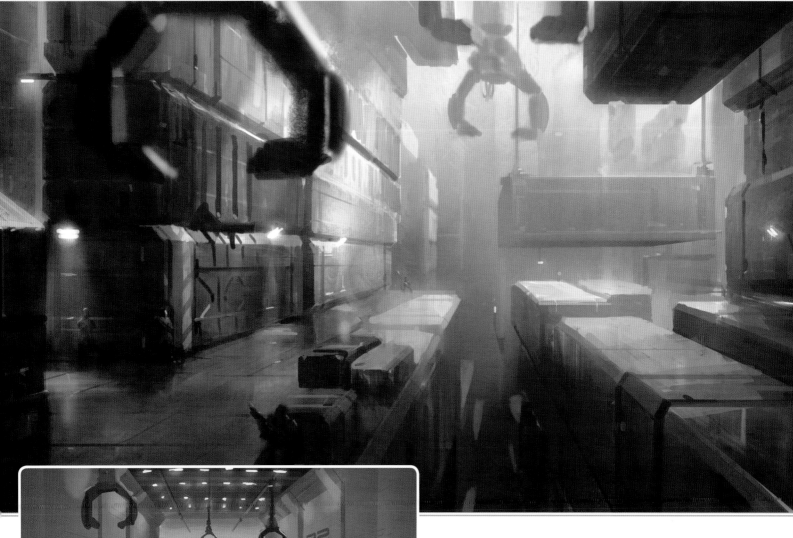

The Citadel's shipyards are understandably massive, since more than 13 million people live on the station and it is more than 40 kilometers long. References were taken from modern-day shipyards and scaled up to reflect the Citadel's immense size.

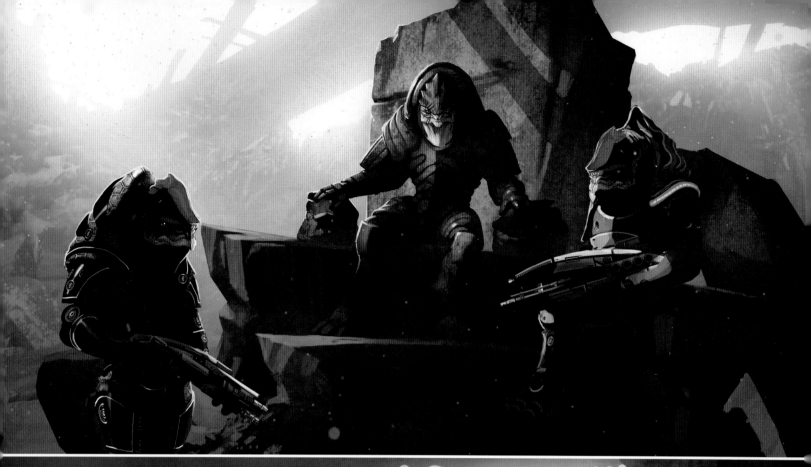

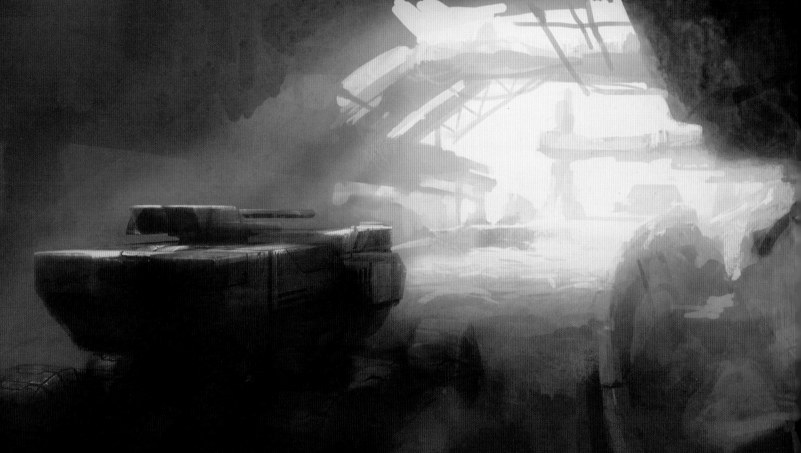

TUCHANKA

The top production painting was made to help the cinematic department understand the place where the player finds Wrex. The krogan, consumed by constant internal warfare, live in ruins, and Wrex sits on a throne surrounded by the rubble of his once-glorious civilization. The armored vehicle was originally a concept design for the vehicle that would become the Mako in the original *Mass Effect*, but was deemed too large. Here it was repurposed as a krogan vehicle, where it fit in perfectly. Its oversized tires helped it drive over rubble and war-torn terrain.

On the facing page is concept art for the underground bunkers of Tuchanka, where the krogan took cover from nuclear war and the burning heat of the surface.

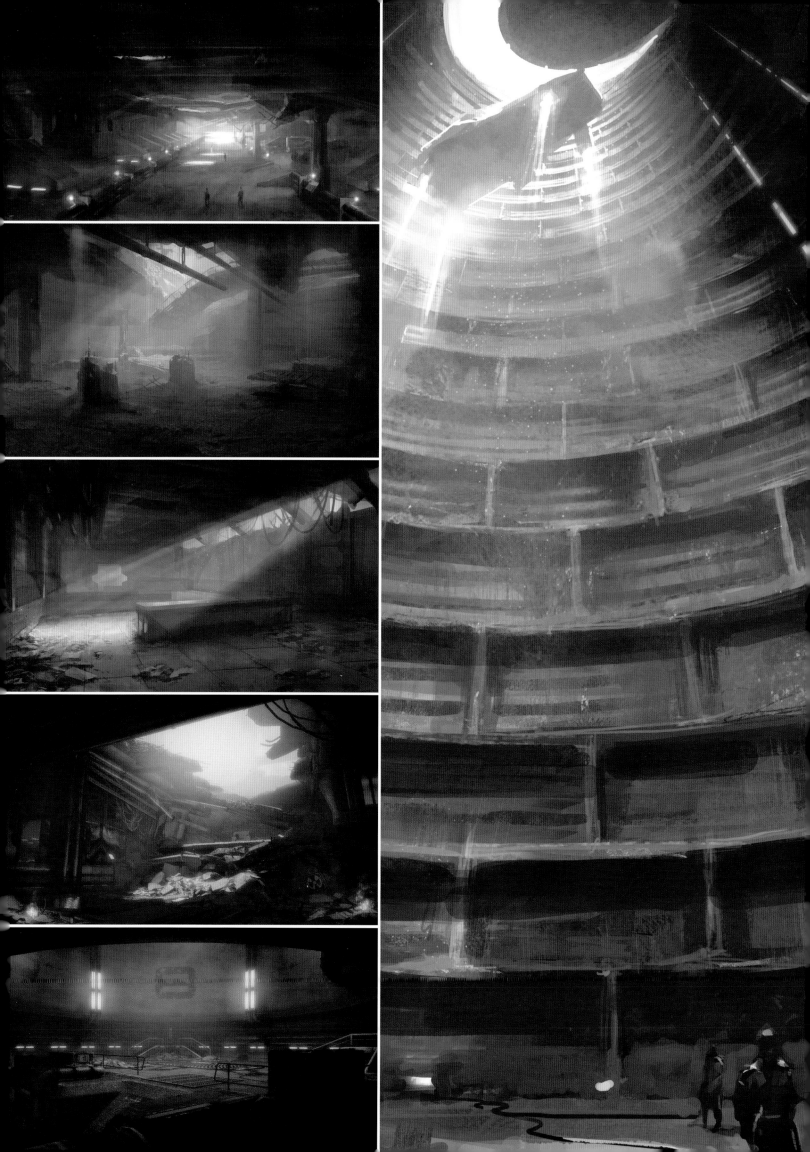

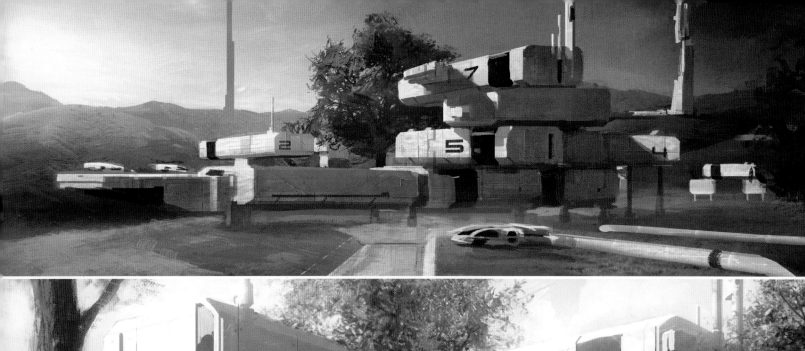

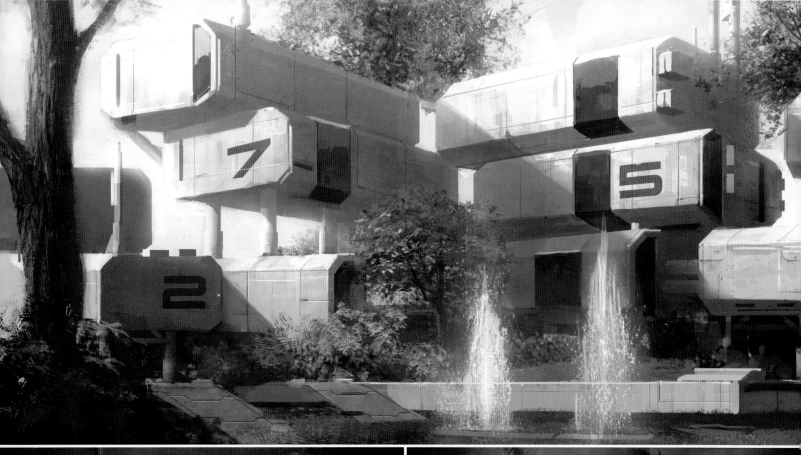

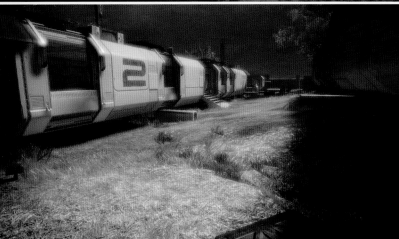

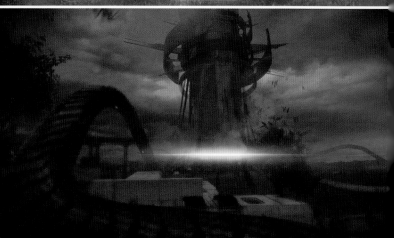

HORIZON

Horizon is a colony with prefabricated buildings. It was imagined that these structures were modular and were stacked in transport ships much like modern-day shipping containers. They would then be assembled in various configurations, depending on the size and needs of the colony. In the lower right is a concept of the Collector ship looming over Horizon.

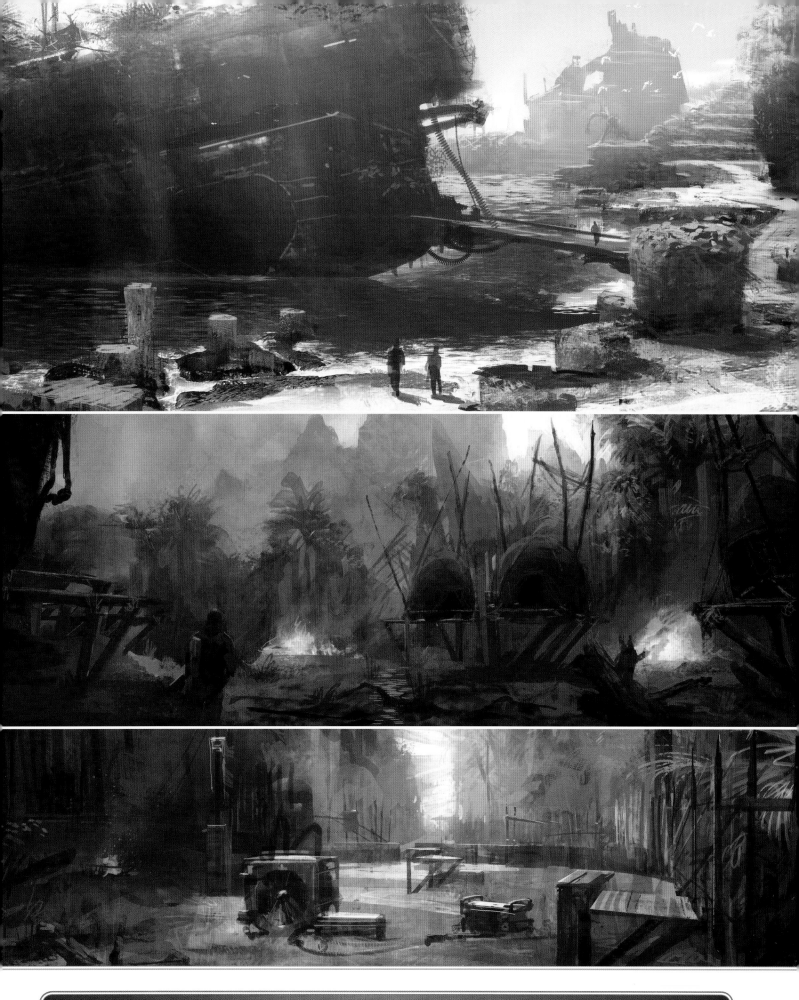

2175 AEIA

In the concept art for Jacob's loyalty mission on 2175 Aeia, we see an uncharted planet where his father's ship crashed some ten years earlier. We wanted the ship to be overgrown by the jungle, and the mud-and-wood huts show the time and effort that the shipwrecked survivors put in over the years.

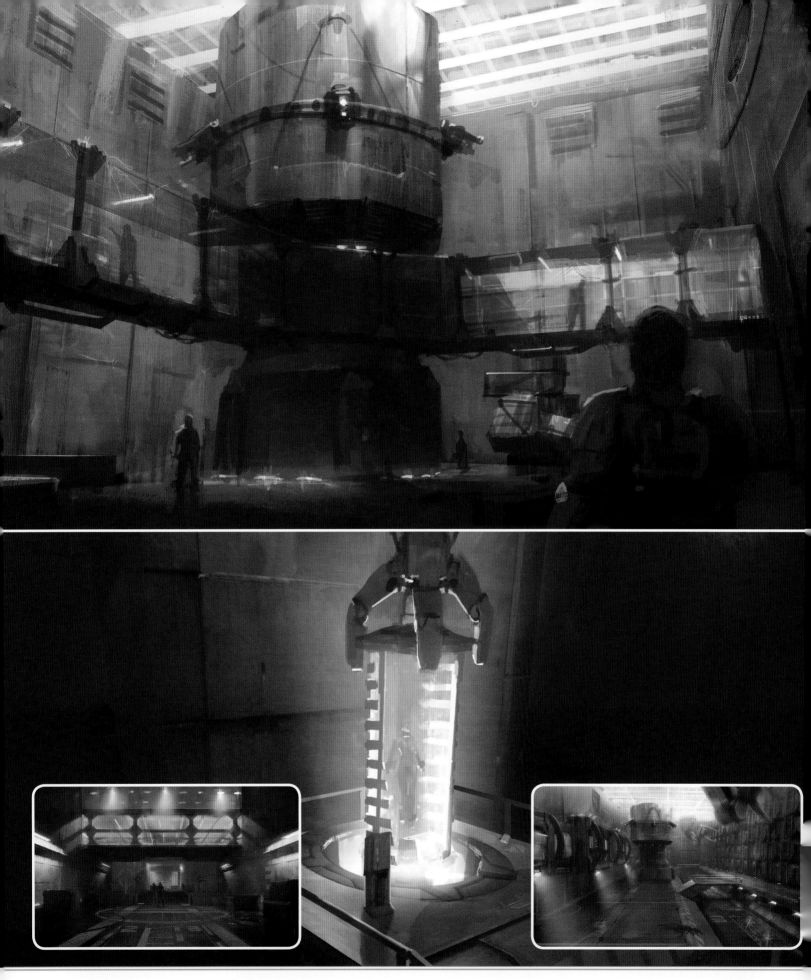

PURGATORY

The prison ship *Purgatory* has long arms where staff and utilities are located. The prisoners are housed in the body of the ship, which resembles a fish's skeleton. *Purgatory*'s interior emphasizes the division between the guards and the prisoners—the guards walk in the armored glass hallways, while the prisoners are in courtyards. Jack, one of the galaxy's most powerful biotics, was kept in a cryogenic cell for the ultimate in solitary confinement.

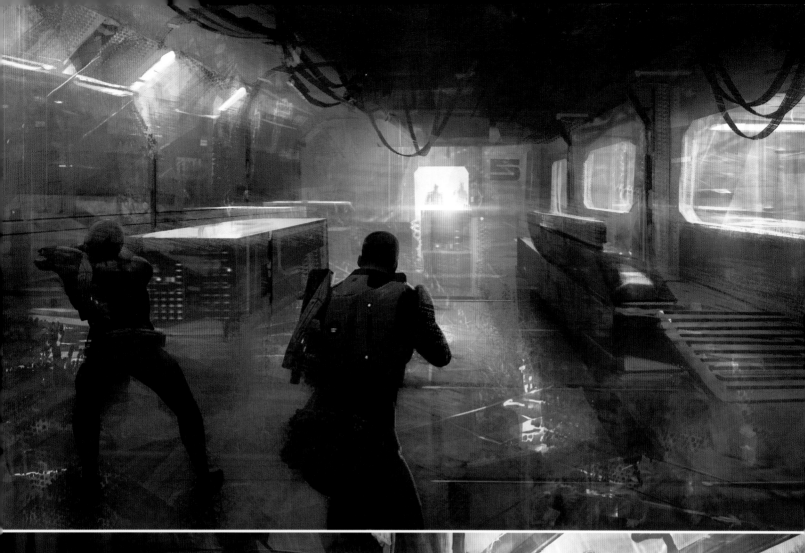

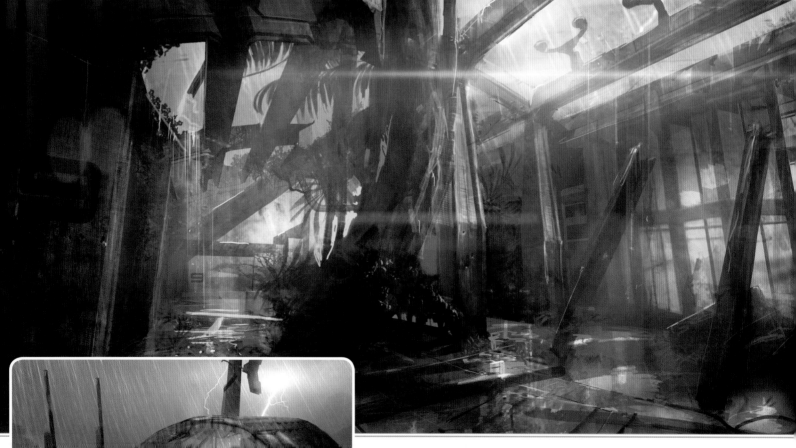

PRAGIA

Jack's loyalty mission takes place on Pragia in an abandoned Cerberus base. Rain and lightning were intended to give the level a horror-movie feel, conveying the brutality of Jack's childhood.

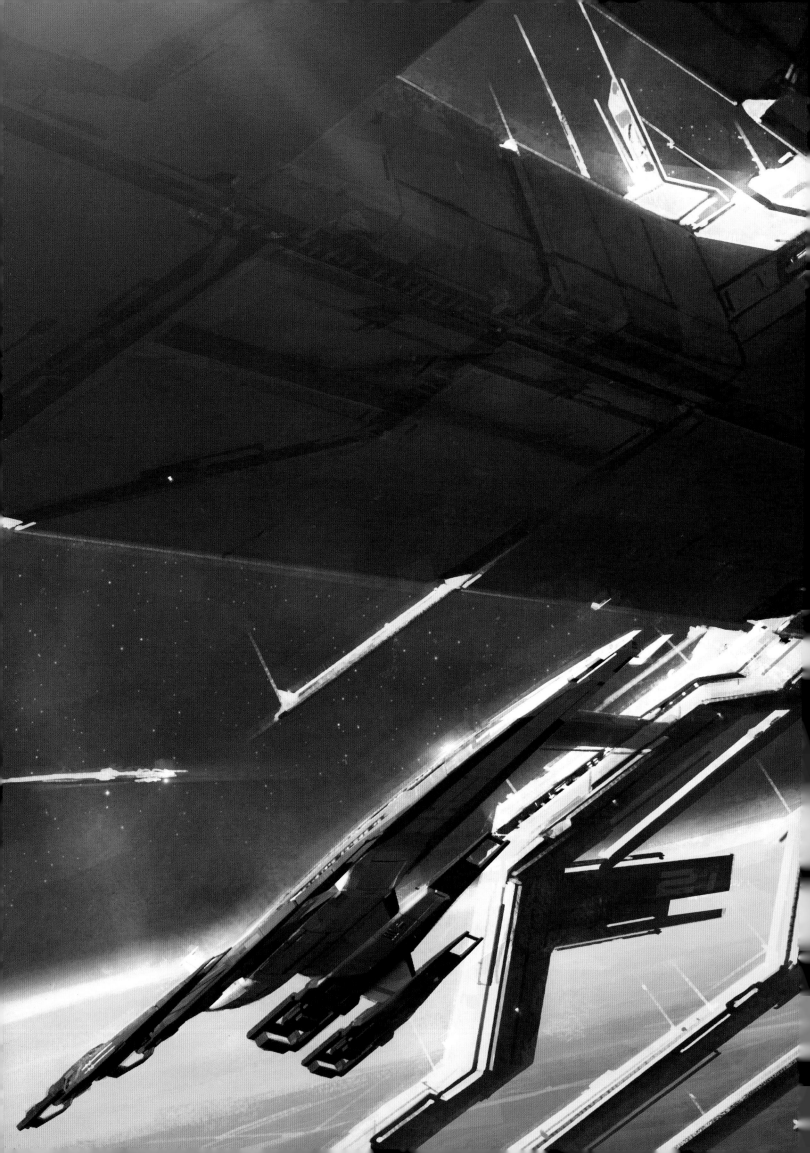

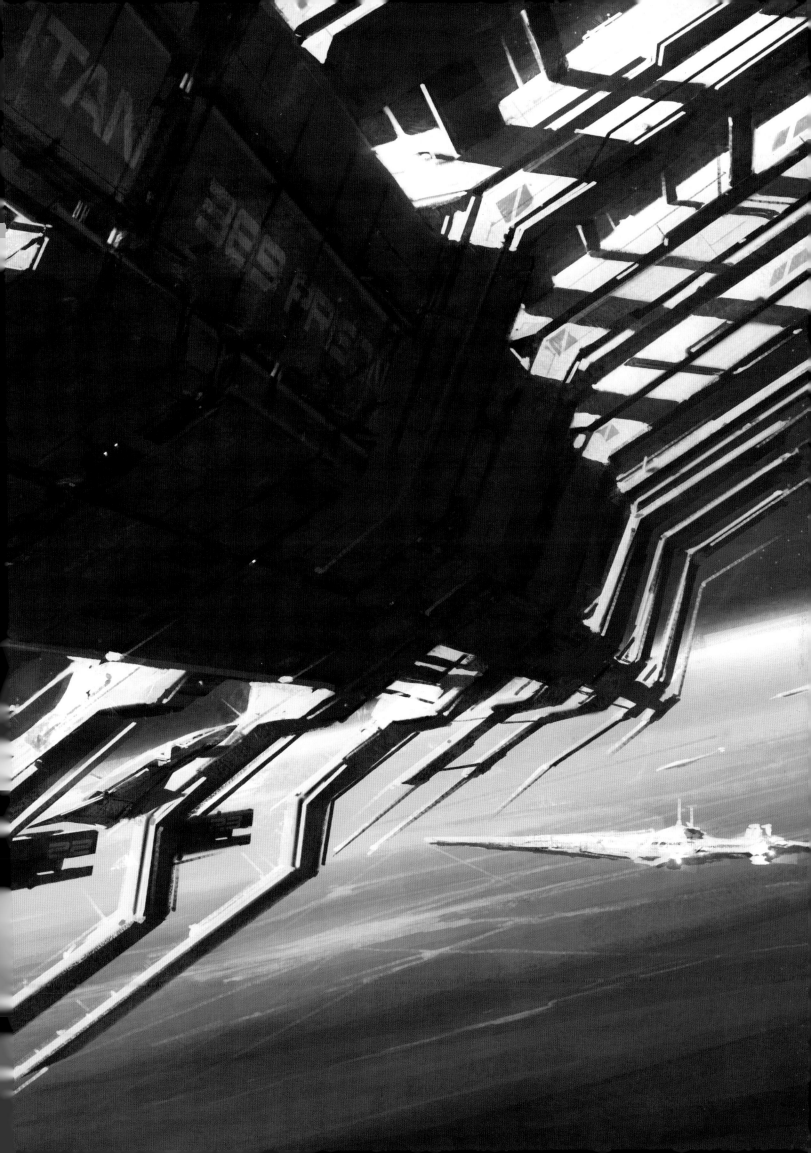

THE MIGRANT FLEET

This concept shows the scale of the quarian Migrant Fleet, over 50,000 ships strong. Below is the interior of a liveship that provides food and supplies to the quarian fleet. All available space is crammed with cargo, like a caravan filled with hoarded goods. The heavily recycled air supply gives the atmosphere a hazy glow.

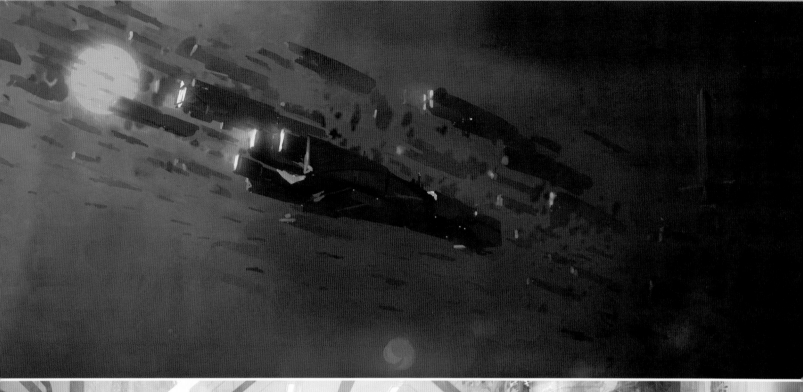

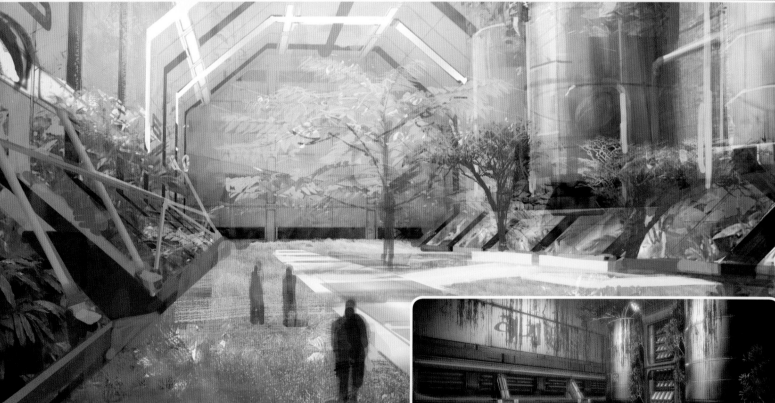

The quarians follow a vegan diet, not out of ethical concern, but because of practicality: the amount of water needed to hydrate an animal is exponentially more than the amount needed to grow plants, and on a starship, all water would need to be conserved carefully.

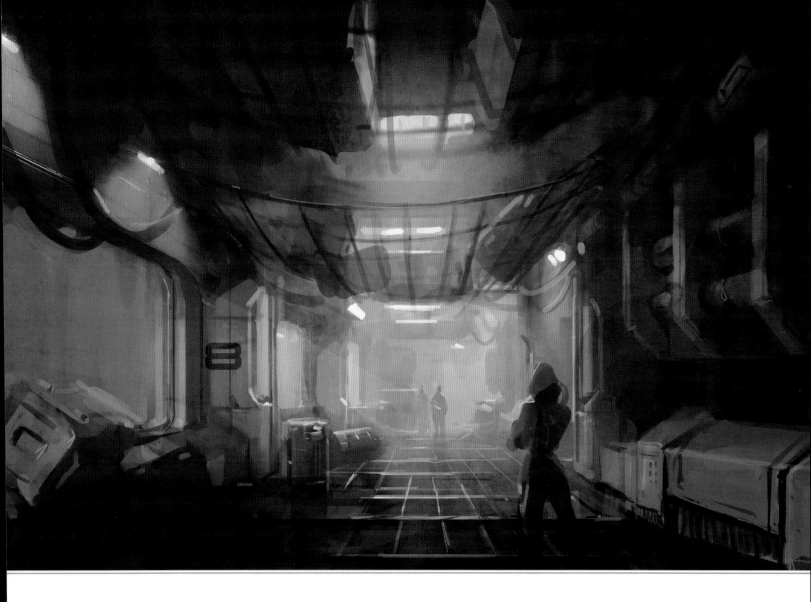

The liveship's spherical design was intended to make it stand out in the fleet. The sphere maximizes the quarians' yield of crops. Other ships were designed to show that they have been lived in for a long time, with a central ring at the heart of the ship and cargo modules strapped onto them when the quarians ran out of living space. This helped create a refugee feel to the Migrant Fleet, which was ejected from its homeworld centuries ago.

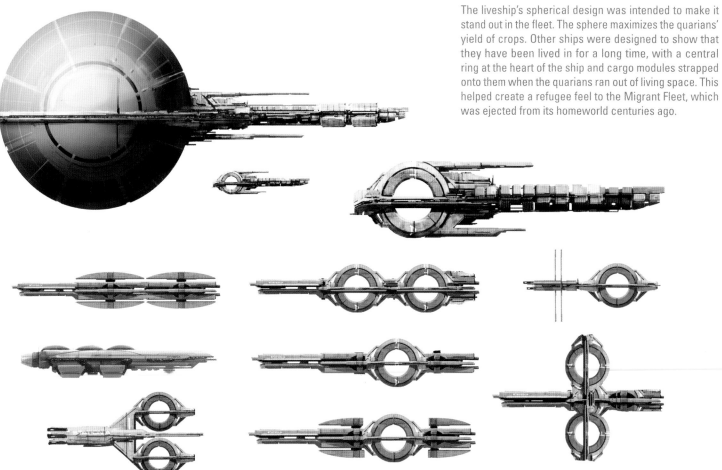

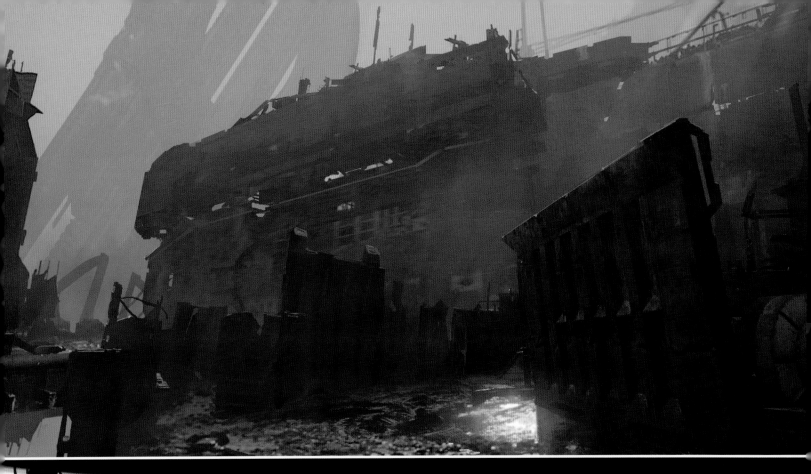

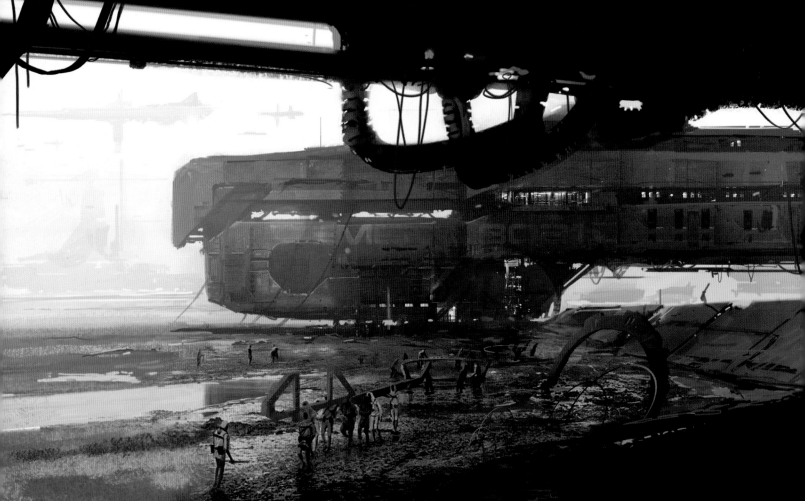

KORLUS

Korlus was based on a ship-breaking area in India where defunct oil tankers and other giant cargo ships were disassembled and recycled. Here, the ships are starships, and the environment is understandably polluted by all the byproducts of destroying spacecraft.

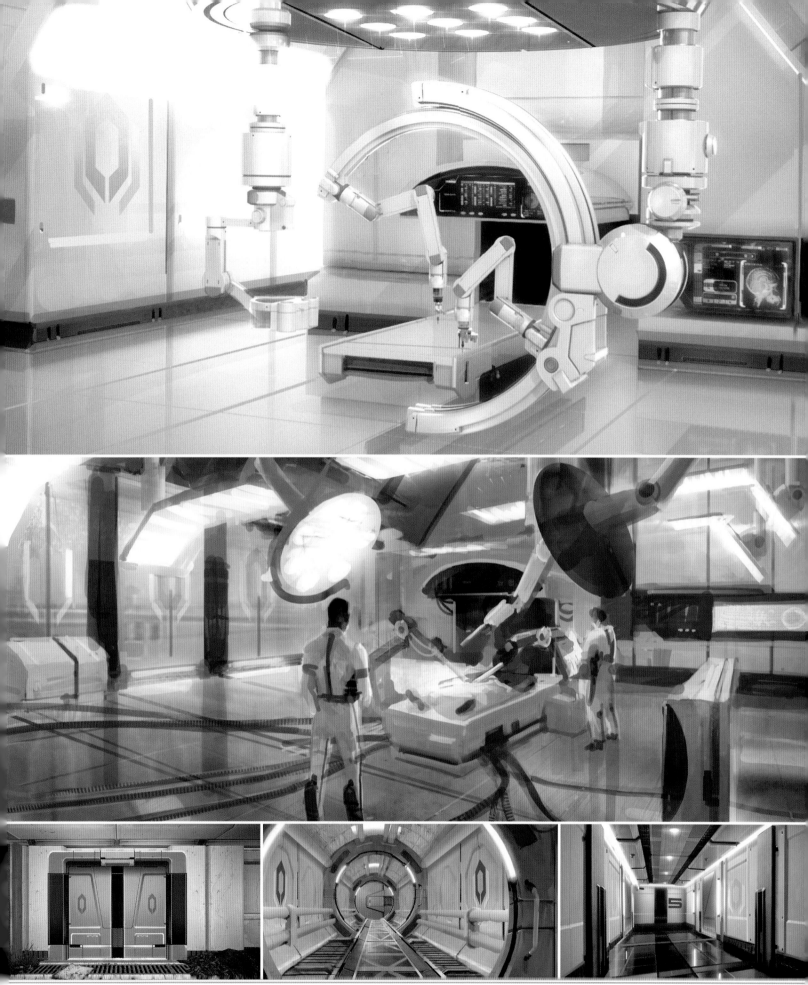

THE LAZARUS RESEARCH STATION

Concepts for the Lazarus Research Station, where Shepard was restored to life. The Cerberus station showed a more human approach to architecture, which is not as clean and refined as asari environments. Cerberus interiors went with a white, black, and orange palette, which tied in with the Cerberus logo.

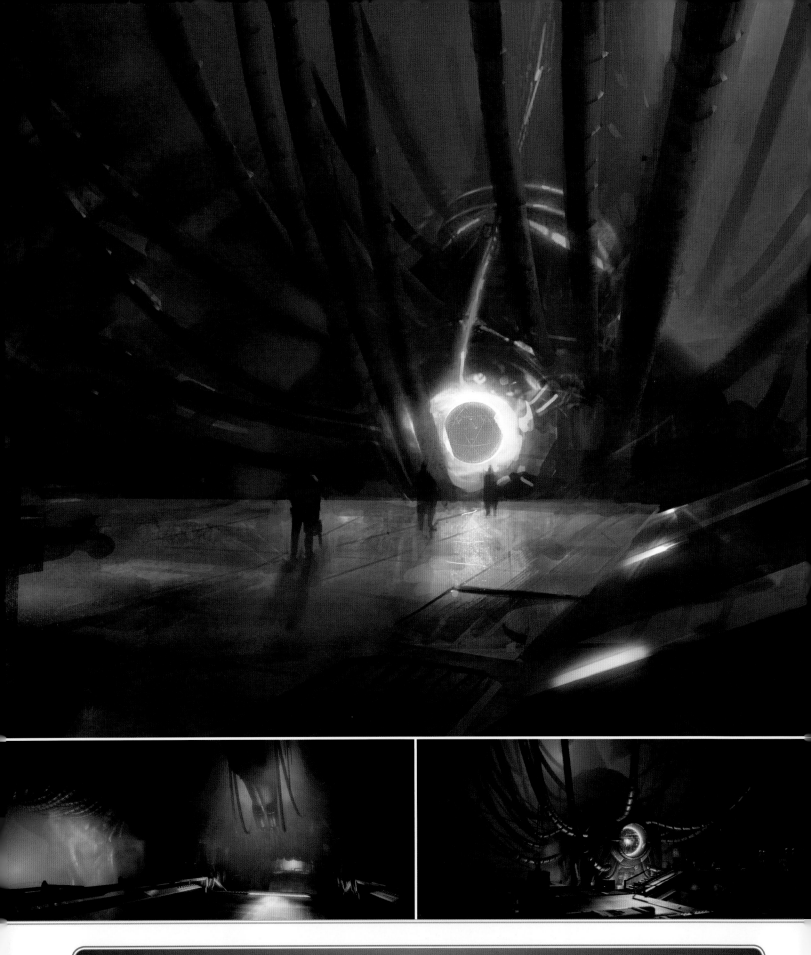

THE DERELICT REAPER

The idea of the Cerberus team analyzing the Reaper helped solve a potential level-design problem—how does one walk around inside a creature that wasn't built for that purpose? The Cerberus team built platforms for ease of navigation, allowing us to create a level that was capable of handling the combat system.

On the facing page are some of the earliest concepts of the derelict Reaper, showing the blast damage of the mass-accelerator round that killed it. These concepts were made to help decide how alien to make the interior of the Reaper. Reapers are alien, but they are also a machine species that would have a sense of logic to their internal layout.

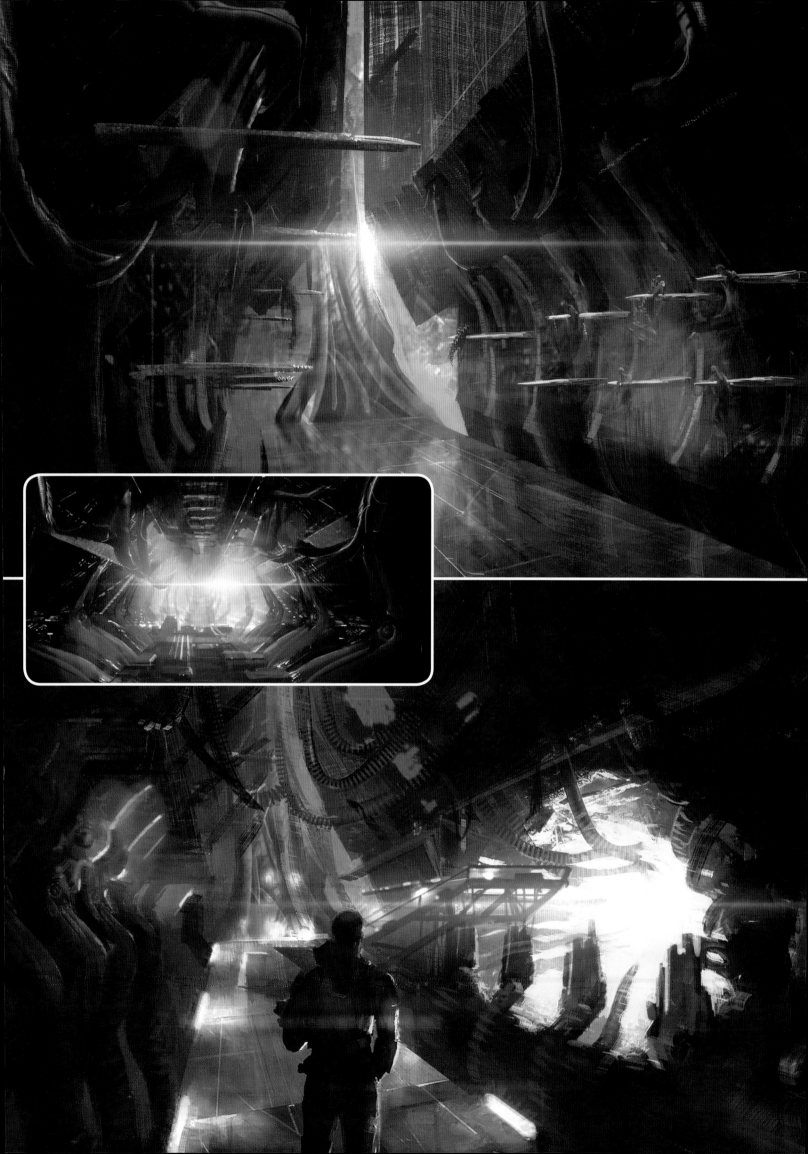

KASUMI'S STOLEN MEMORY

For Kasumi's mission, Hock's mansion was conceived as a house in the Hollywood Hills, but with more advanced, *Mass Effect*–era architecture. Early on, the mission was proposed to be on Illium or another asari planet, but ultimately it took place on a human one, and the architecture changed accordingly.

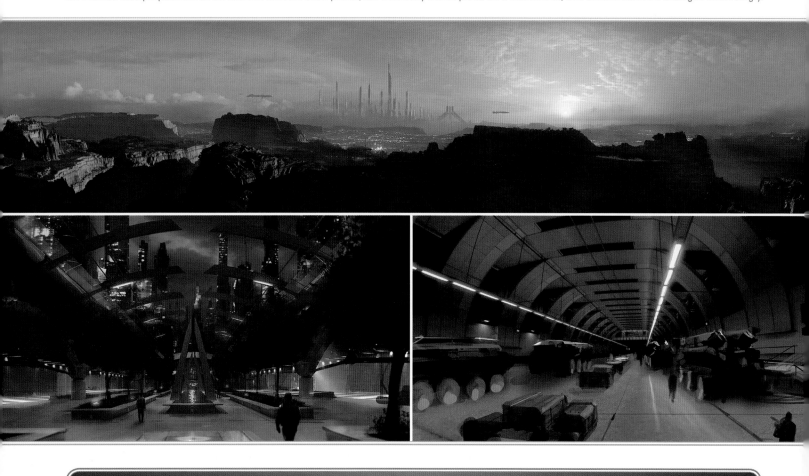

LAIR OF THE SHADOW BROKER

The Shadow Broker's ship was found on a planet that rotated very slowly, creating a hot side and a cold side and extreme storms on the narrow strip in between. To withstand the blazing sun, the rear of the ship was developed with a massive shield, which created a very distinctive silhouette.

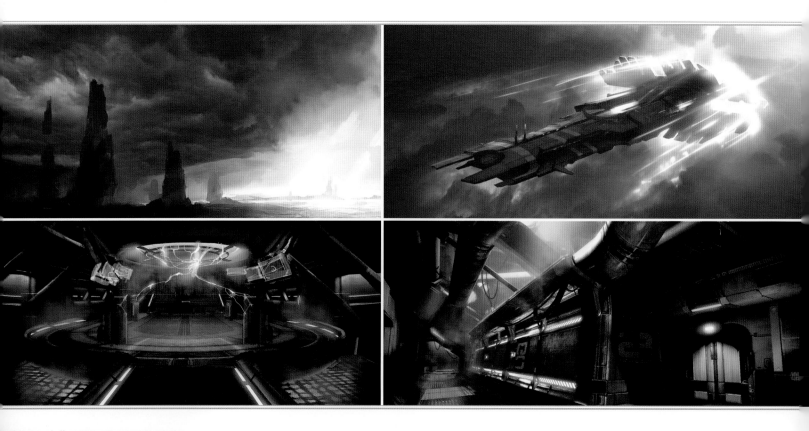

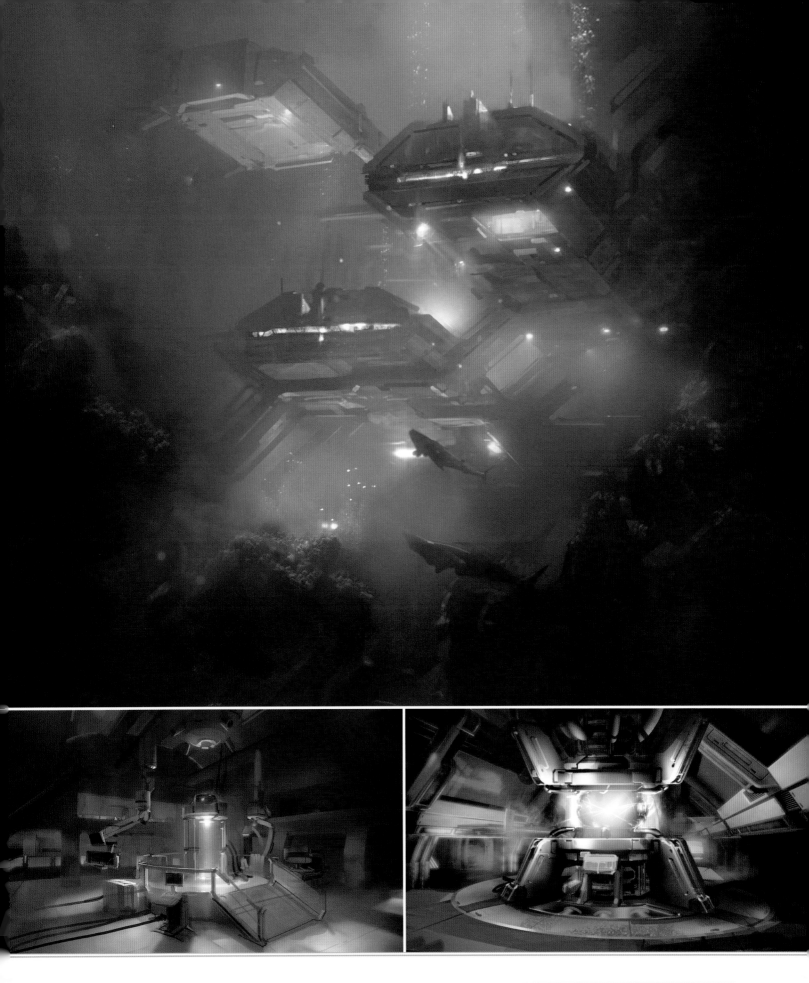

ARRIVAL

Arrival was originally set in an underwater base built by humans. Shepard was supposed to land on an ocean planet and take a submarine down to the main level. The idea at this stage was to give it a feel like the movie *The Abyss*, with separate containers for each section of the base. Eventually, the base was moved to the surface of an asteroid, which became a key plot point.

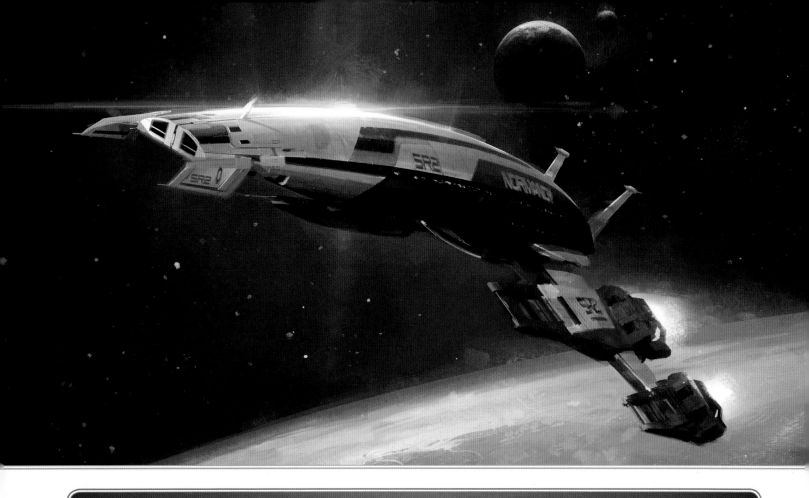

THE NORMANDY SR-2

The story of *Mass Effect 2* required that the *Normandy* be destroyed, which gave us the freedom to redesign the ship. The *Normandy* SR-2 got a larger body and multiple floors. The new cockpit is more recognizable. We also worked to give the ship's design a sleeker look.

There were many different visions for the *Normandy* SR-2. We adjusted the tail fins, the engine placement, and the size of the wings relative to the body. We wanted the *Normandy* to have a muscle-car element to its paint job and to feel more aggressive than typical concepts for spaceships or fighter planes. Originally, we proposed that the player could have up to five levels of customization for the *Normandy*'s exterior, but this was cut since it would mean space scenes would not benefit from the spectacular quality made possible by pre-rendering.

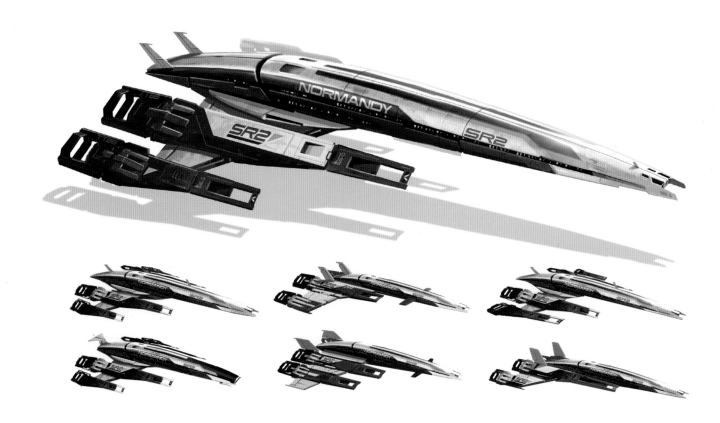

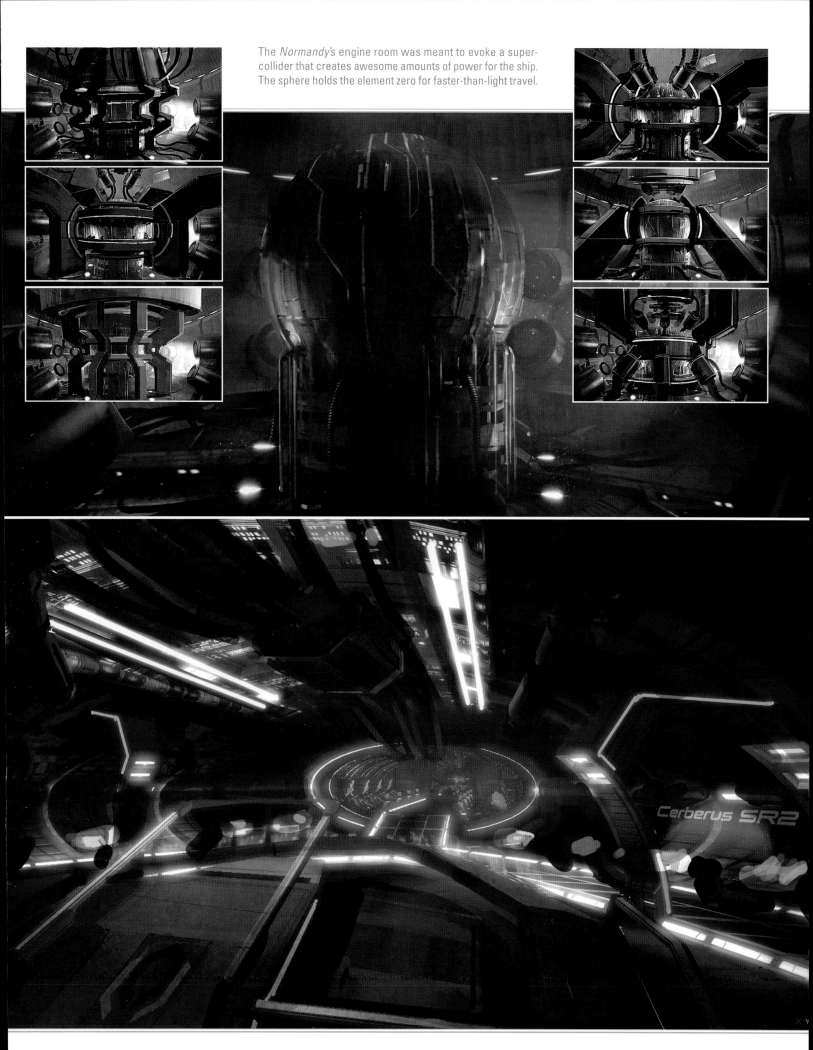

The *Normandy*'s engine room was meant to evoke a super-collider that creates awesome amounts of power for the ship. The sphere holds the element zero for faster-than-light travel.

Cerberus SR2

For ease of navigation, the interior had to be familiar to the players of the first *Mass Effect*. It felt like a higher-tech version of the SR-1, with more space and rooms for the "dirty dozen," the key party members that join Shepard in *Mass Effect 2*.

THE COLLECTOR SHIP

The Collector ship went through several iterations and was one of the more difficult levels to create. Originally, the ship's design went so far as to have trees and grass in its interior to disarm human captives and make them feel more docile while they were prepared to be harvested. We then decided that the priority should be that the ship should feel like the Collectors actually constructed it, so we referenced termite hills and insect hives for a more packed-mud, organic feel. The lowest image is the Proto-Reaper, suspended above the interior level. The concept shows how this creature was still under construction by the Collectors.

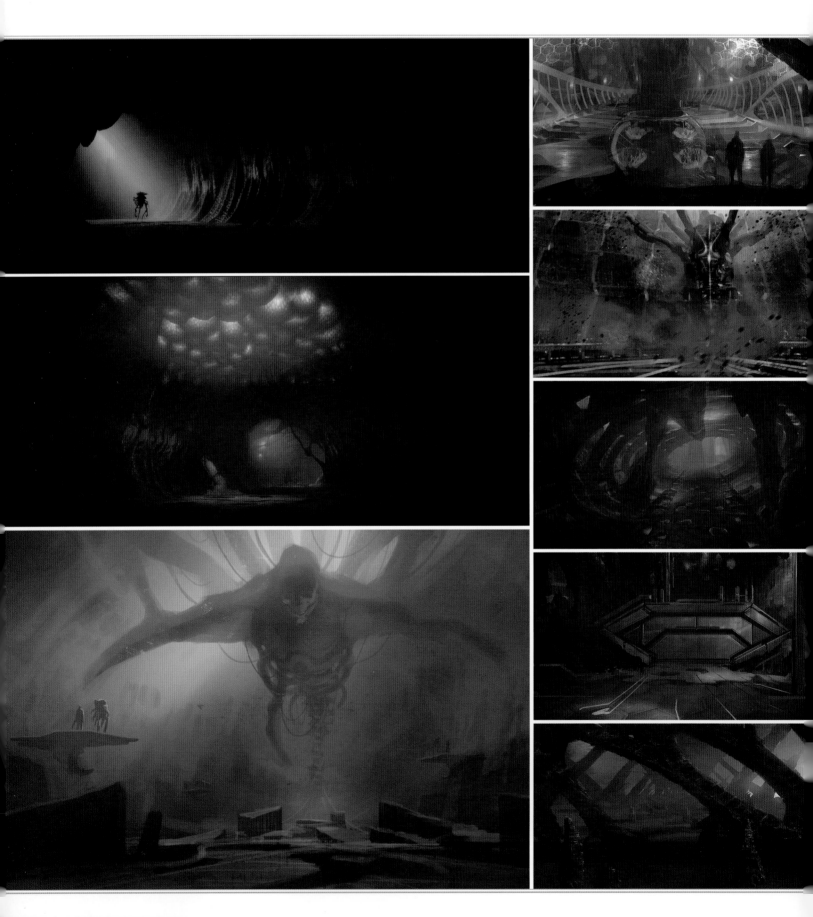

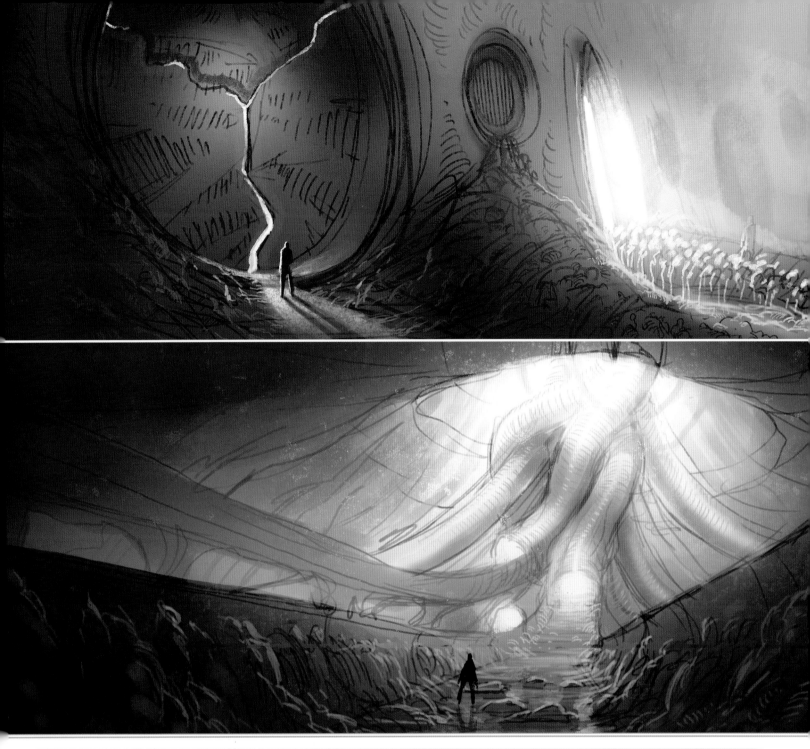

The top images are concepts for what the interior of the Collector ship would look like. The central passage features many containment pods for captive humans, and the feeding tubes above them meet up at the body of the Proto-Reaper. The lowest image has concepts for the exterior of the Collector ship. Again, we referenced termite mounds to show that this was, like the Reapers, a synthesis of artificial and organic life.

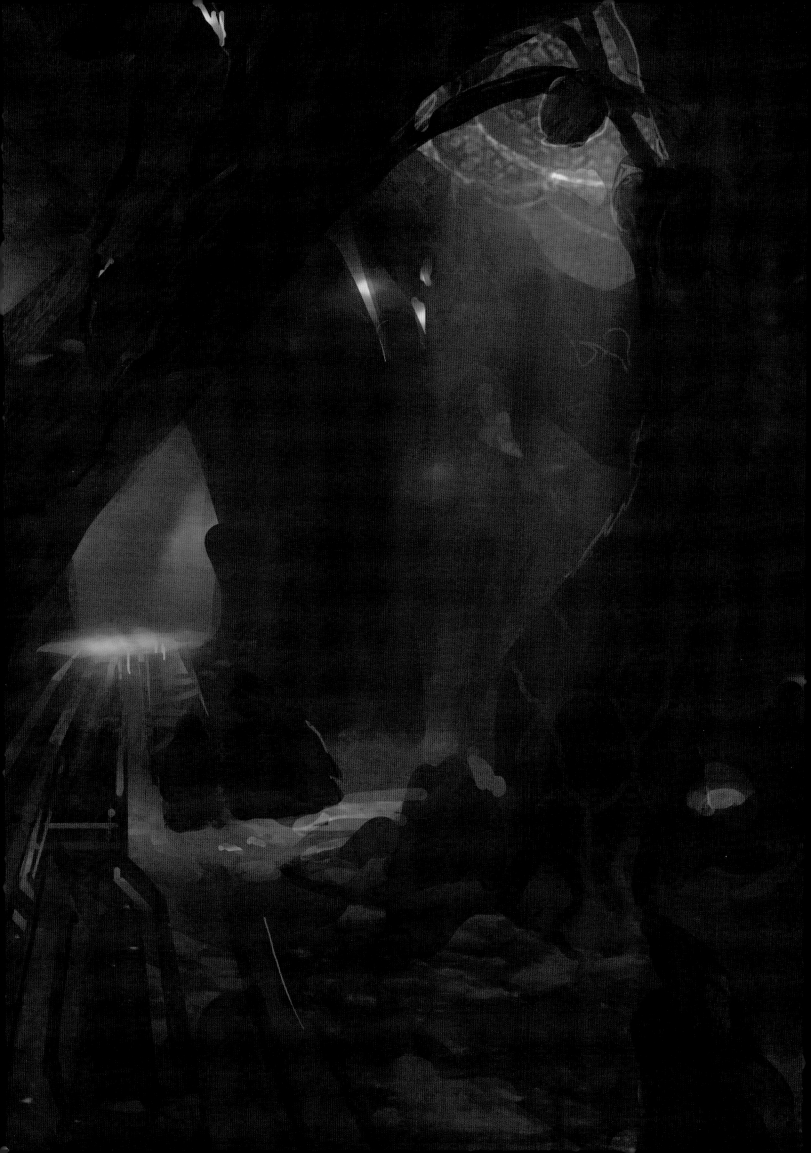

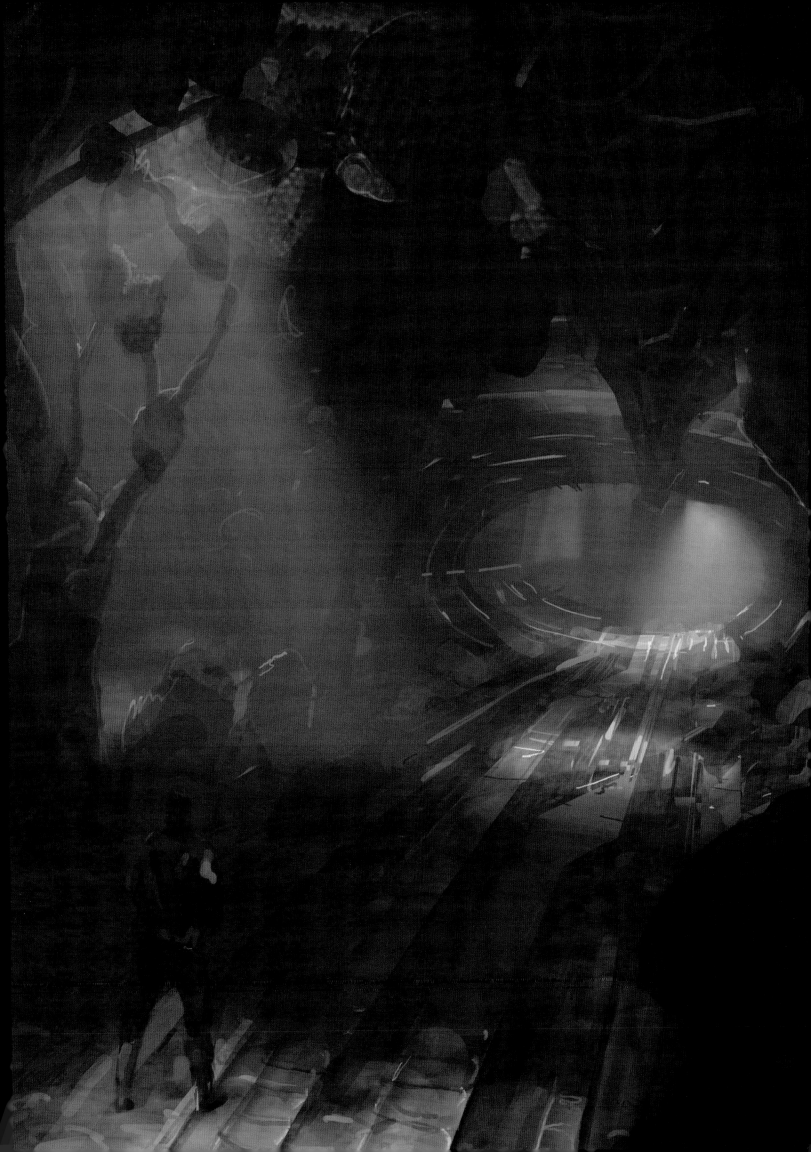

MECHS

Only a few concepts were done for the YMIR heavy mech; the decisions mostly revolved around how to create an iconic head that could be added to the dog-mech and light-mech bodies to reflect that they all came from the same manufacturer. We raised the shoulders to give it a unique silhouette and a look reminiscent of a gorilla.

All variations on the FENRIS dog mech reflect the design decision to forgo a mouth in favor of a sensor array, a chief feature for a mech that fulfills a sentry role.

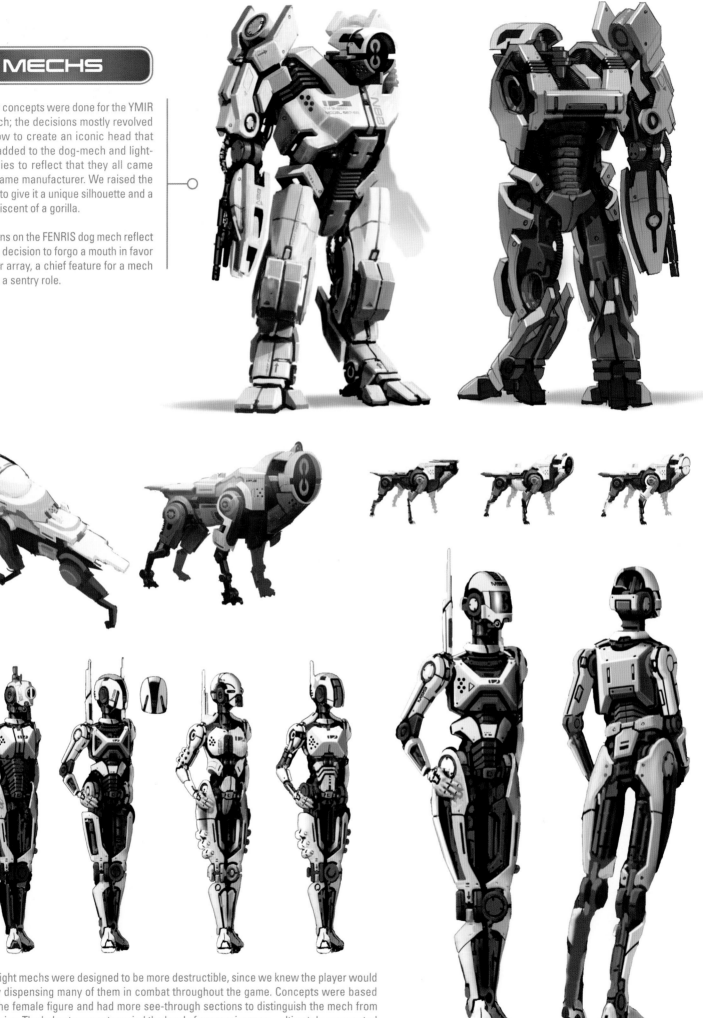

The LOKI light mechs were designed to be more destructible, since we knew the player would be quickly dispensing many of them in combat throughout the game. Concepts were based more on the female figure and had more see-through sections to distinguish the mech from other enemies. The helmet concepts varied the level of aggressiveness—ultimately, we wanted a neutral, dead look rather than having them seem too hostile.

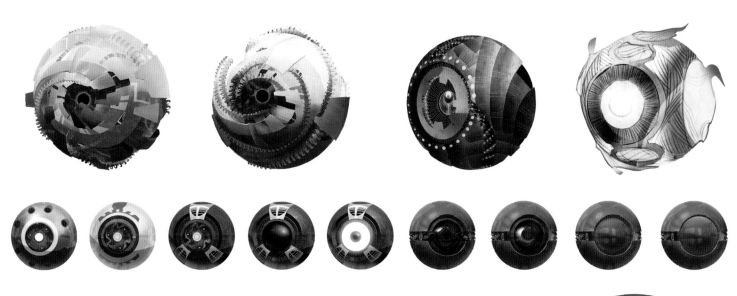

THE OCULUS & THE TECH DRONE

The idea behind the oculus was that of an all-seeing eye that can spot and kill the player. The appearance was supposed to be a smooth sphere with Reaper technology stuffed in underneath. The actual design was based on a stereo speaker, and the reference for the eye was, of course, HAL 9000.

The bottom concepts are some of the ideas for the engineer's tech drone, an enemy meant to be more of an annoyance than a challenge. The drone's final design was meant to be unobtrusive and reminiscent of the omni-tool that created it.

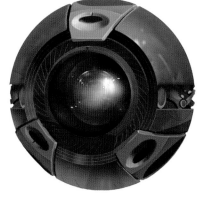

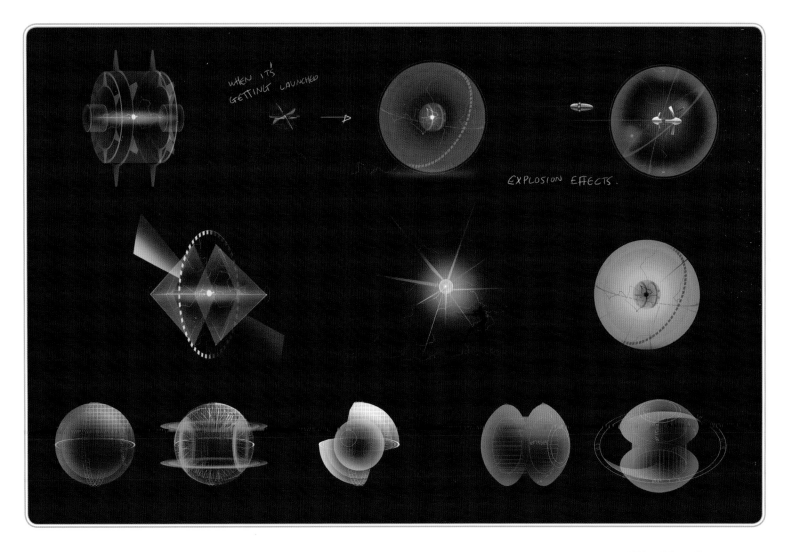

WEAPONRY

Mass Effect 2 has a wide variety of conventional guns, broken down into five classes. There are handguns, shotguns, sniper rifles, assault rifles, and submachine guns. We decided not to make weapons quite as futuristic in *Mass Effect 2* to broaden their appeal, but we still tried to keep the weapons distinct by giving them the iconic *Mass Effect* dual barrels as often as possible. To create a general sense that the Citadel species were supplied by the same arms companies, everyone except the Collectors and geth had a similar design to their weapons.

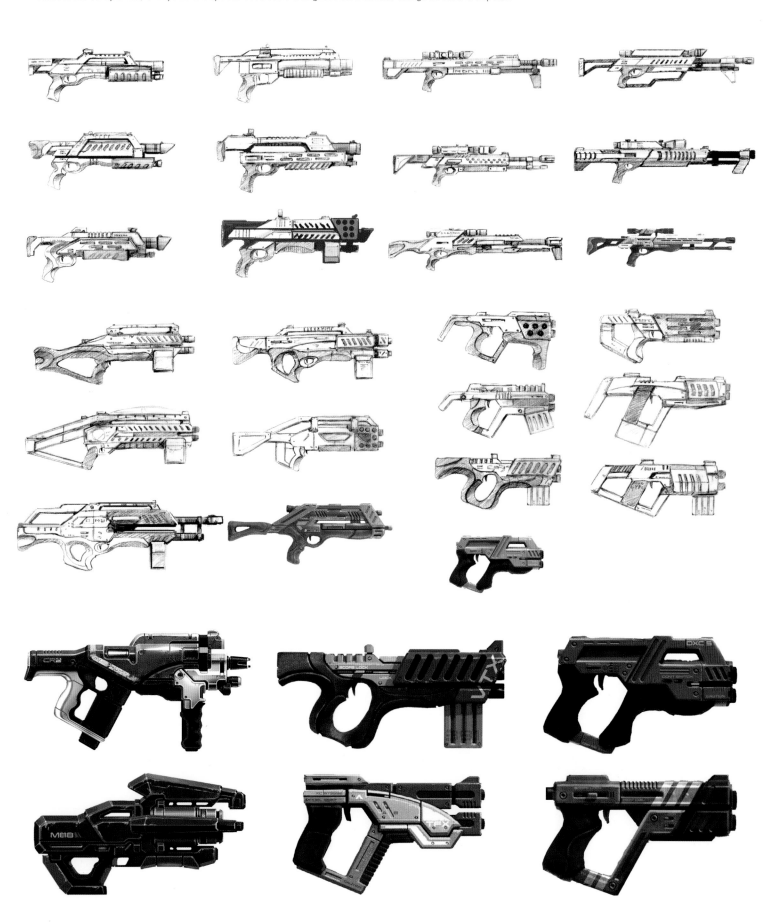

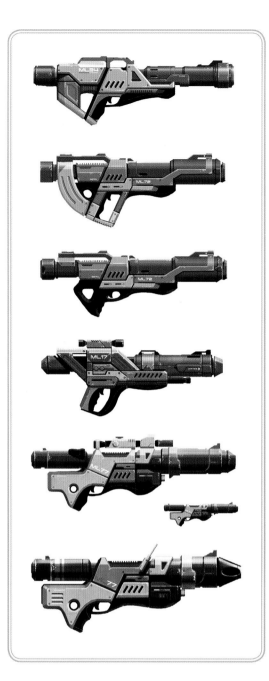

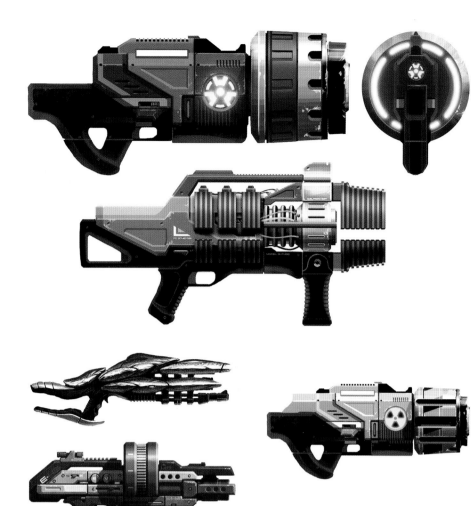

Mass Effect 2 introduced heavy weapons, as shown above. Each weapon had a unique use in gameplay, and all were designed to be large and bulky to demonstrate their increased firepower.

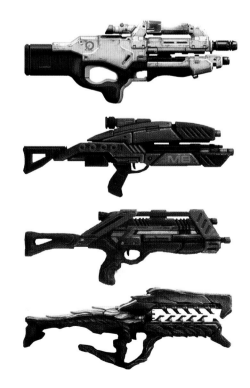

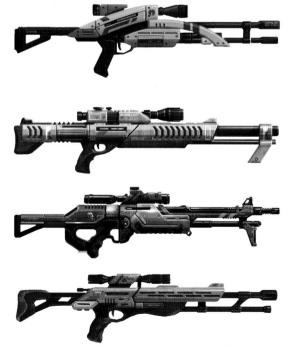

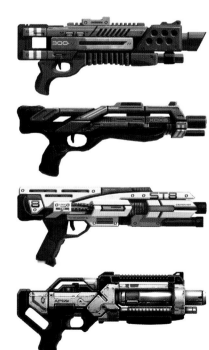

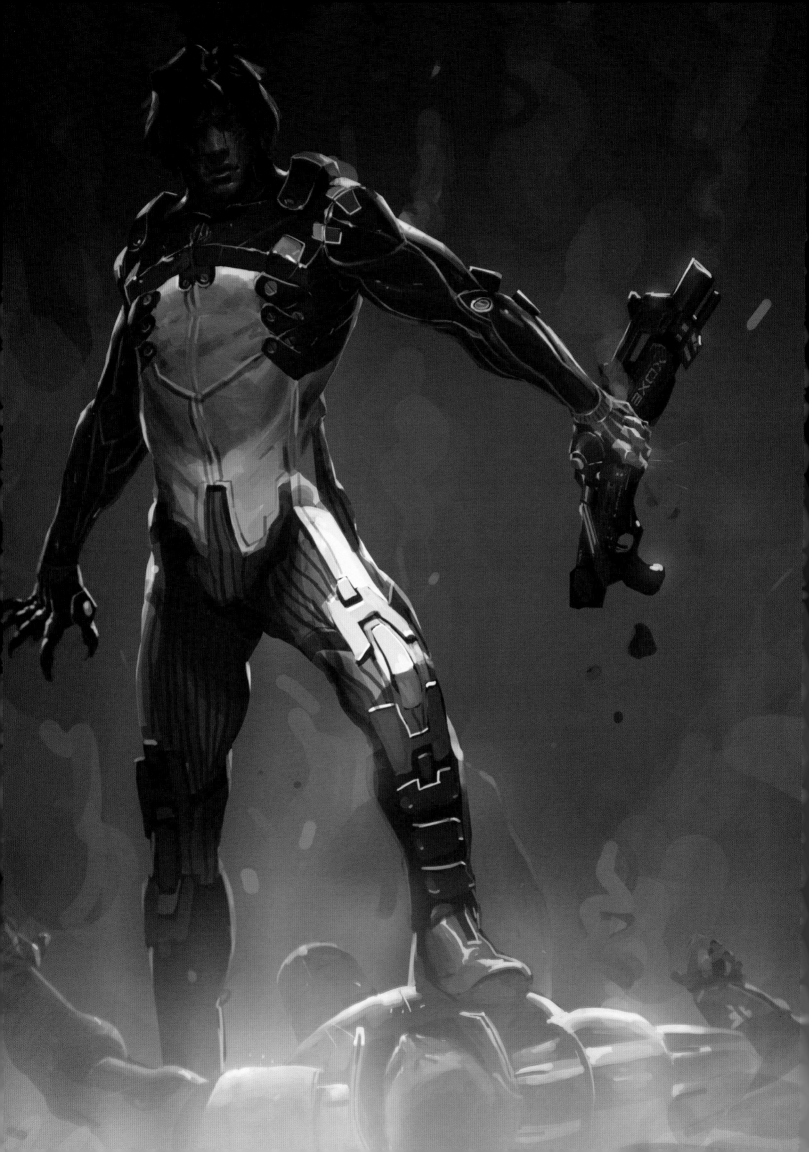

» MASS EFFECT **3**

ASHLEY WILLIAMS

Ashley, Kaidan, and Liara were meant to be love interests throughout all three parts of the trilogy. After taking them away from players in *Mass Effect 2*, they were ready for a passionate return in *Mass Effect 3*. For Ashley's reappearance in the series, we let her hair down and gave her sex appeal, while keeping her in a uniform that introduced the new Alliance colors. Ashley first bumps into Shepard as an Alliance officer on Earth, so her iconic look is a stylish officer's uniform, but later she will don a full set of armor.

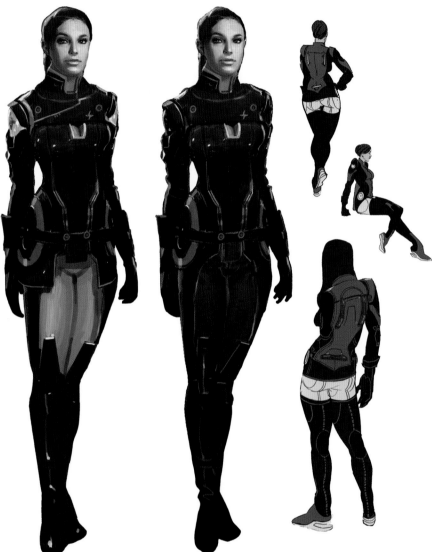

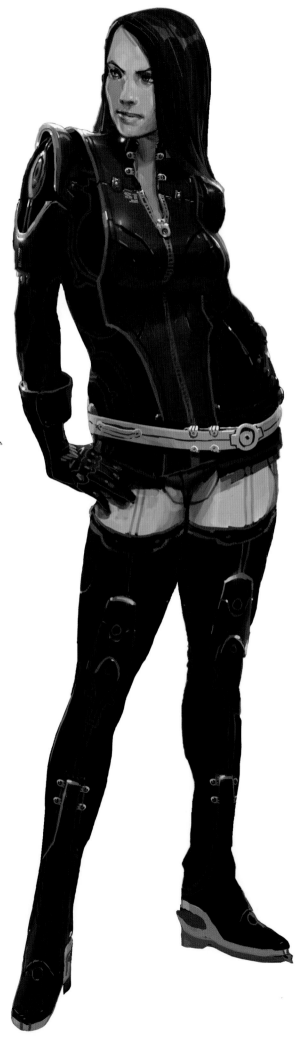

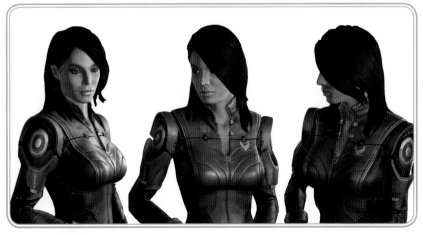

We tried many hairstyles for Ashley. Ultimately the team decided on a less formal look, appropriate since she and Shepard are well acquainted by *Mass Effect 3*.

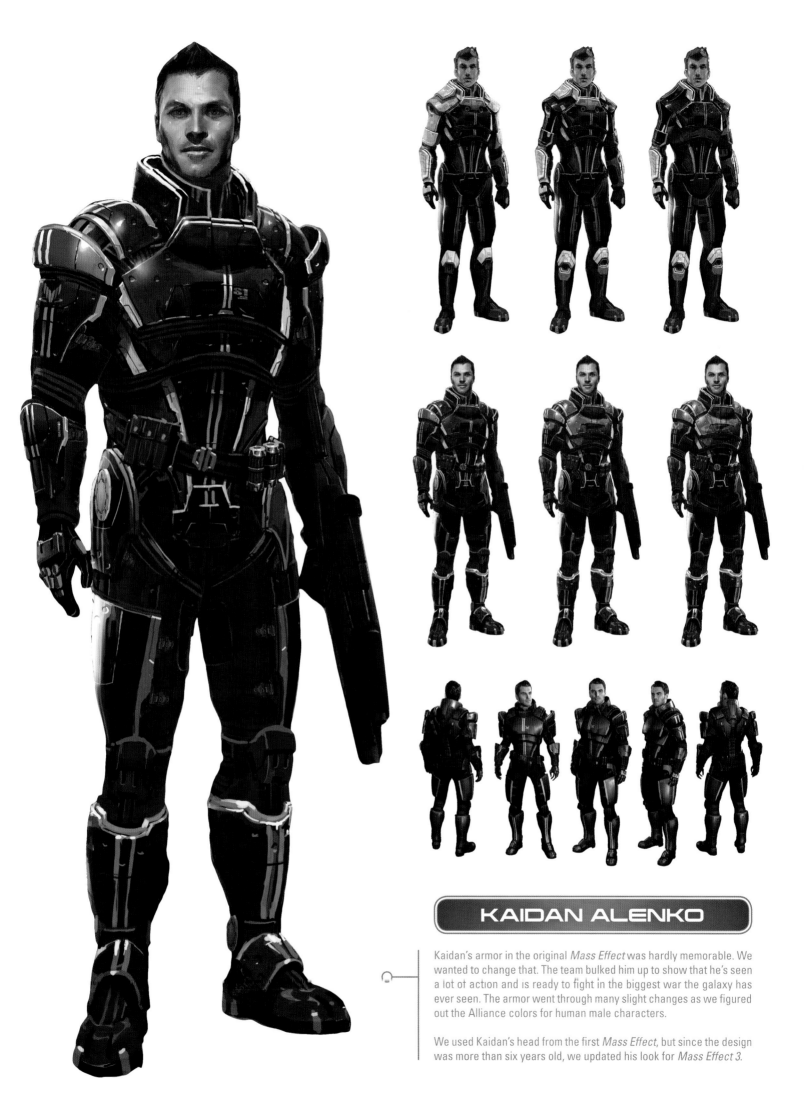

KAIDAN ALENKO

Kaidan's armor in the original *Mass Effect* was hardly memorable. We wanted to change that. The team bulked him up to show that he's seen a lot of action and is ready to fight in the biggest war the galaxy has ever seen. The armor went through many slight changes as we figured out the Alliance colors for human male characters.

We used Kaidan's head from the first *Mass Effect*, but since the design was more than six years old, we updated his look for *Mass Effect 3*.

JAMES VEGA

The idea for James Vega was to create a blue-collar military officer—a heavy-muscled tank of a man. We gave his armor more heft to imply that James is an unstoppable force. The team added a beard, scars, and tattoos to make him stand out from the other Alliance marines, notably Ash and Kaidan, who are both very clean-cut.

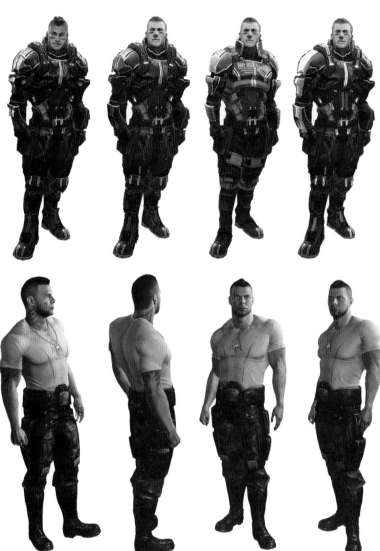

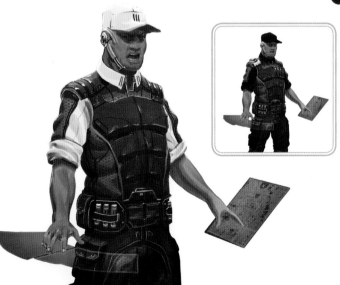

ADMIRAL ANDERSON

Admiral Anderson, heading into combat for the first time in the trilogy, donned fatigues that wouldn't look out of place on the battlefield but would also reflect his rank.

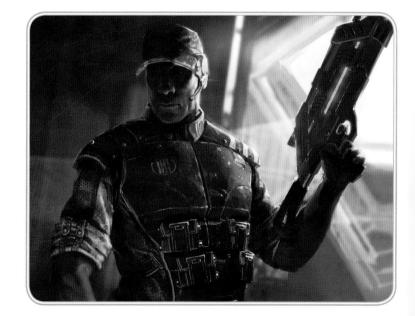

GARRUS VAKARIAN

We added silver to Garrus's signature blue-and-black armor to reflect his new rank. His eyepiece was slightly altered, and we added more detail to his armor. The idea was for Garrus to look familiar, but with heavier armor to withstand the battles he'd be facing in *Mass Effect 3*.

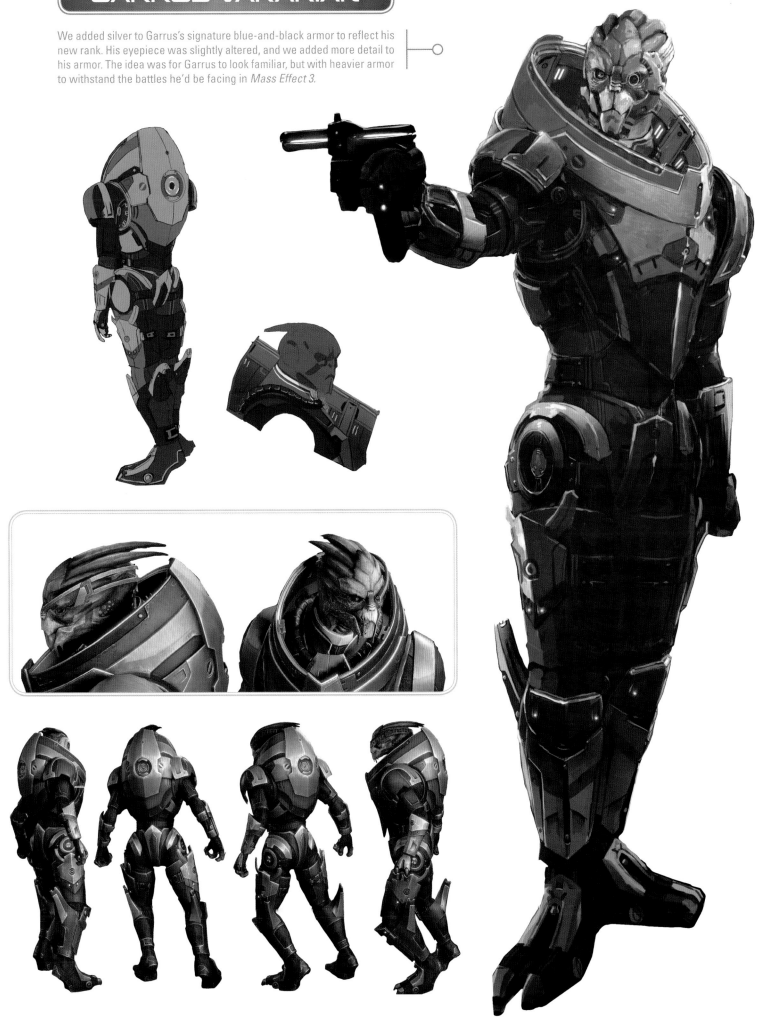

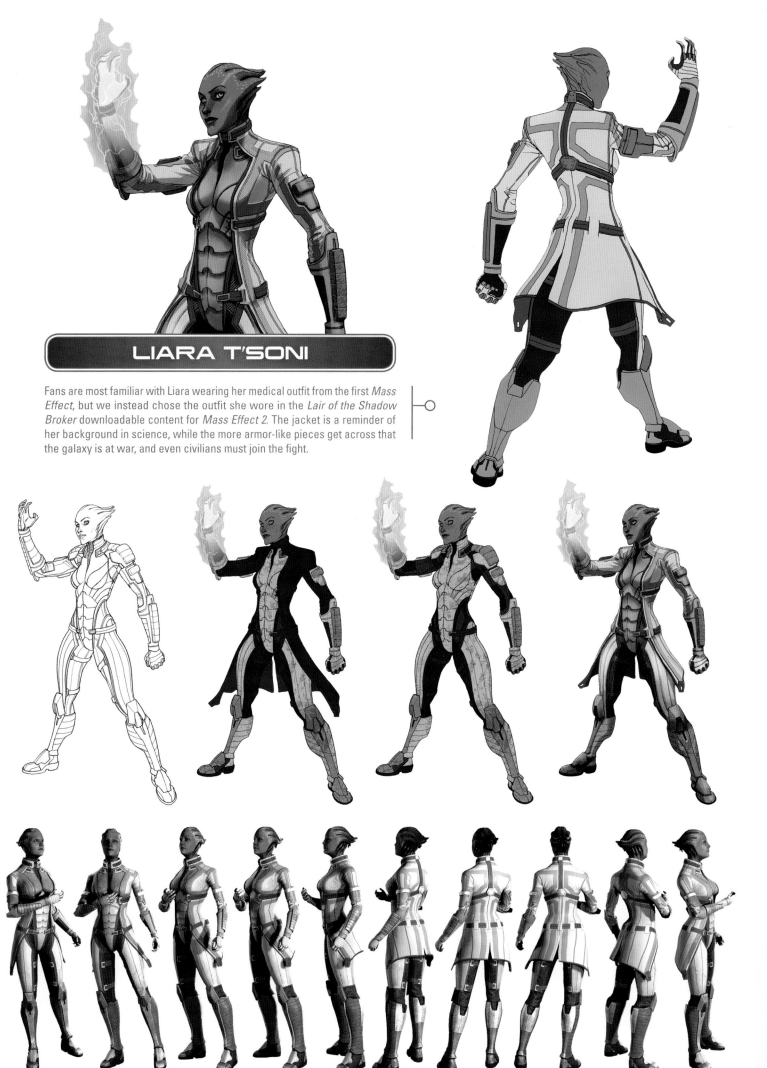

LIARA T'SONI

Fans are most familiar with Liara wearing her medical outfit from the first *Mass Effect*, but we instead chose the outfit she wore in the *Lair of the Shadow Broker* downloadable content for *Mass Effect 2*. The jacket is a reminder of her background in science, while the more armor-like pieces get across that the galaxy is at war, and even civilians must join the fight.

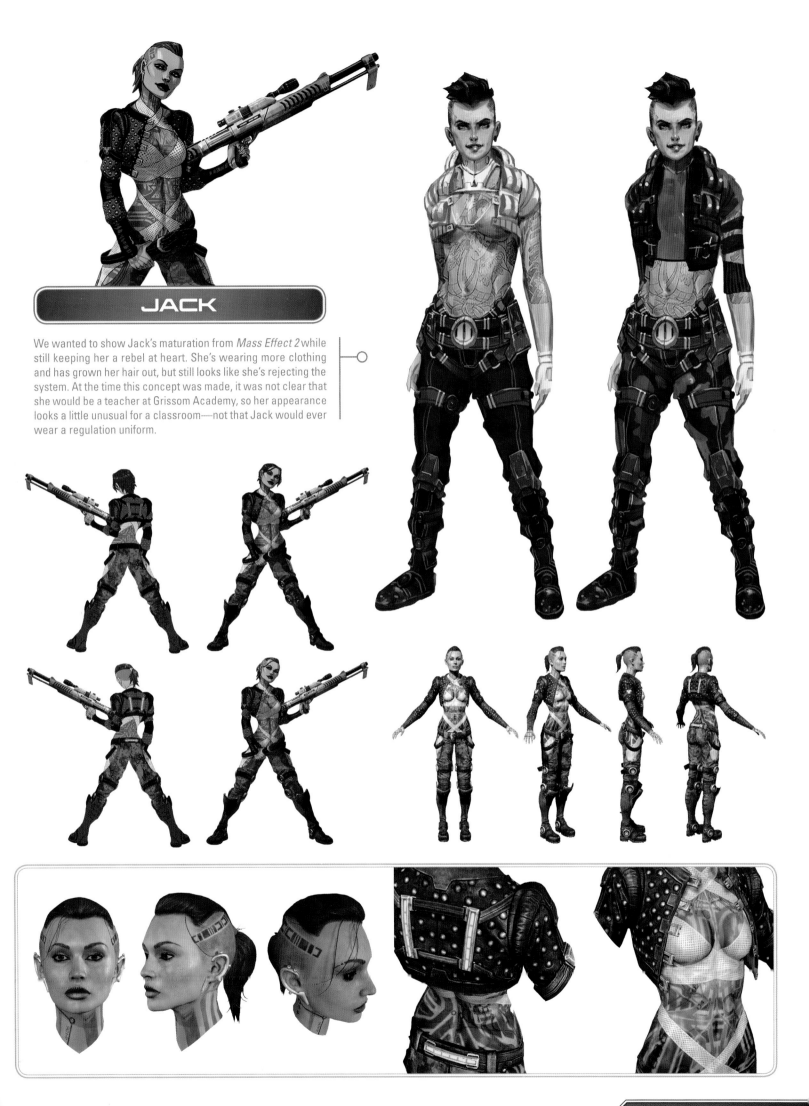

JACK

We wanted to show Jack's maturation from *Mass Effect 2* while still keeping her a rebel at heart. She's wearing more clothing and has grown her hair out, but still looks like she's rejecting the system. At the time this concept was made, it was not clear that she would be a teacher at Grissom Academy, so her appearance looks a little unusual for a classroom—not that Jack would ever wear a regulation uniform.

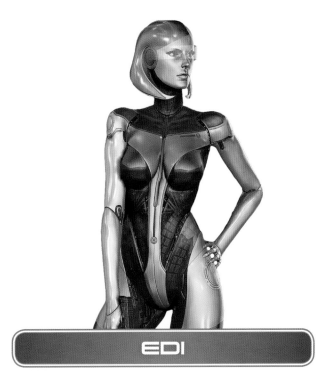

EDI

EDI's body needed to be sexy, chrome, and robotic, the *Mass Effect* version of Maria from *Metropolis*. We had a lot of discussion about how robotic she would appear, what her "hair" would look like, and whether or not her face would be expressive. Since the body is an infiltration unit that once had skin over the metal, we decided she should have the same facial effects as the other humans. Otherwise the unit would be easily spotted.

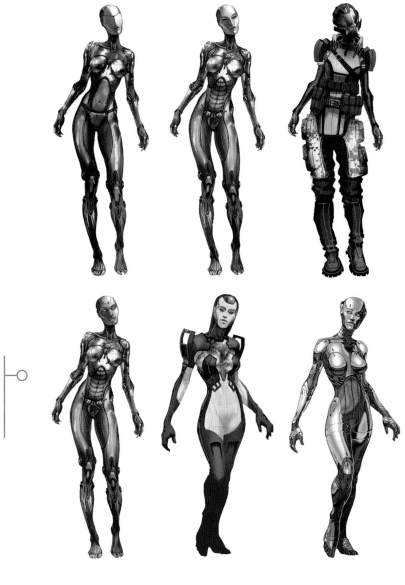

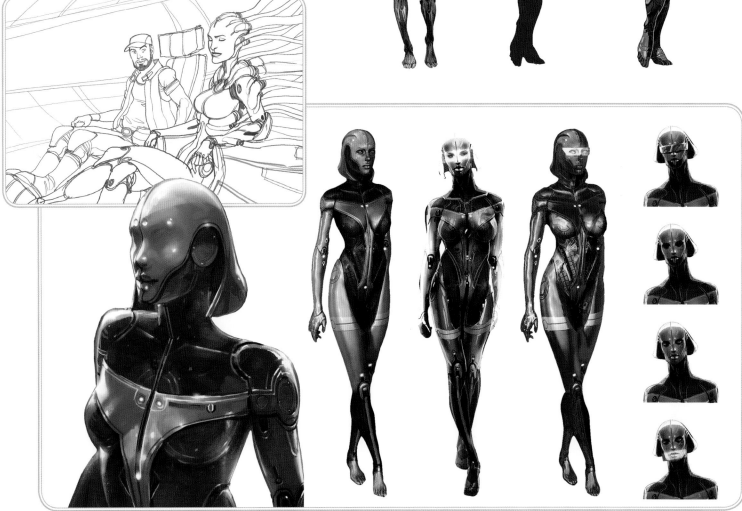

Some of the early drafts of EDI had a model without eyes. We thought holographic, omni-tool-like eyes might work, but we decided against this in the end, as it wouldn't work with the digital acting system we use.

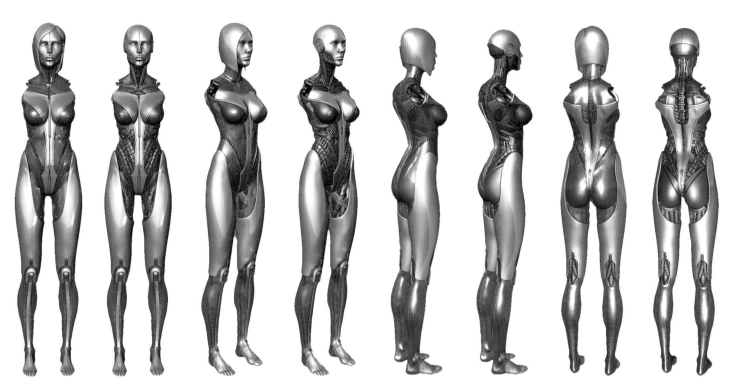

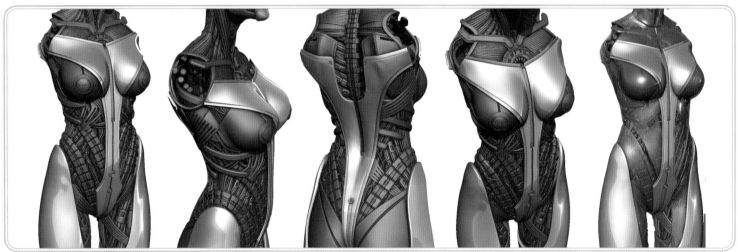

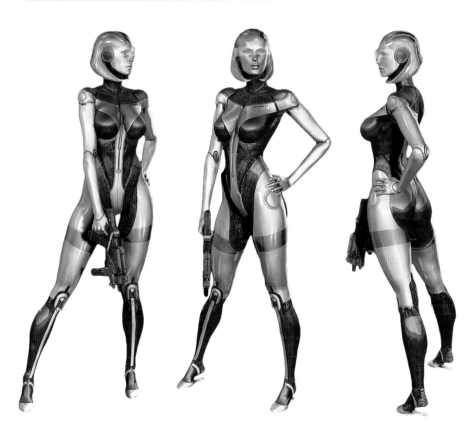

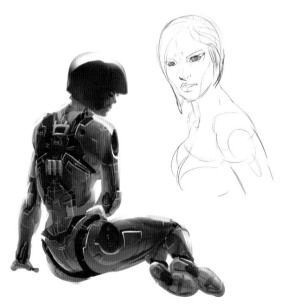

The partially completed 3-D models above show the level of detail that went into EDI's design. A lot of discussion centered on the shape of her body, the split between the solid and transparent surfaces, and the finer points of her two-tone appearance.

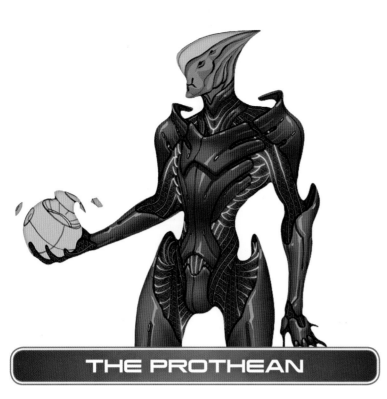

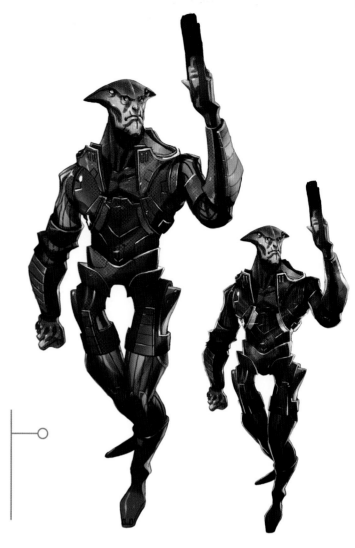

THE PROTHEAN

The Prothean statues on Ilos in the original *Mass Effect* were visually ambiguous, because we were never sure how much of the Protheans we would show over the course of the trilogy. By the time *Mass Effect 3* came around, we knew that the Collectors were Prothean victims of the Reapers. The look of the Collectors influenced how we created the Prothean squad member.

We tried to make him look more intelligent than the Collectors, as a Prothean needs to look capable of inventing some of the galaxy's most advanced technology.

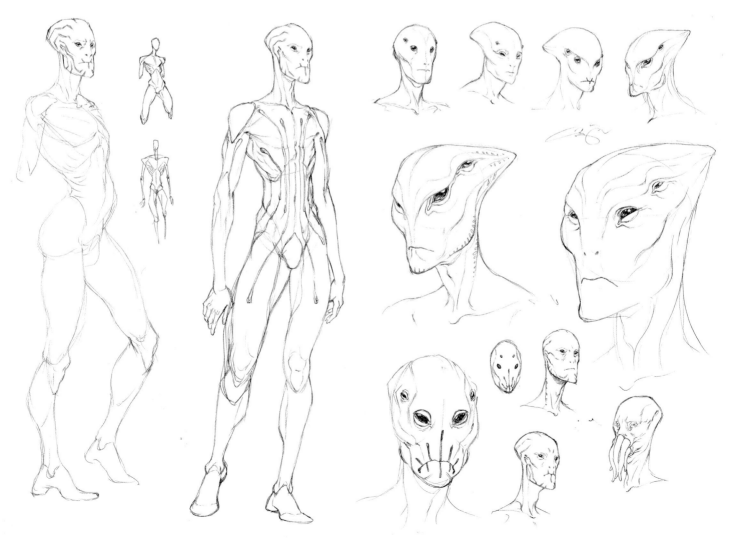

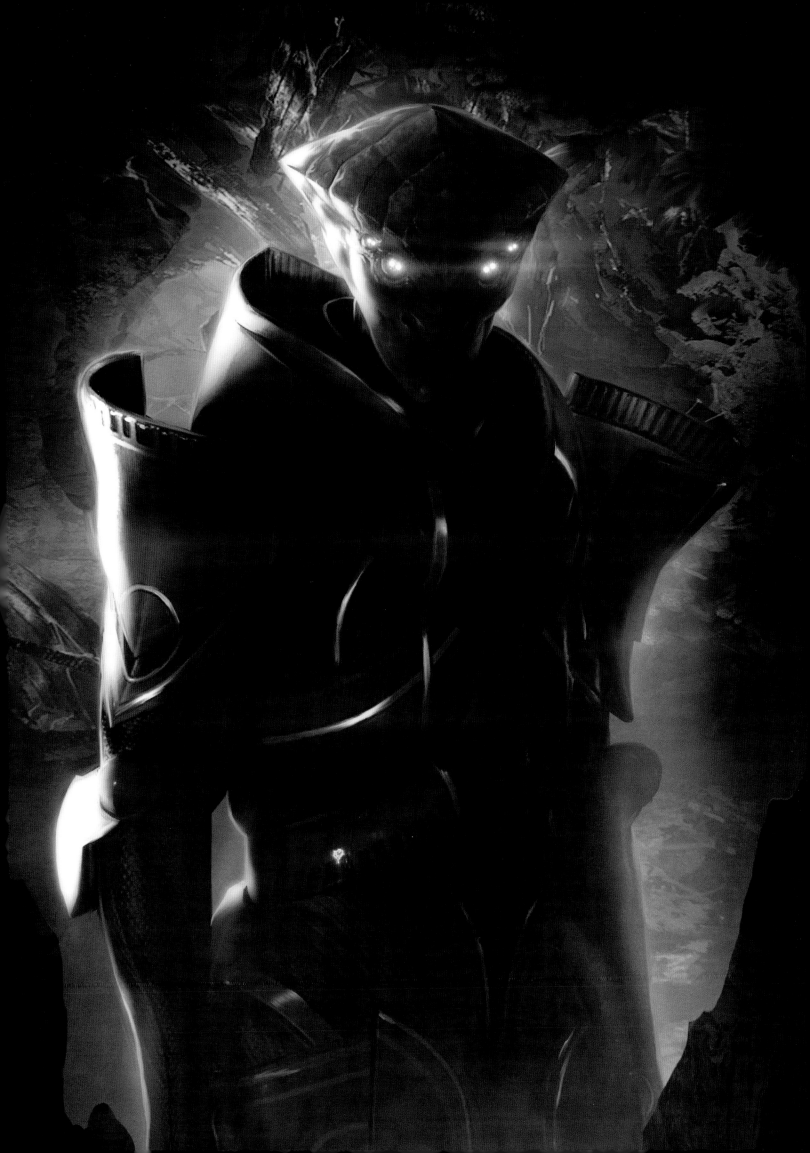

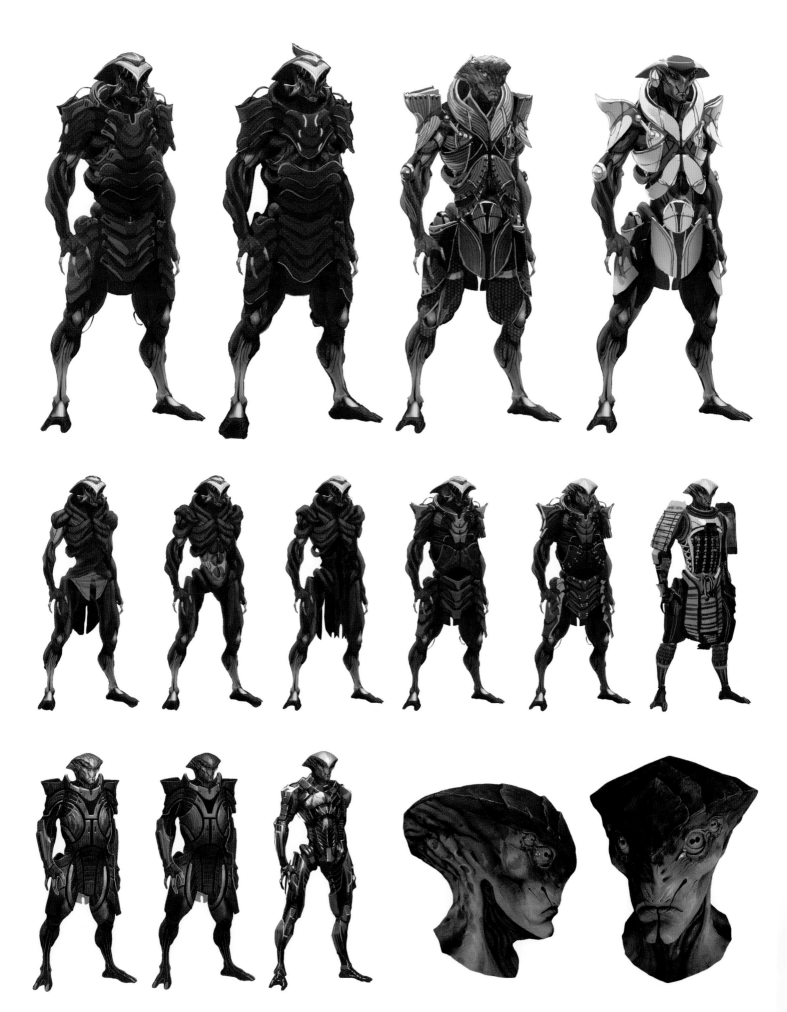

We had numerous designs for the Prothean's armor. It needed to have an ancient feel but still be fantastically high tech. Eventually we steered toward clothing more like a samurai's than the high-tech armor Shepard wears, to suggest the wearer had been in stasis for more than 50,000 years.

Above is the final modeled head for a Prothean, showing off the shell shape that was a key feature of the Collectors. We added multiple pupils to the eyes and secondary nostrils off the upper lip for a very alien feel.

THE CHILD

One child would be the face of the people on Earth whom Shepard could not save. Below are variations on the child's clothing, which we wanted to feel appropriate for the far future but not so unusual that they would seem out of place on a child today.

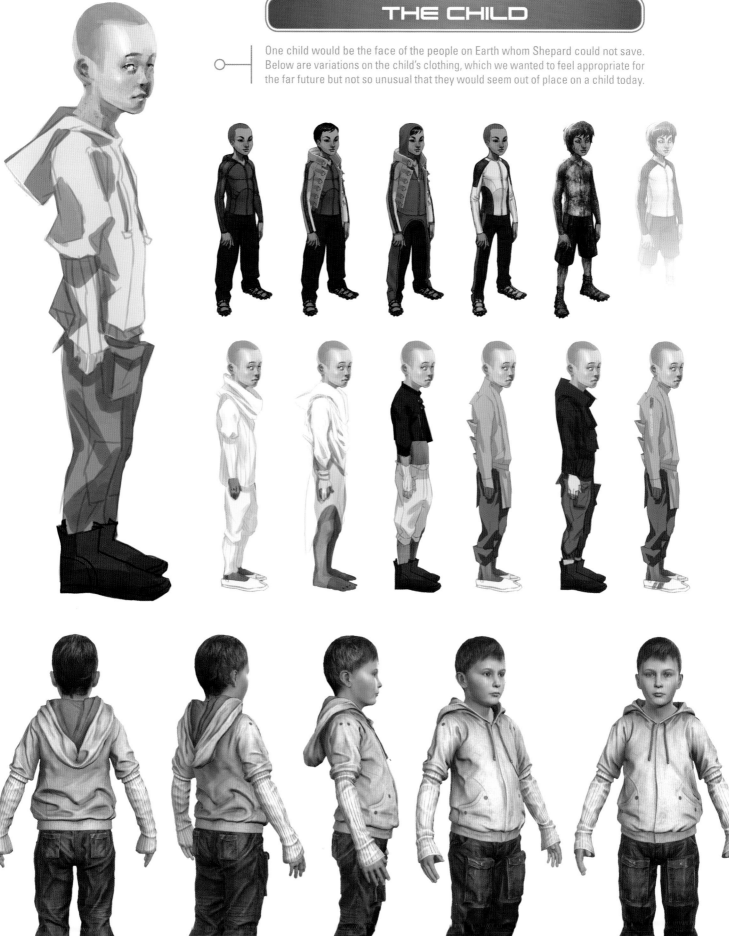

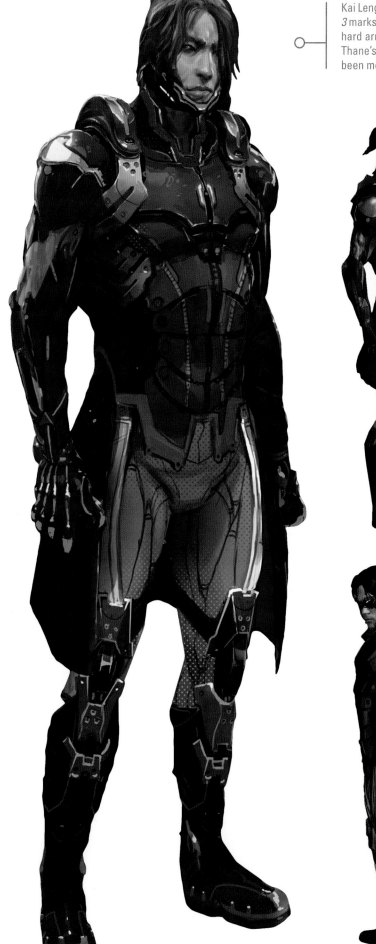

KAI LENG

Kai Leng, Cerberus's top assassin, was featured in the *Mass Effect* novels. *Mass Effect 3* marks the first time he appears in a game. Early concepts gave him metal legs and hard armor, but this evolved into a stealthier appearance with a coat reminiscent of Thane's. His face and body kept a few obvious cybernetic implants to imply that he'd been modified since the events in the books to become even deadlier.

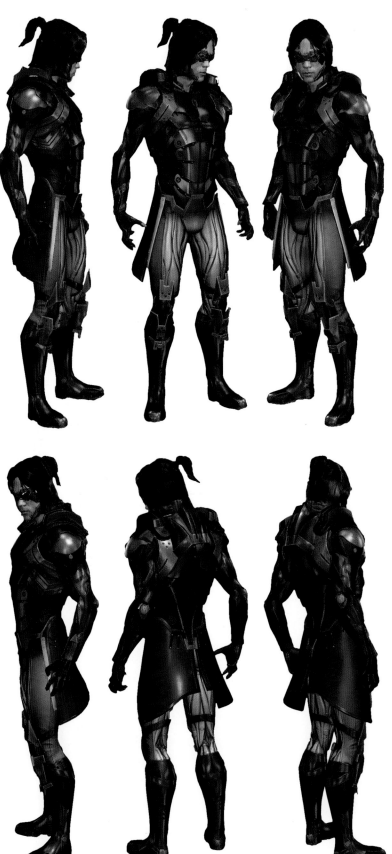

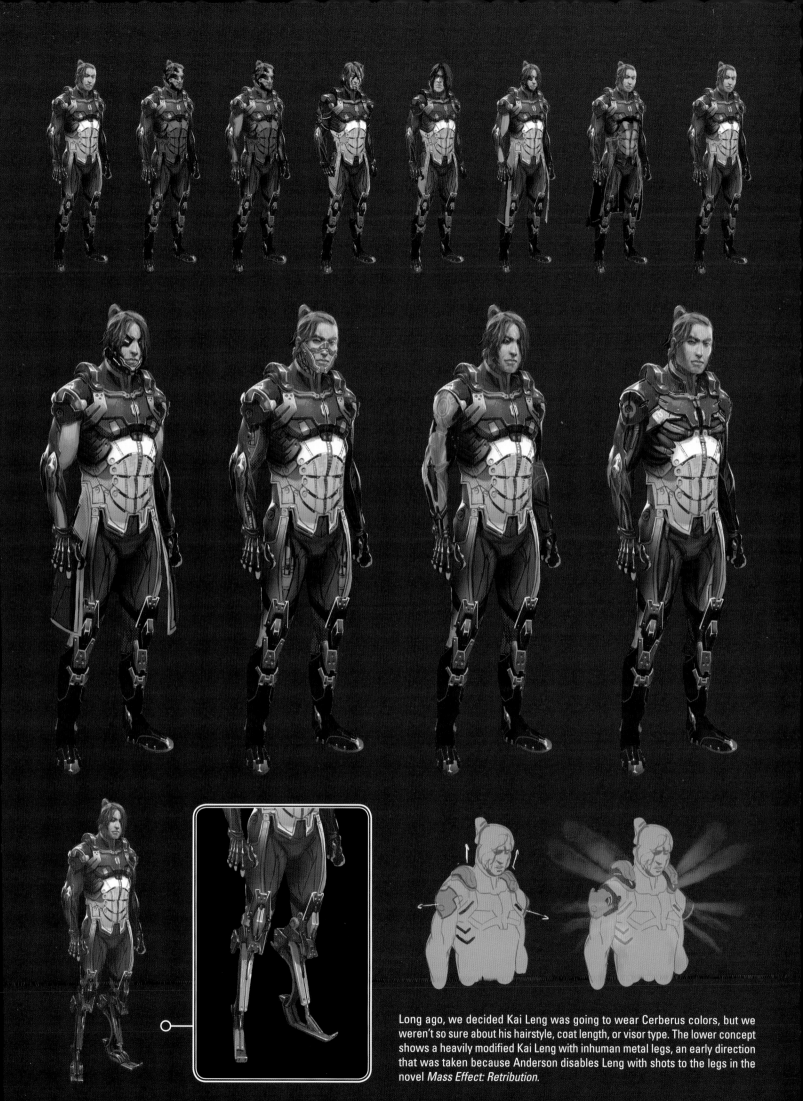

Long ago, we decided Kai Leng was going to wear Cerberus colors, but we weren't so sure about his hairstyle, coat length, or visor type. The lower concept shows a heavily modified Kai Leng with inhuman metal legs, an early direction that was taken because Anderson disables Leng with shots to the legs in the novel *Mass Effect: Retribution*.

THE ILLUSIVE MAN

One of the plans on the drawing board was to have the Illusive Man turn into a Reaper creature for the final battle. Eventually, this plan was scrapped, since we wanted to give players the satisfaction of fighting a character they know rather than a random creature. The design implies that the Illusive Man's weapon is his intelligence, not his physical strength.

Below are concepts for the Illusive Man and his observation room. Some vary the color of the dying sun in the background, and one version shows the sun eclipsed.

Numerous facial concepts were made to establish what level of indoctrination the Illusive Man had undergone. A few variations went so far as to reference Saren from the first *Mass Effect*.

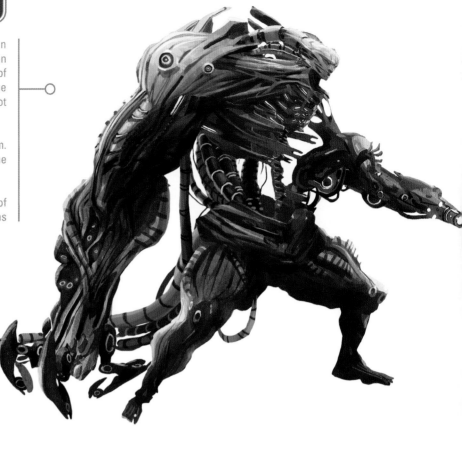

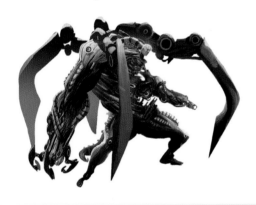

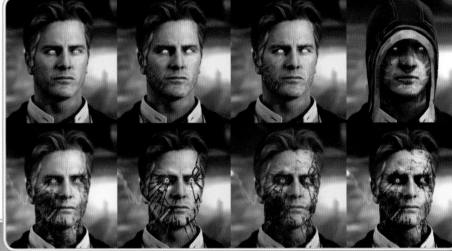

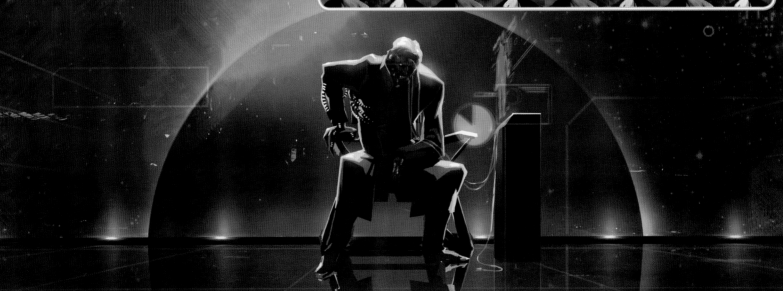

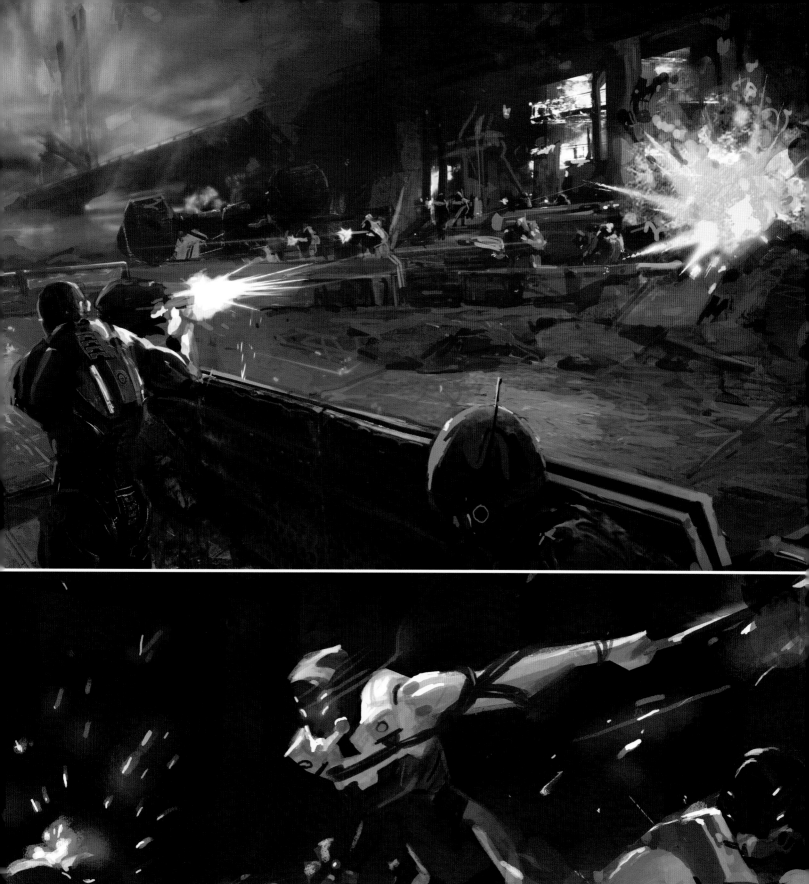
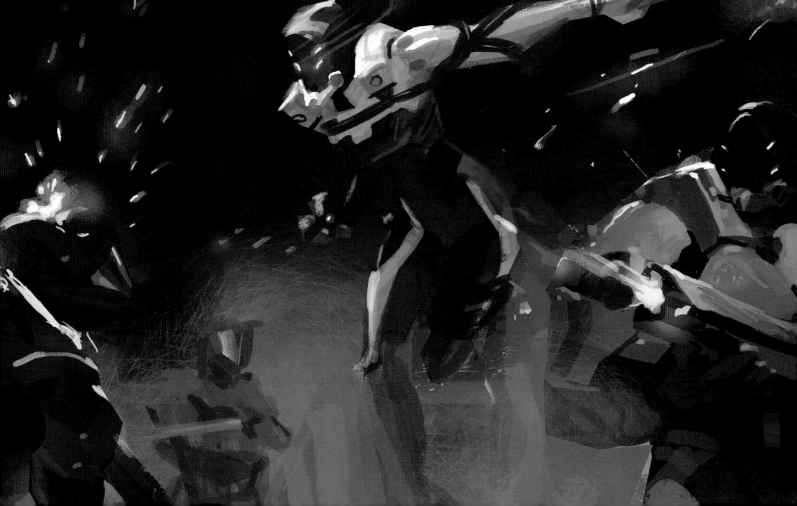

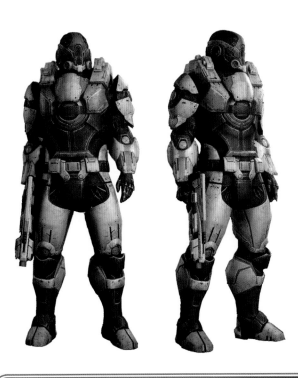

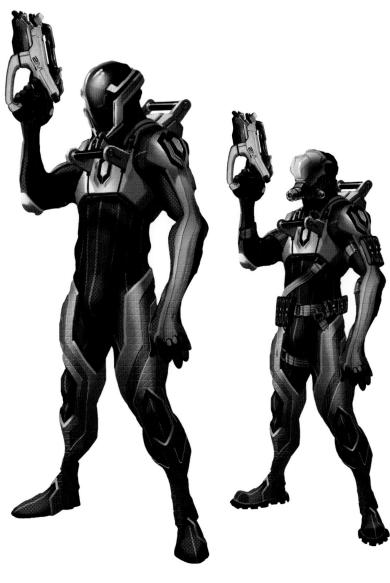

CERBERUS FORCES

The trooper is the most common Cerberus enemy in the game. We decided the armor needed to look more robust than it did in previous games to show that troopers are battle-hardened foes who have fought all kinds of enemies across the galaxy. Common features for all Cerberus enemies were the coloring, rectangular eye slits, and circles over the shoulders and chest. Heavy armor pads over the collarbone completed the tougher look.

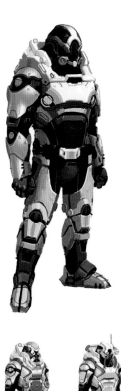
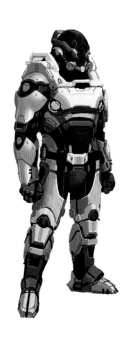
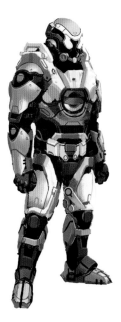
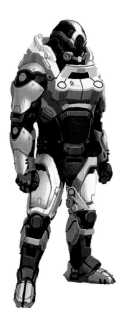
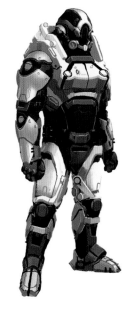

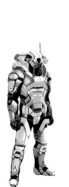
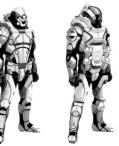
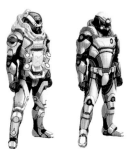
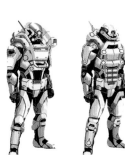
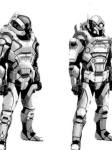

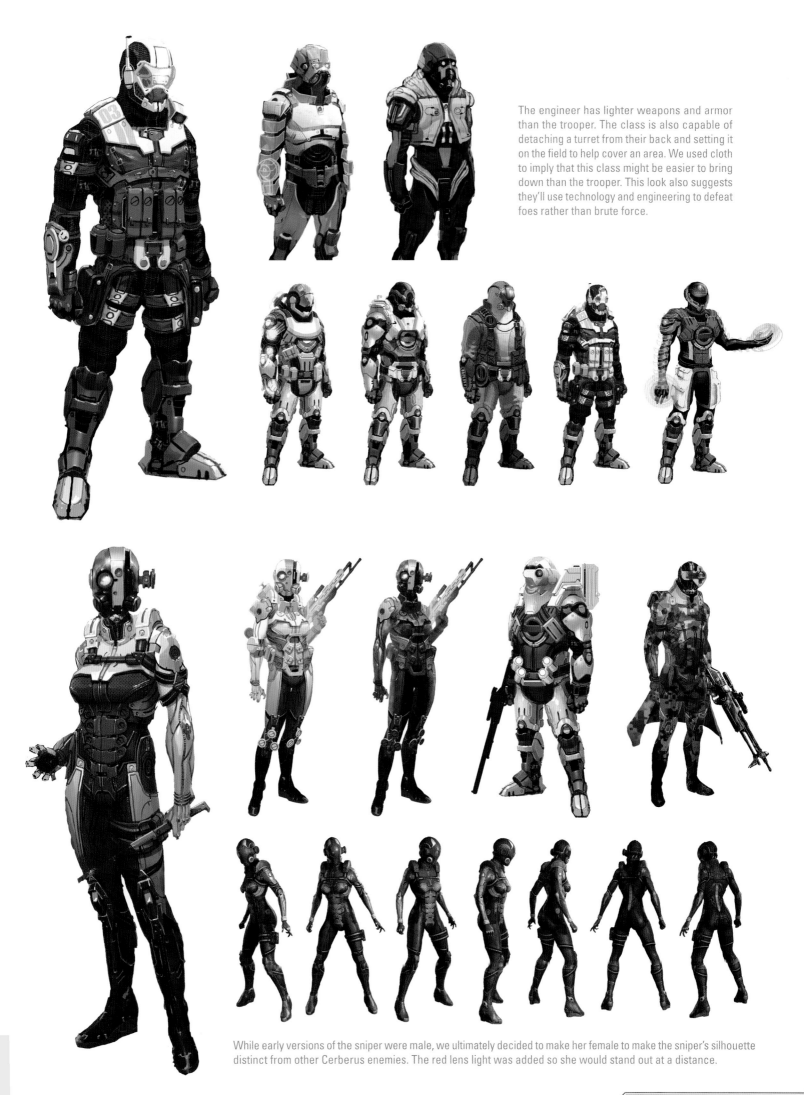

The engineer has lighter weapons and armor than the trooper. The class is also capable of detaching a turret from their back and setting it on the field to help cover an area. We used cloth to imply that this class might be easier to bring down than the trooper. This look also suggests they'll use technology and engineering to defeat foes rather than brute force.

While early versions of the sniper were male, we ultimately decided to make her female to make the sniper's silhouette distinct from other Cerberus enemies. The red lens light was added so she would stand out at a distance.

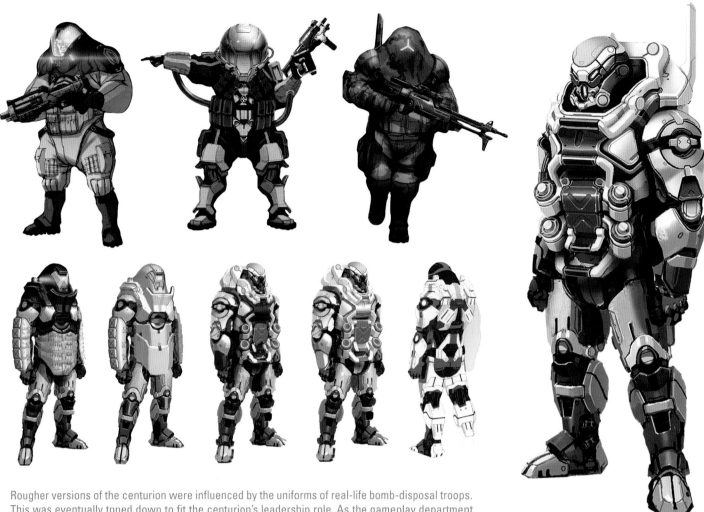

Rougher versions of the centurion were influenced by the uniforms of real-life bomb-disposal troops. This was eventually toned down to fit the centurion's leadership role. As the gameplay department created weapons for this class, we altered the armor to accommodate things like grenade canisters, matching form with function.

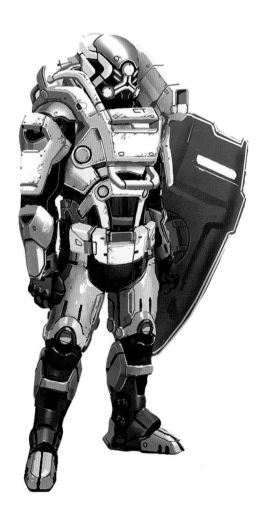

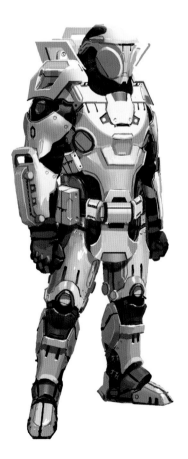

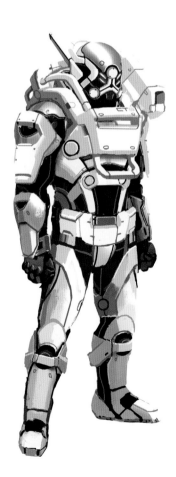

What makes the guardian unique is the heavy gun on the shoulder, required because the class also carries a large, impervious riot shield.

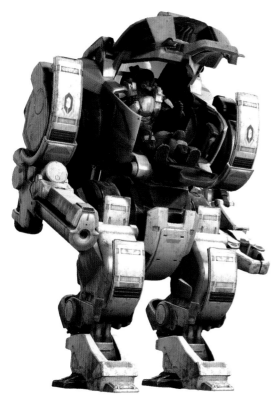

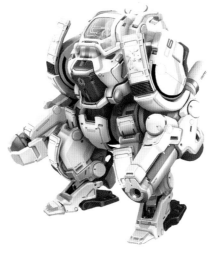

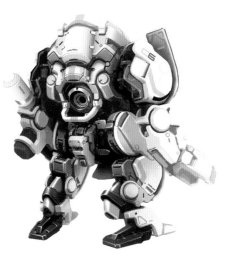

The Atlas went through multiple iterations. An early version cast the Atlas as a heavy *Mass Effect 2* YMIR mech with a soldier inside. Eventually, a canopy was added to protect the soldier, and we made the Atlas larger than the YMIR. The canopy was made clearly visible so it would be an obvious weak point. These changes had consequences: increasing the size of the Atlas created a lot of extra work for the animation department.

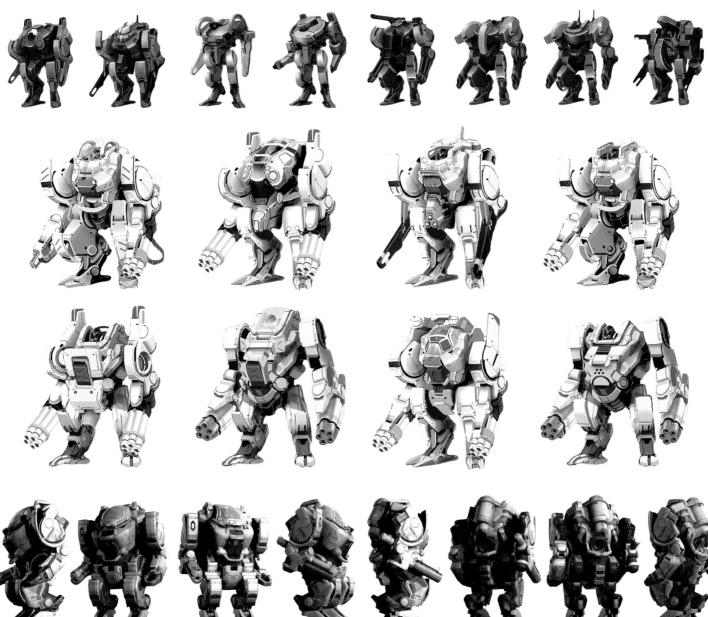

REAPER FORCES

One of the biggest challenges in creating *Mass Effect 3* was designing enemies that side with the Reapers but are not Reapers themselves. After all, Shepard wouldn't last long in a fight with a two-kilometer-long starship. To allow us to maintain the series' signature squad-based combat, we created horrific versions of the galaxy's established species, like asari and batarians, and set the action during an invasion where Reaper ground forces were going house to house harvesting victims.

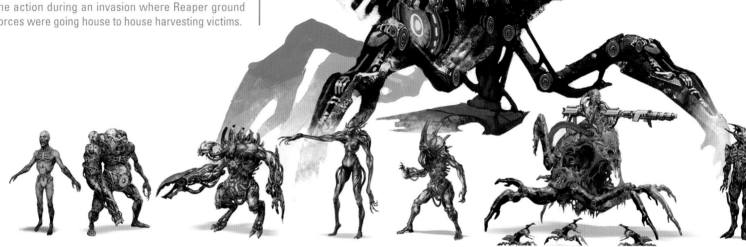

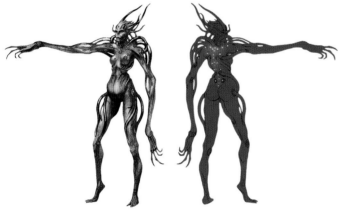

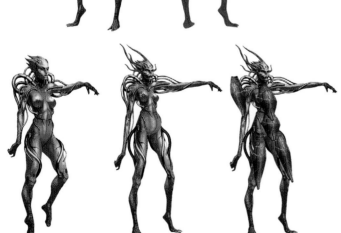

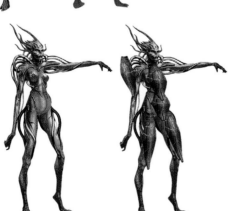

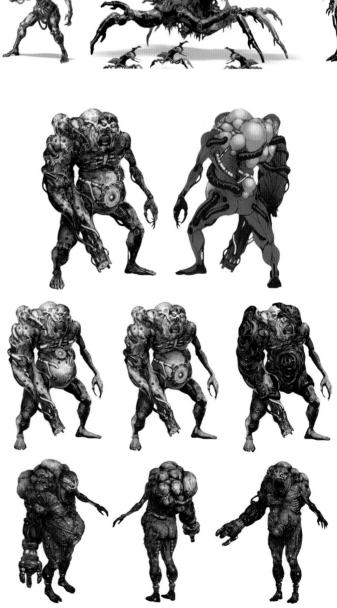

The banshee is a Reaper version of an asari matriarch—she is stretched taller by the conversion process to make her silhouette both wispy and intimidating.

The cannibal is a Reaper version of a batarian with a human corpse for an arm. The corpse's legs fuse with a large gun. This seemed appropriate, as the Reapers' early fronts during the invasion were in batarian and human space.

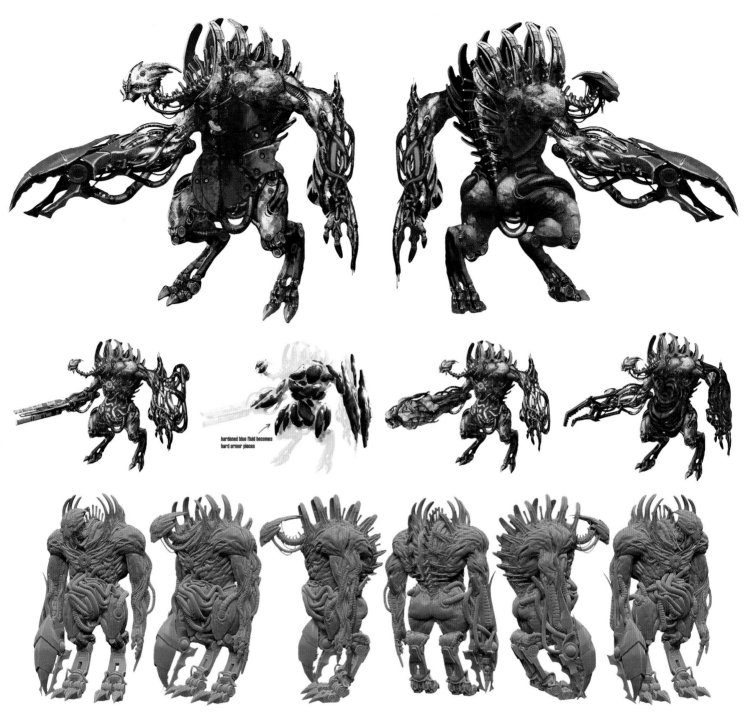

The brute was named to suggest its appearance: a large enemy with an oversized claw, able to pick up and mash Shepard into the ground. The krogan were a perfect species to use as a model. We decided to swap out the krogan head for something turian, making for a grisly synthesis of two species whose planets were closely linked in the invasion plan. The exposed vital organs were appropriately repulsive, but we ultimately added armor plating that could be blown off, making the brute extremely tough.

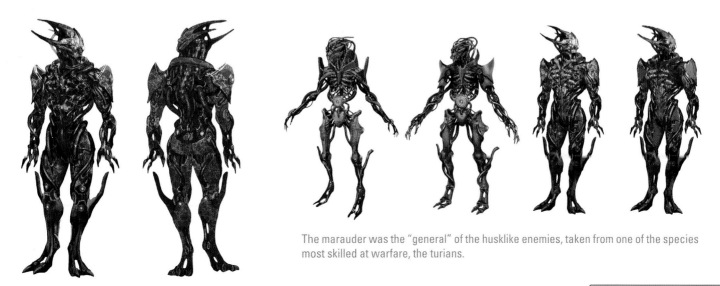

The marauder was the "general" of the husklike enemies, taken from one of the species most skilled at warfare, the turians.

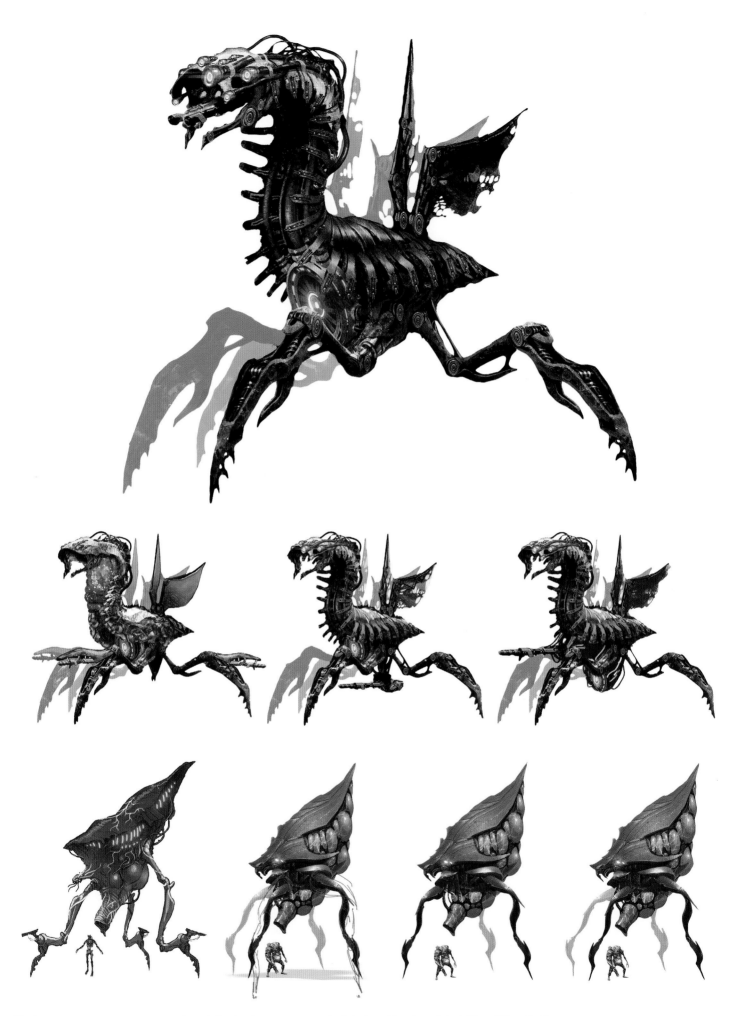

The harvester was a great opportunity to bring back a creature we had designed for the original *Mass Effect*. While it appeared in a short mission in *Mass Effect 2*, we didn't exploit its full potential until *Mass Effect 3*. We added dual cannons underneath its head and a large porthole on its stomach. It could now spawn enemies during combat, making it the Reaper equivalent of a troop dropship.

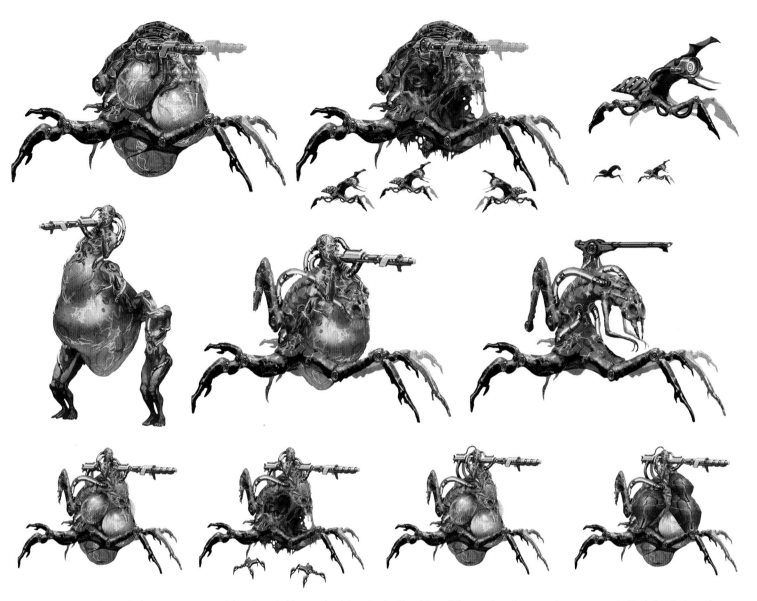

To kill or spare the rachni queen was one of the player's biggest decisions in the first *Mass Effect*, and we knew early on we wanted to bring the species back. Early versions had a human corpse turned into a gun mounted on the creature. When this was deemed too disgusting, we added large sacs that could be punctured, releasing miniature rachni. We're not sure if this is actually more palatable, but it made for more interesting gameplay.

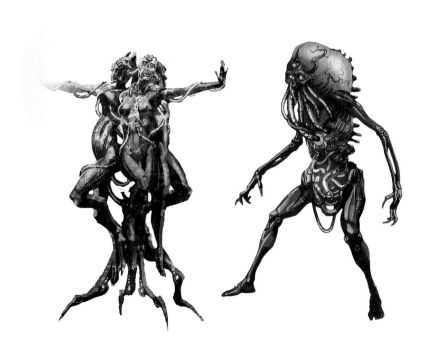

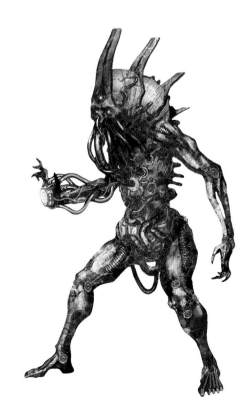

This creature (called the pariah or the adjutant at various points) was never fully developed before being cut. Planned gameplay, at one point, was to have it teleport around the battlefield. This proved too much even for the relatively generous physics of the *Mass Effect* universe.

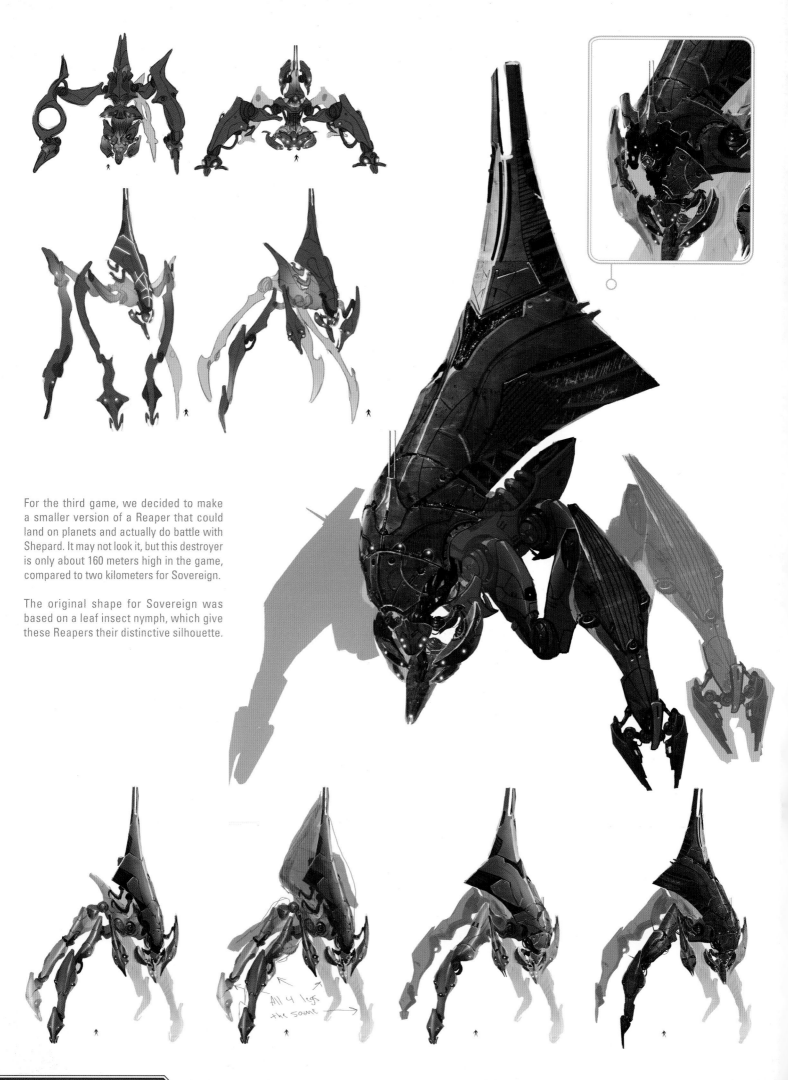

For the third game, we decided to make a smaller version of a Reaper that could land on planets and actually do battle with Shepard. It may not look it, but this destroyer is only about 160 meters high in the game, compared to two kilometers for Sovereign.

The original shape for Sovereign was based on a leaf insect nymph, which give these Reapers their distinctive silhouette.

All 4 legs the same

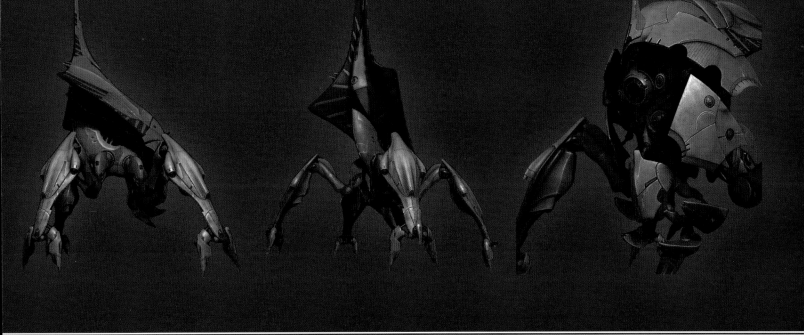

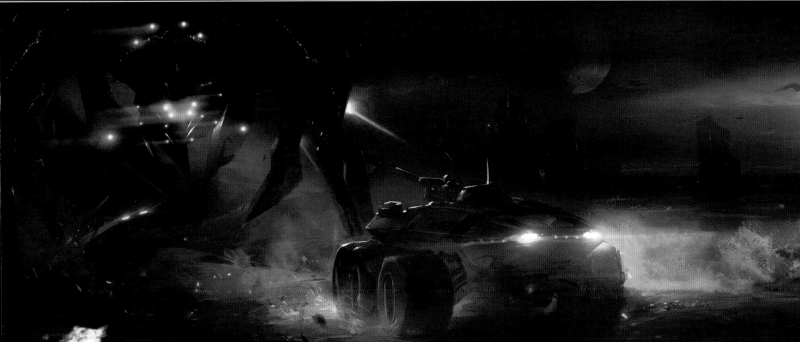

Here we have multiple views of a 3-D model of the Reaper destroyer. The middle-right image shows the faceplate opening up to reveal its main gun. Mechanics like these maintain the synthetic but still organic feel of the Reapers; we wanted to imply that they are thinking creatures that adopt patterns of living things in their construction.

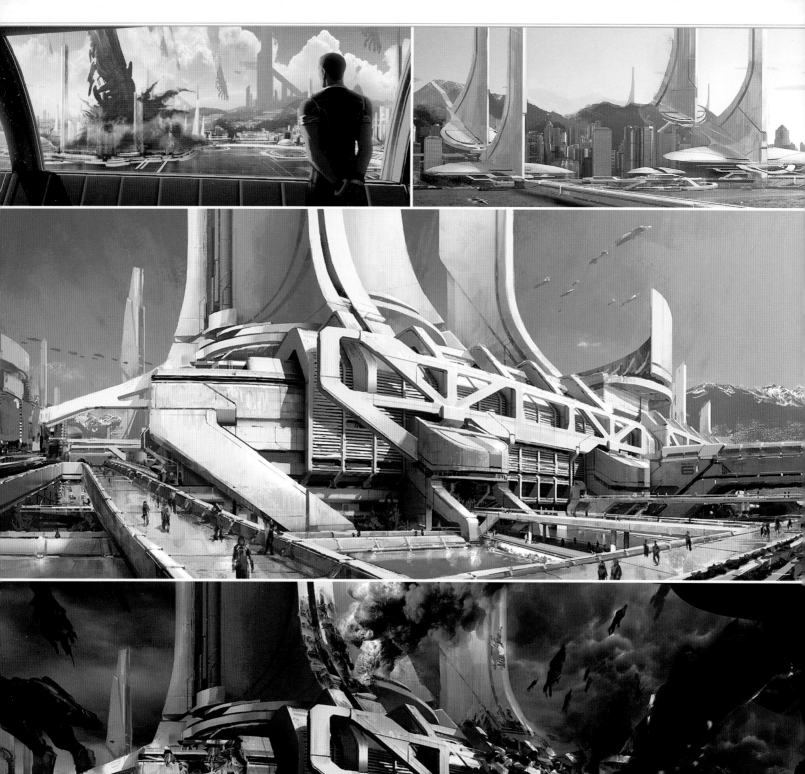

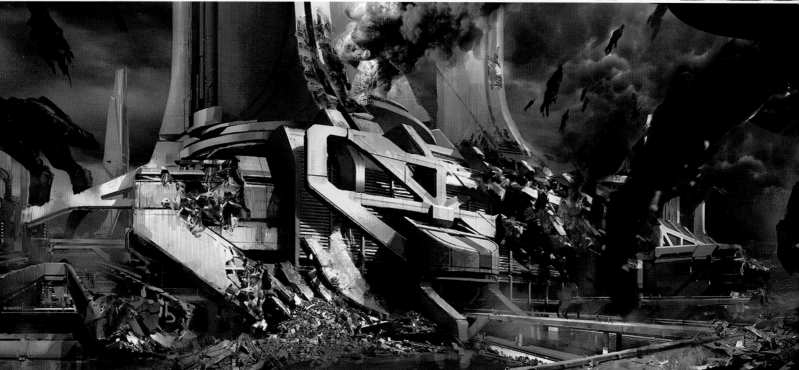

EARTH

Earth was an exciting level to design for *Mass Effect 3*, because it marks the first time in the trilogy that Shepard visits the planet. We knew we wanted a beautiful harbor setting and kicked around many ideas for the city, including Rio de Janeiro and Hong Kong. In the end, we stayed closer to home, choosing Vancouver. These concepts show the process of designing an iconic look that wouldn't conflict with the alien architecture that was already in place. We blended large curves with strong 45-degree angles and added a slightly weathered look with human signage to make it familiar.

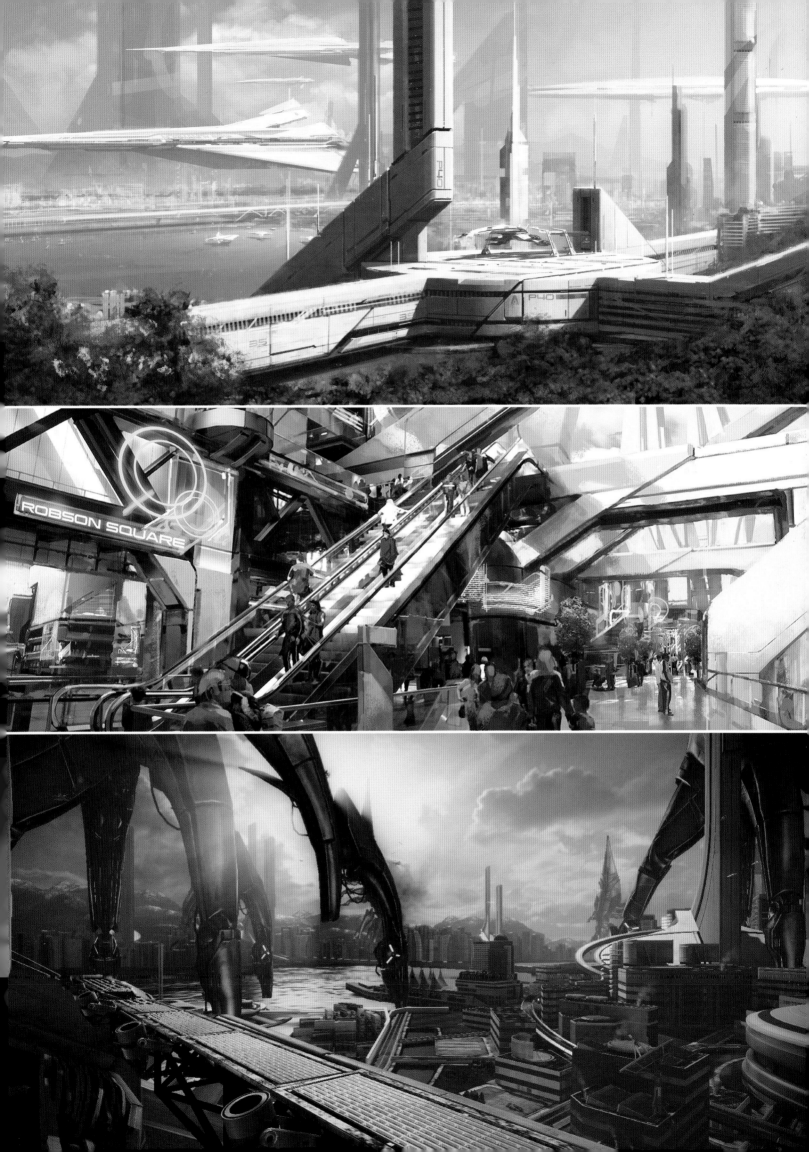

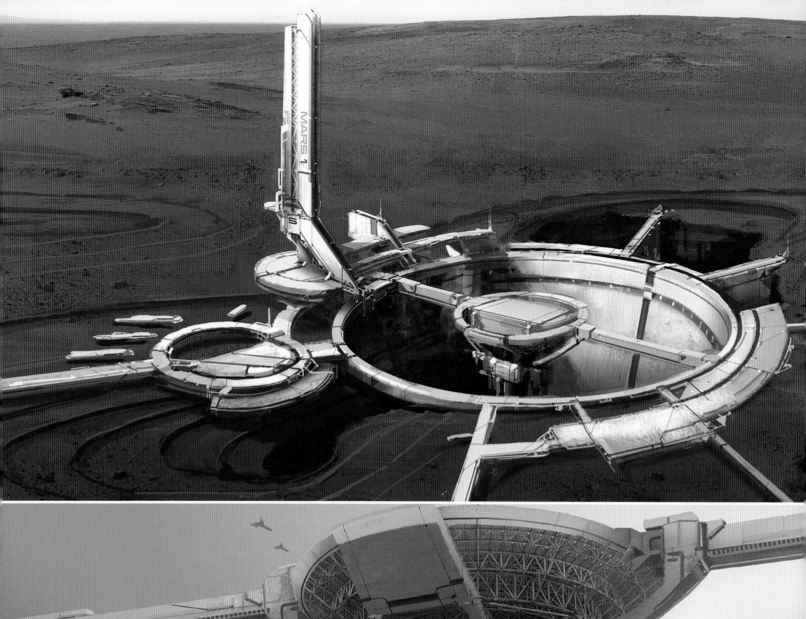

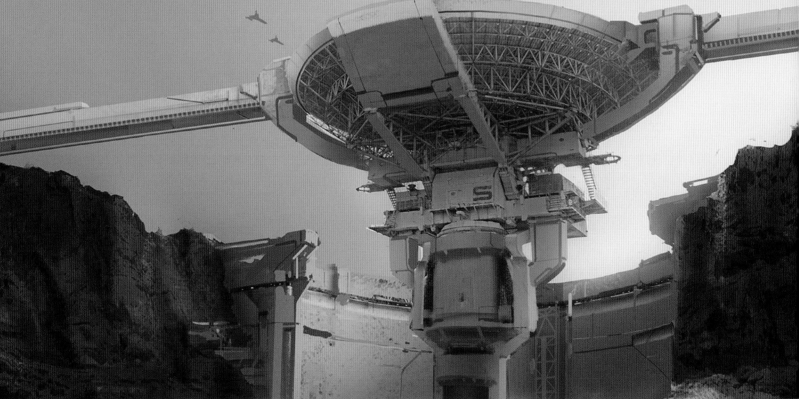

MARS

After Earth, Mars was probably the second most exciting planet to design. We knew it would have human architecture, and we wanted to capture the realistic feel of a drill site on the red planet, excavating Prothean secrets of the Mars archive. We kept the base quite low to the ground to help it survive sandstorms and other harsh Martian weather, and went with a circular design that supported a large drilling shaft down the middle. The large spokes coming off the circle serve as docking stations for shuttles and rovers.

The design of the interior has a clean, industrial look, more like a first-world factory than a backwater mining station. The architecture also shows how humans' decades of studying the Prothean archives influenced the design of the mine.

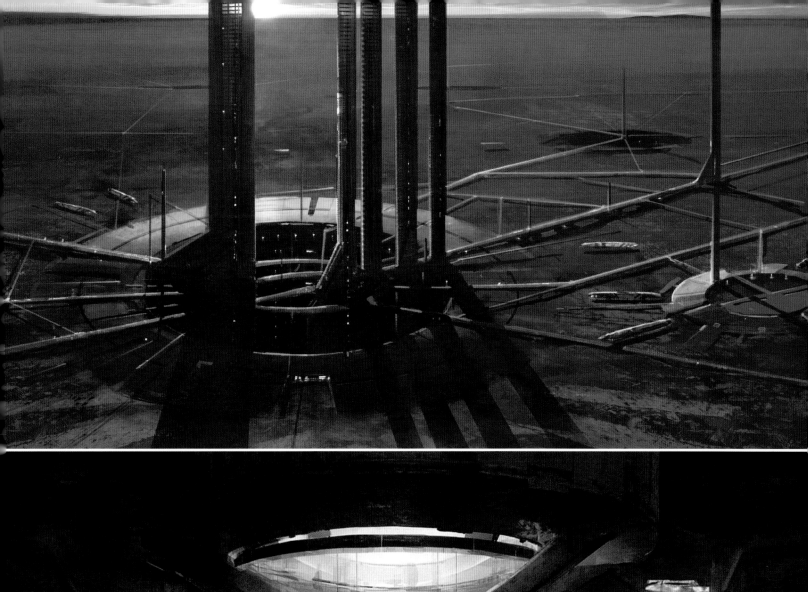

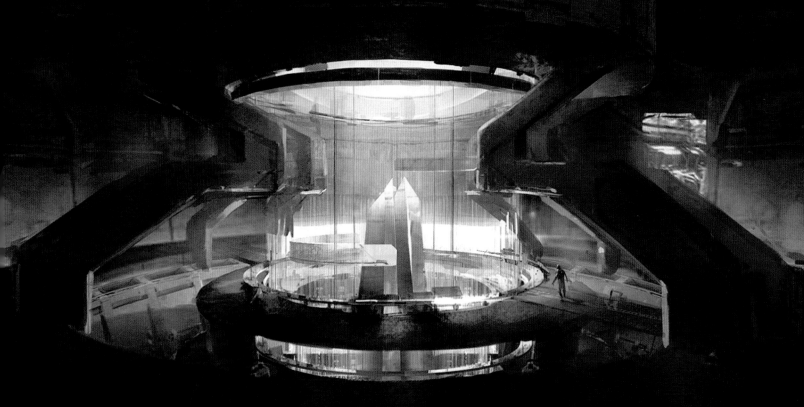

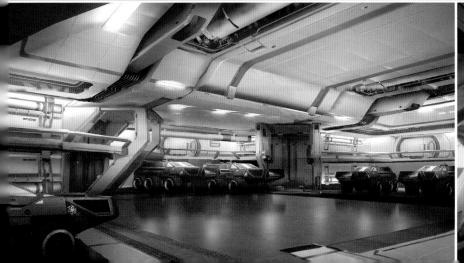

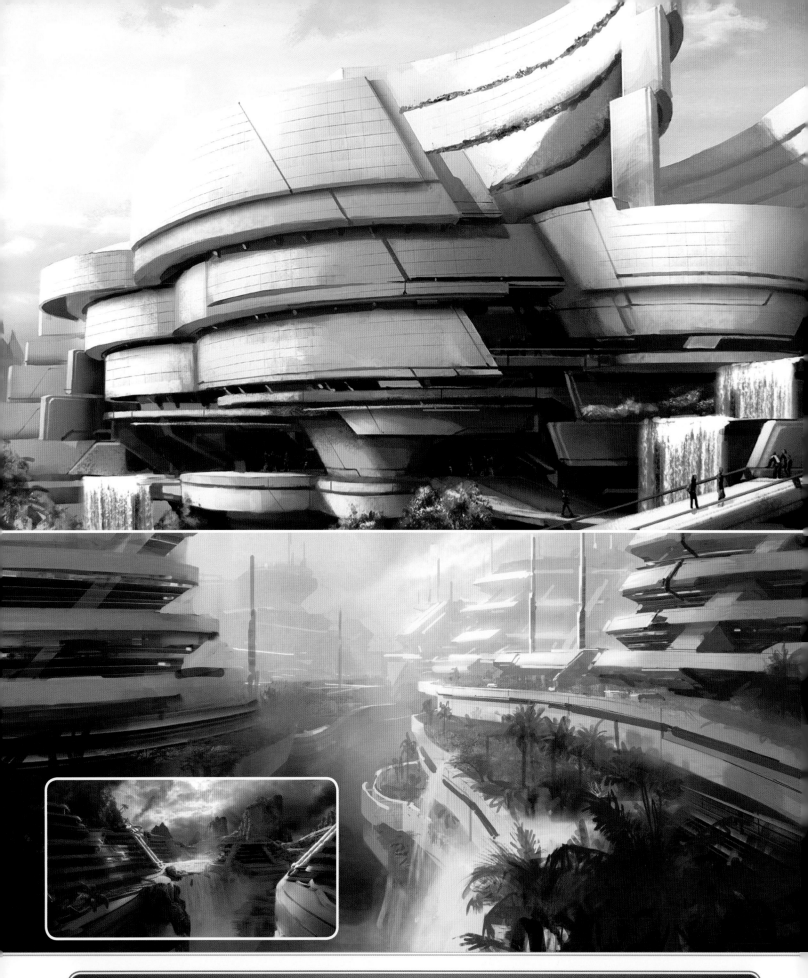

SUR'KESH

Sur'Kesh, the salarian home world, had to harbor an amphibious species. We went with a lush, tropical jungle that implied humidity. We thought the large curves of the structures mimicked some of the more organic shapes in salarian armor and clothing. The actual inspiration for this building was a shopping center in Istanbul. We intentionally designed the interiors to blur the line between the landscape and the structure, which helped give the base a very open and inviting feeling. The rubble is the result of Cerberus dropping in a commando team, turning the idyllic building into a battleground.

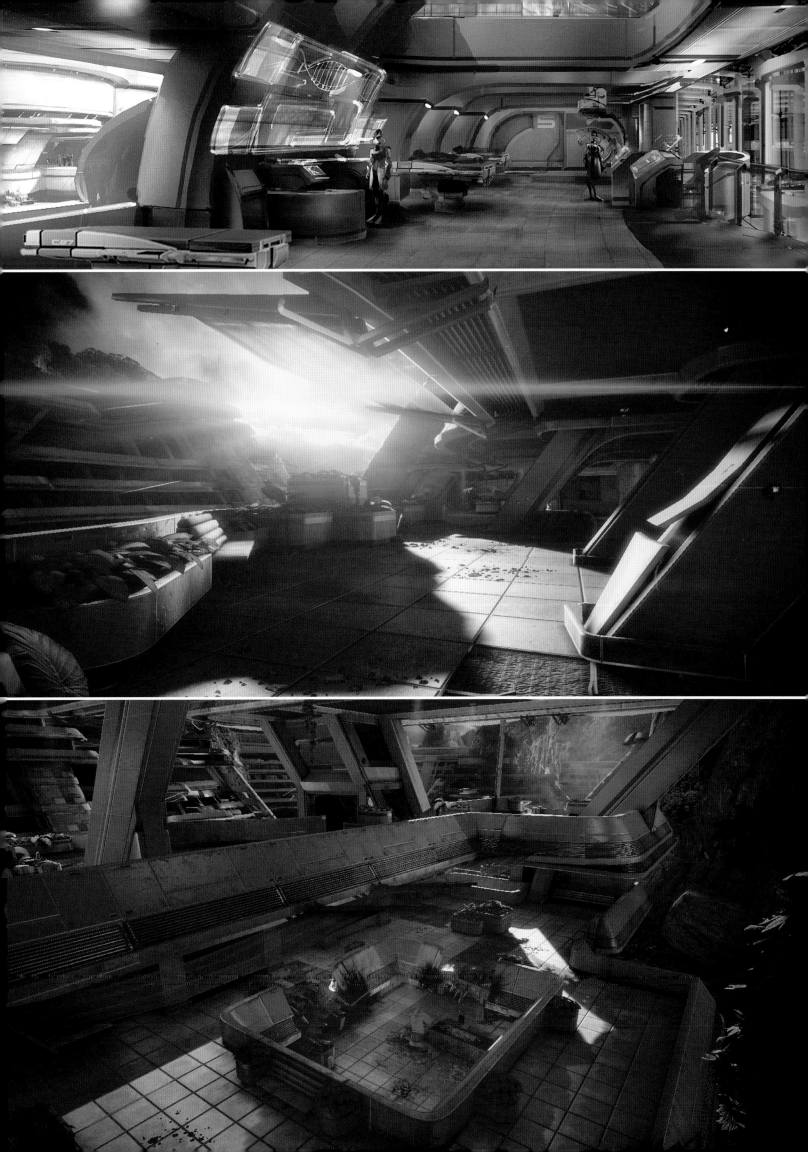

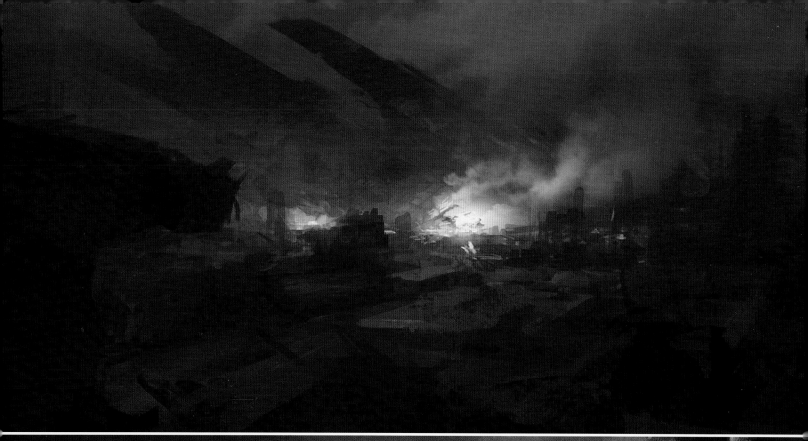

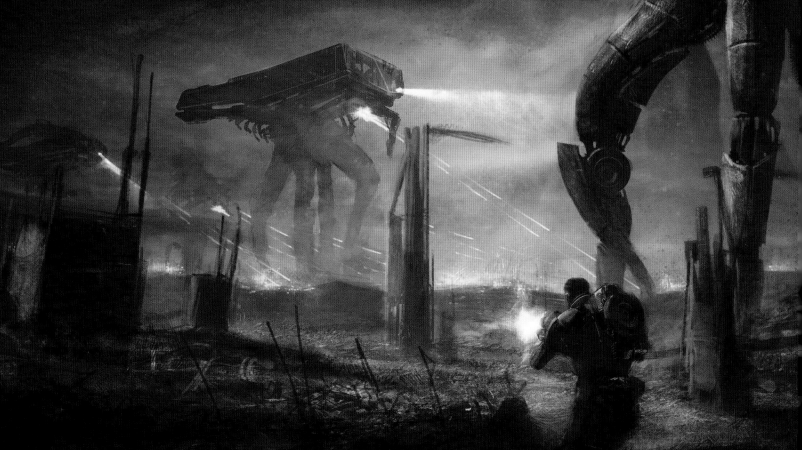

TUCHANKA

Tuchanka was well established in *Mass Effect 2* as a bomb-blasted planet that was mostly rubble. The top image was created to help visualize the adventure with the turian crash site. The lower image was a very early concept showing what Reaper walkers invading the planet might look like.

The lost krogan city on the facing page was meant to evoke the feeling that the krogan were worth saving, and that they once created things of beauty before their society crumbled and and the krogan nearly became extinct. We showed minor battle damage as well as sparse foliage to imply that life had a small, fragile hope of persisting, even in the midst of mass destruction. The structures were inspired by Frank Lloyd Wright's architecture, over which we placed a veneer of krogan aesthetics that made it seem more brutal in nature. The bottom concept on the facing page was an early draft of the space elevator used to reach the Shroud, a high-tech atmospheric device used to block Tuchanka's harsh sun.

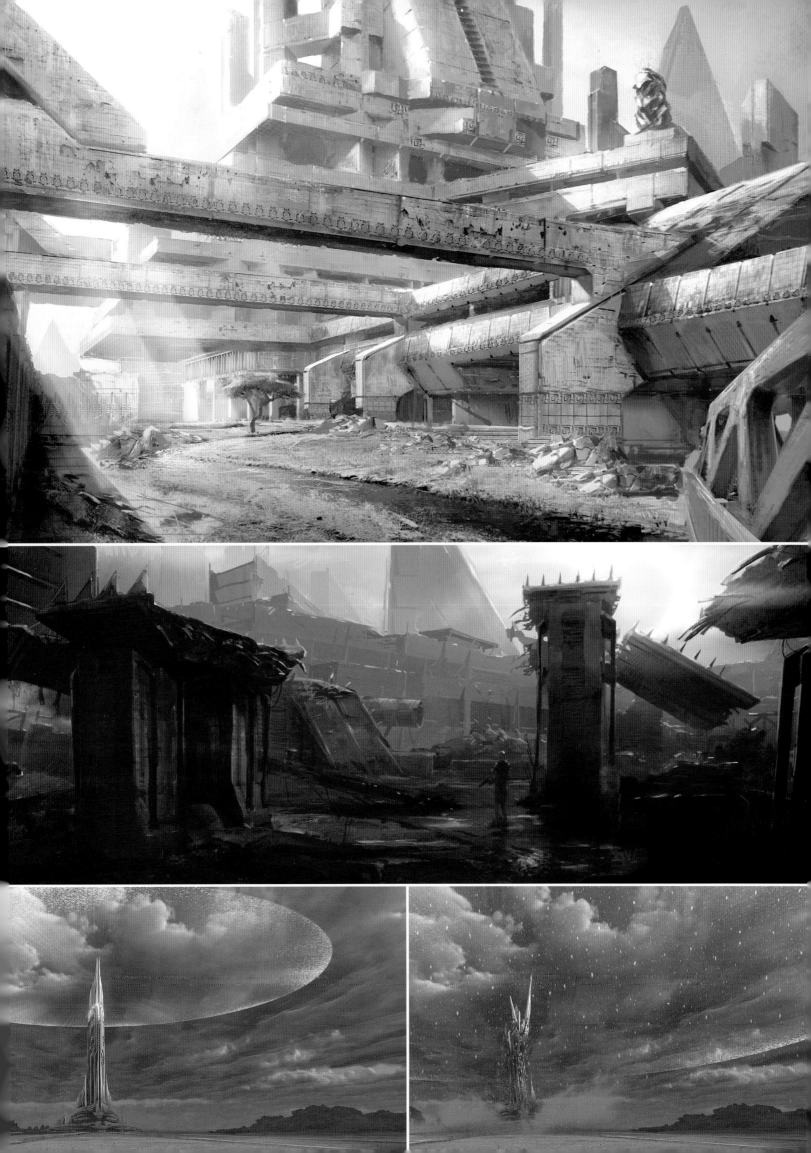

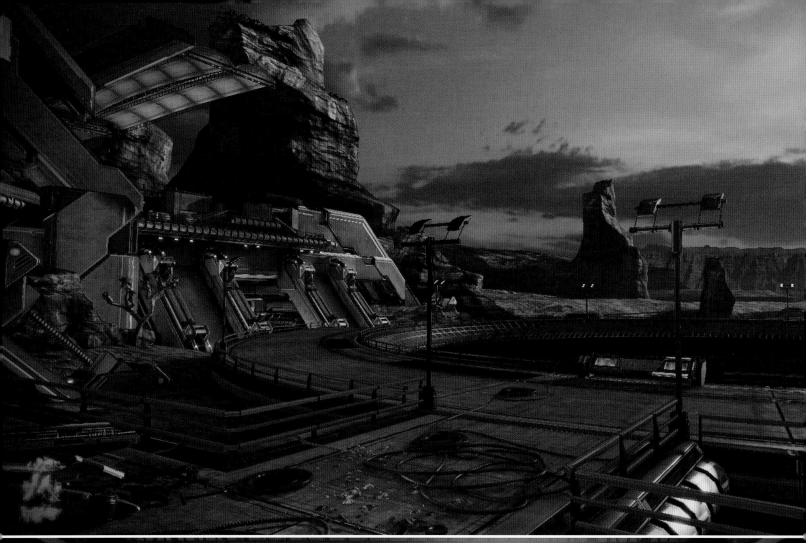

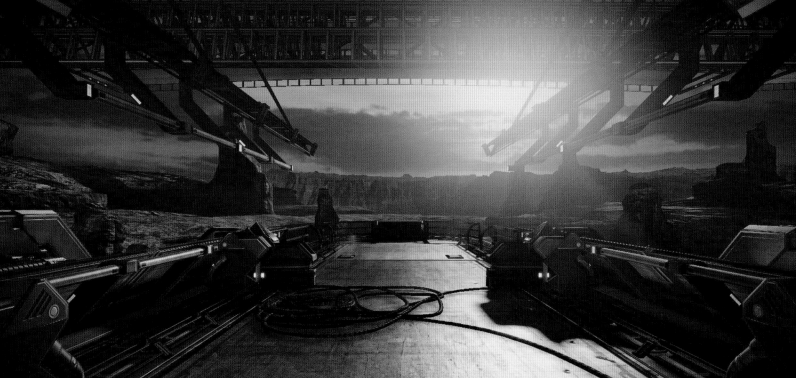

RANNOCH

The challenge for Rannoch, the quarian homeworld, was to create a place that seemed consistent with two alien styles: quarian architecture, seen on the Migrant Fleet, and geth architecture, introduced by the geth occupation of the quarian planet centuries prior. We decided to keep Rannoch's quarian environments industrial looking, with modular stainless-steel sections similar to the Lloyd's of London building.

The interiors and exteriors were meant to blend—there was no hard line between the two. We were careful not to put in battle damage here, since the geth have kept the quarian home world in an almost pristine state.

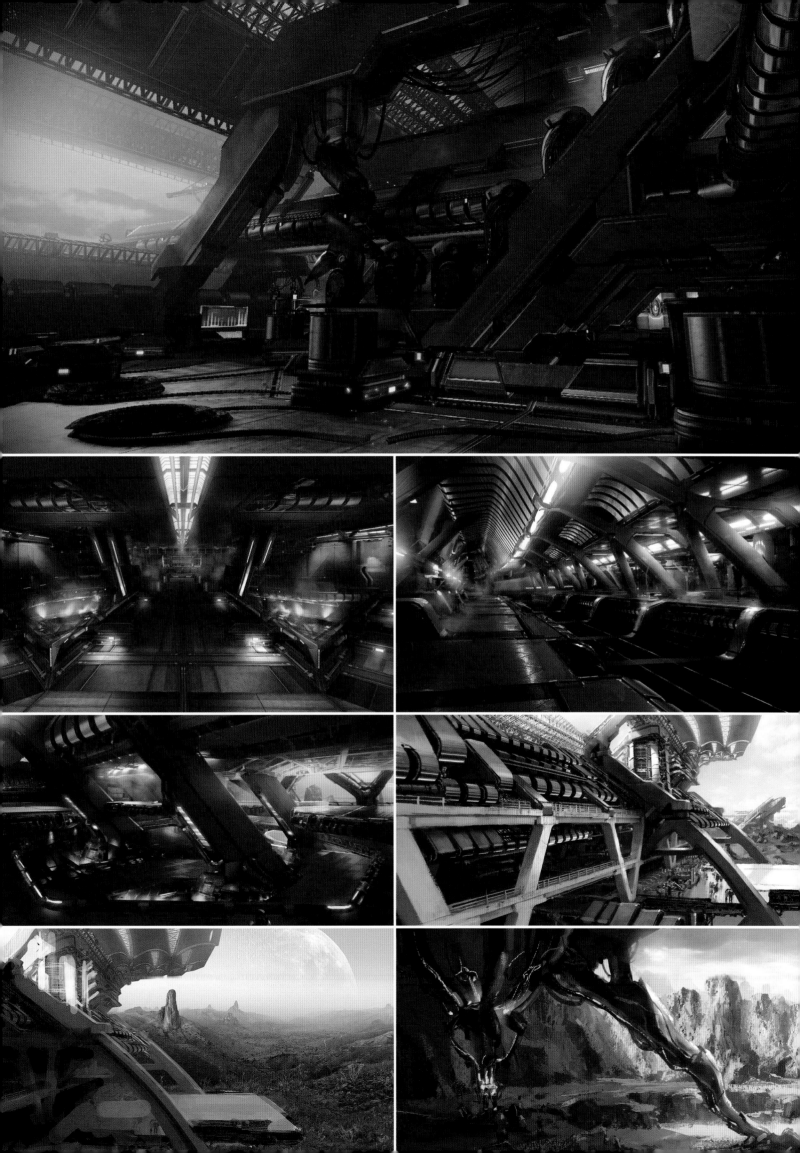

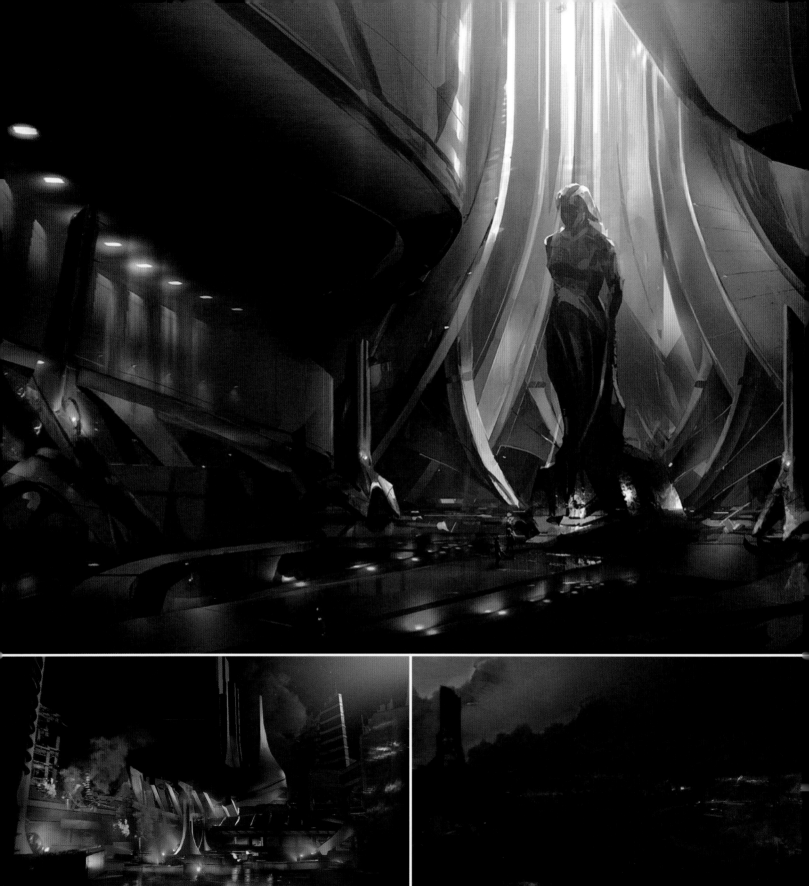

THESSIA

In previous games, players visited asari-influenced worlds, so we knew how to style the asari homeworld for *Mass Effect 3*. The architecture has a lot of large, swooping curves, reminiscent of the work of architect Santiago Calatrava. On the opposite page are early concepts for Thessia that did not show the battle damage from a Reaper invasion that eventually made it into *Mass Effect 3*.

The above concept is for the asari temple on Thessia, which includes upward-swooping lines like a cathedral. The lower images show some of the battle damage added to the planet to tie it to the Reaper attack.

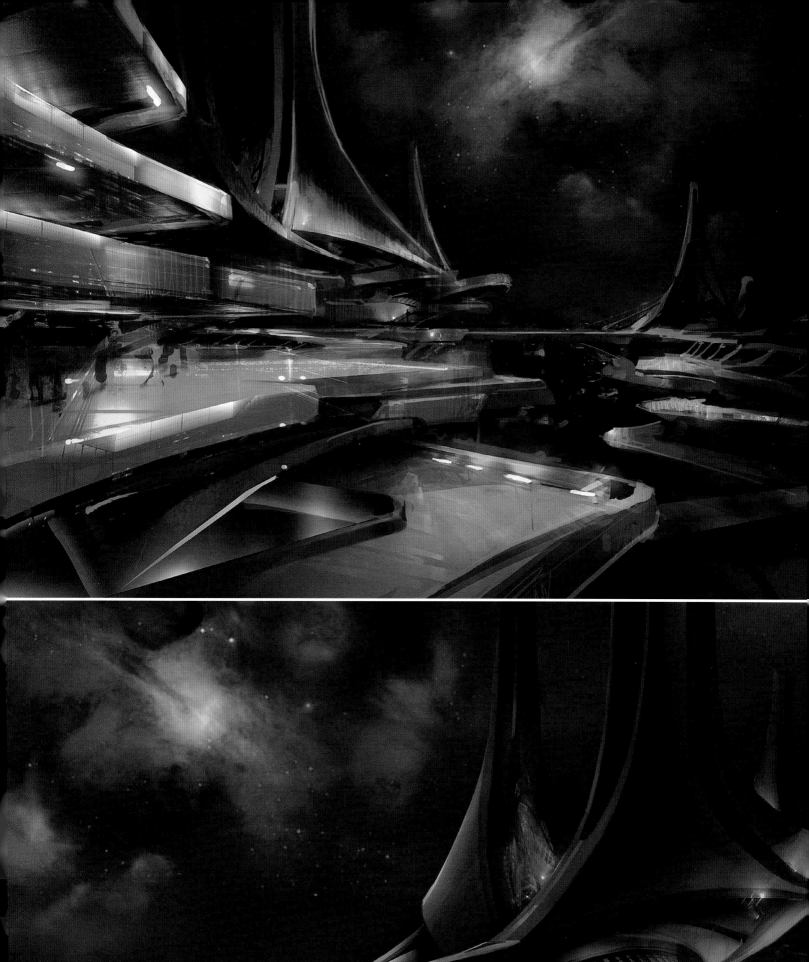

THE CITADEL

We had seen the Citadel in the previous two games, but we needed a few more concepts to show the station from a new angle in *Mass Effect 3*. The bottom image is a concept for the keeper tunnels that were never used, where the creatures would walk around to maintain the station. The blue pads used mass-effect fields to keep the outer skin of the ward arms separate from the rest of the structure so it could shrug off incredible impacts during battle.

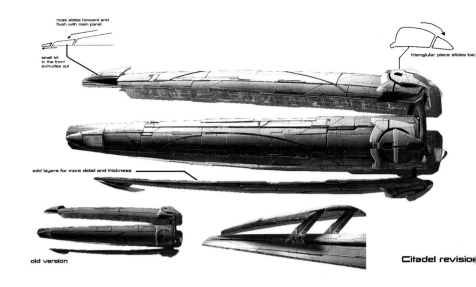

nose slides forward and flush with main panel

small bit in the front extrudes out

triangular piece slides ba

add layers for more detail and thickness

old version

Citadel revisio

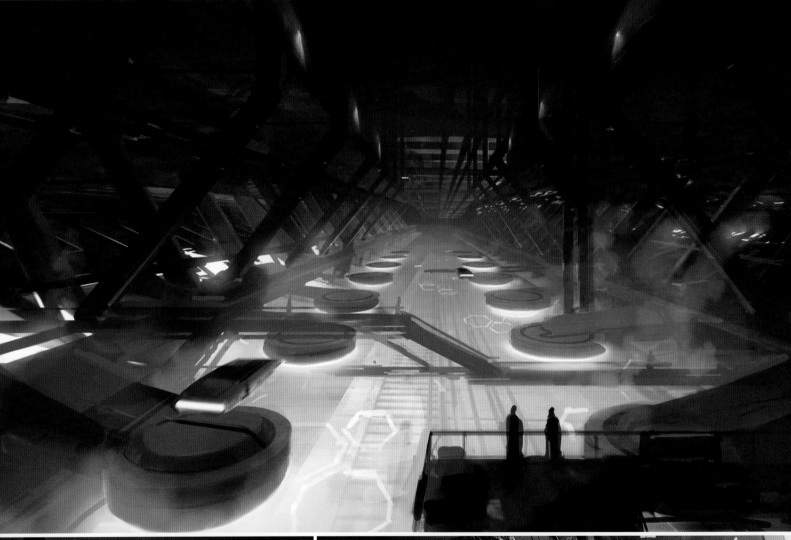

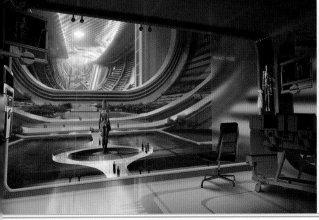

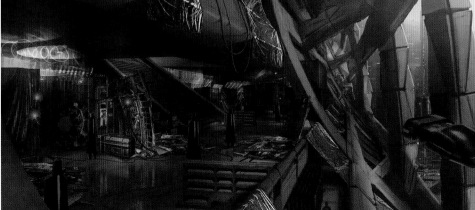

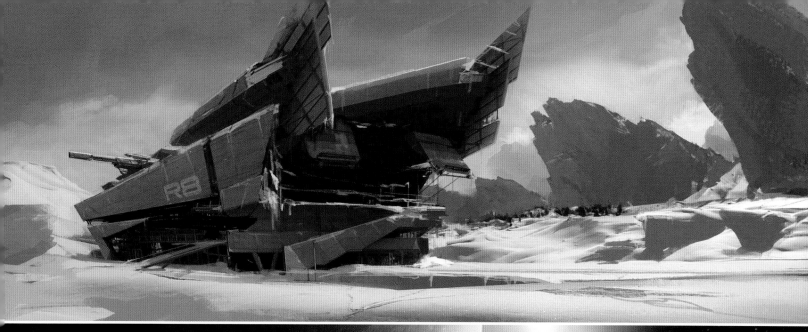

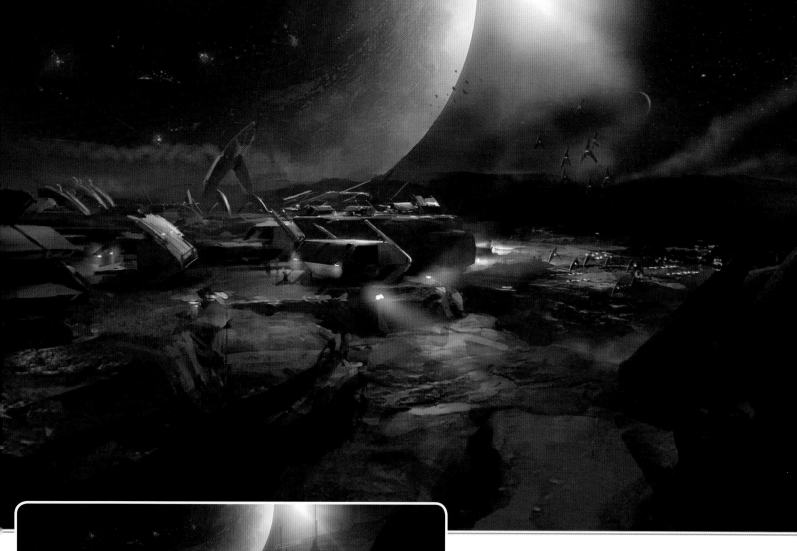

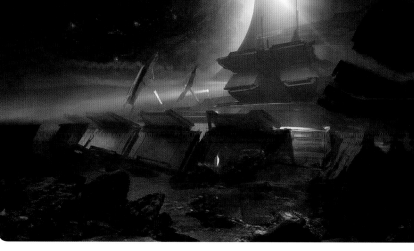

MENAE

The top image is an early concept of a turian outpost, created when we were trying to get a handle on their design. We knew what their ships looked like, but not their architecture. The below two images were made after it was decided that the turians would have a base on Menae, Palaven's moon, from which they could organize a counter-attack on the Reapers. The turian structures were designed to be portable military fortifications that could be set up hastily.

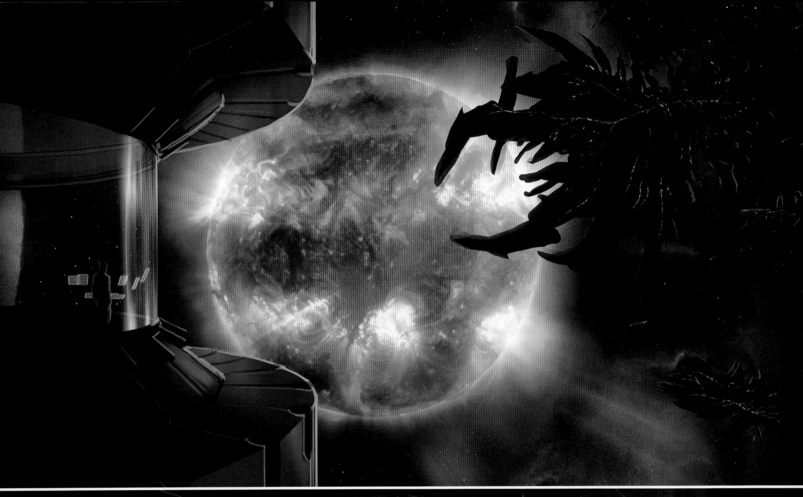

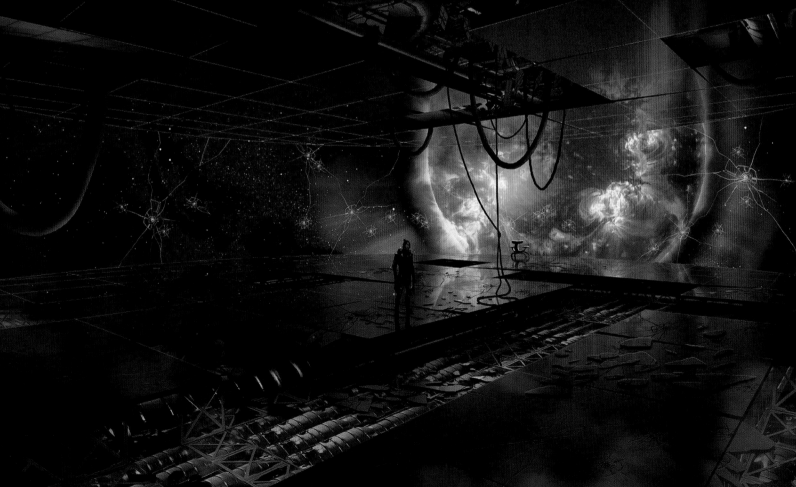

CERBERUS HEADQUARTERS

These are early concepts imagining the Cerberus headquarters. The top image represents a version in which the Illusive Man is not viewing a hologram but instead has a window that looks out at a dying star. The bottom image envisions what the room would look like following a violent confrontation.

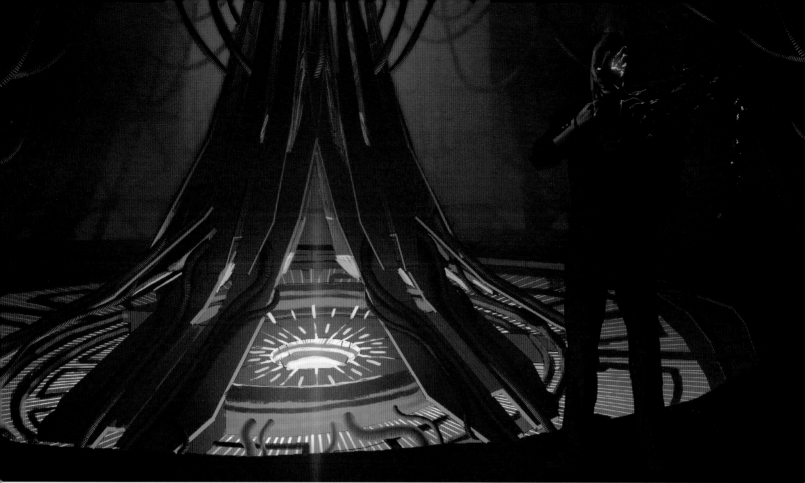

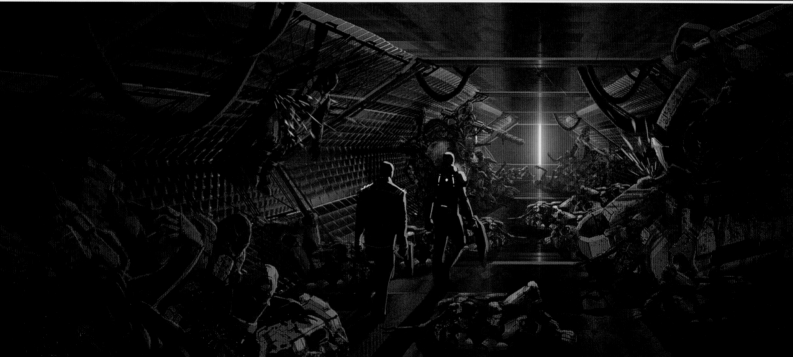

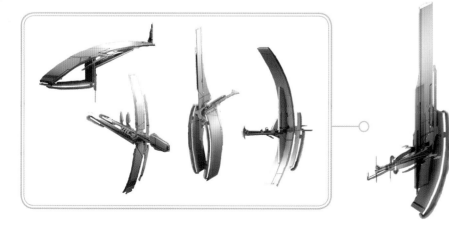

The top concept shows the Illusive Man in the early stages of development, back when he was heavily modified by Reaper cybernetics.

Above is what the final room might have looked like if Shepard fought him in this space. The concept is meant to show the moment right before the confrontation, during which Shepard is walking past the bodies of the last of the Illusive Man's Cerberus troops.

The bottom, rightmost image is close to the final outer appearance of the Cerberus headquarters, which is intended to evoke the image of a blade cutting through space. Its engines are similar to those of Minuteman Station in *Mass Effect 2*.

THE NORMANDY SR-2

The *Normandy* SR-2 did not undergo many changes from *Mass Effect 2*. Most notably, its colors were repainted in Alliance blue to reflect the Systems Alliance's possession of the ship following the events of *Mass Effect 2*'s downloadable content *Arrival*.

On the opposite page, the top two images were ideas for changes to the interior of the *Normandy*. We wanted to convey the feeling that it had been captured and studied by the Alliance. The red and blue color changes were to show that the ship was almost always on high alert, appropriate for the wartime setting. The bottom image was an early production painting of a saboteur or assassin breaking into Shepard's room.

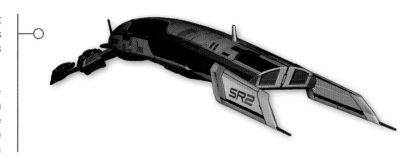

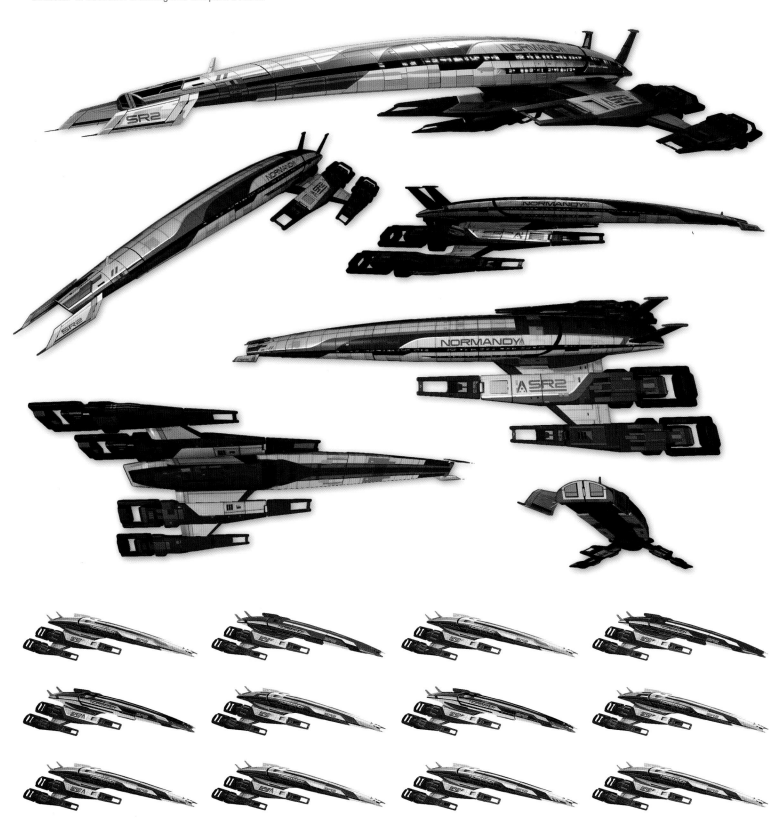

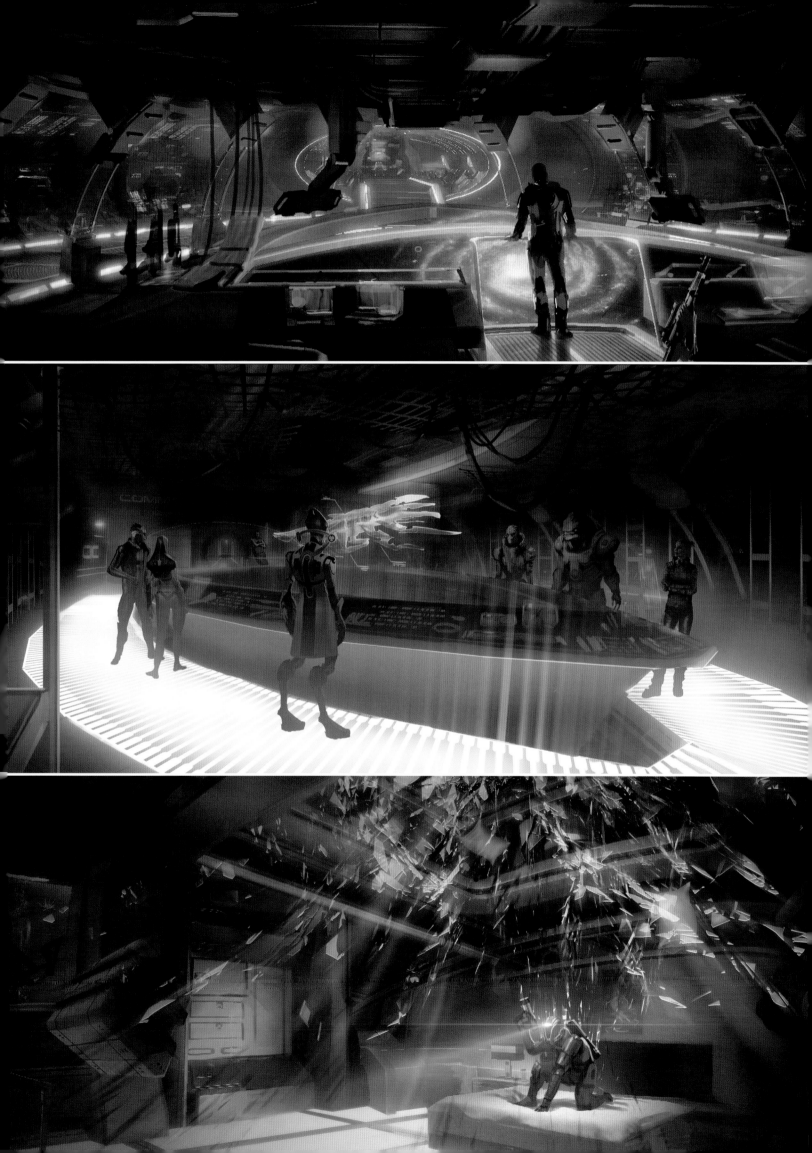

VEHICLES

The human ships in the original *Mass Effect* had red and white detailing. As production progressed on *Mass Effect 3,* we decided that Alliance colors should instead be blue and white. These ships were to be featured heavily in the final battle scenes.

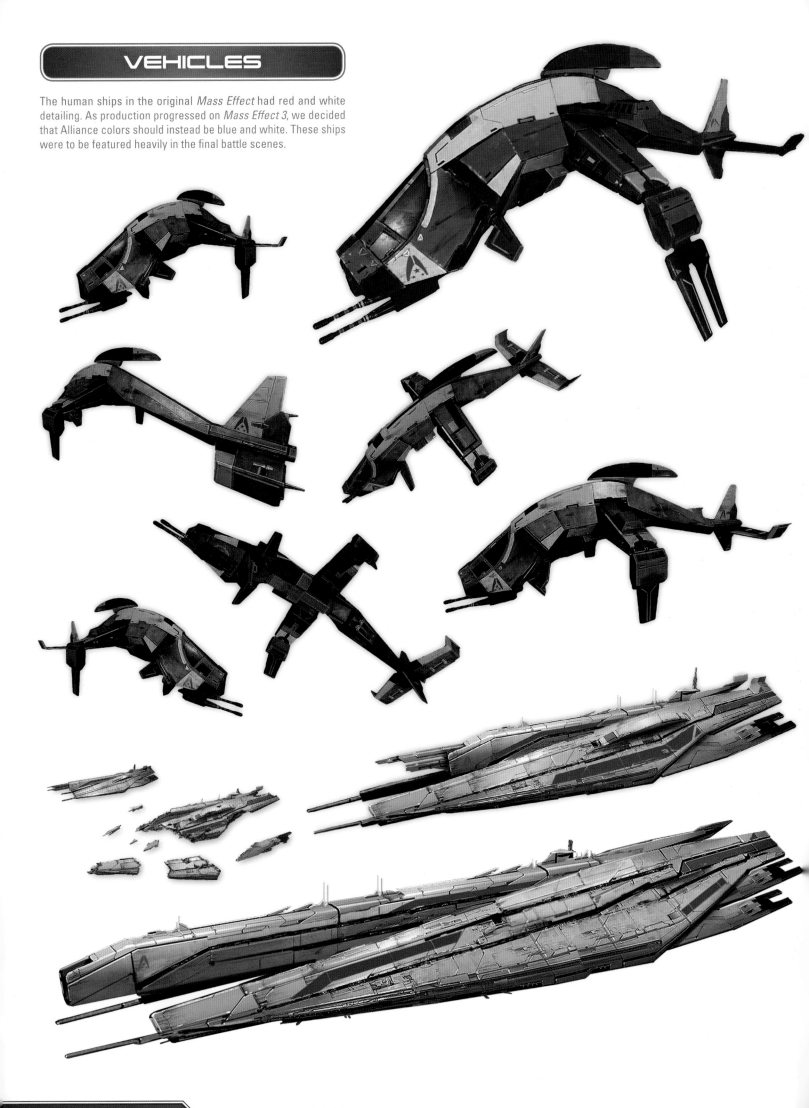

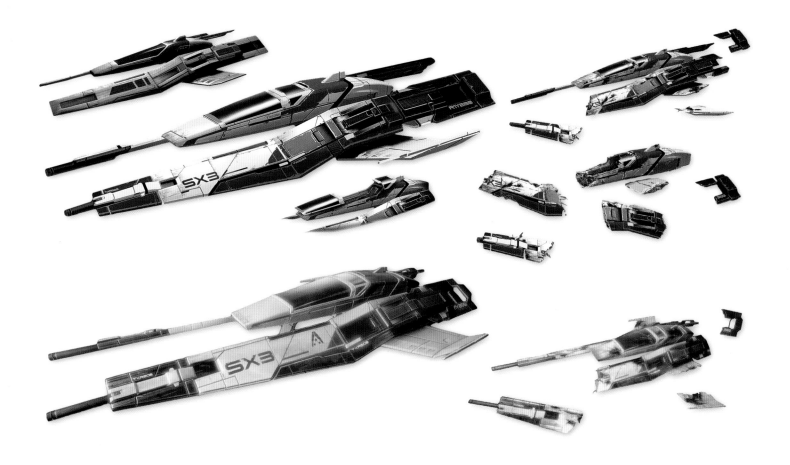

The top images are assets for Alliance fighter ships from the first *Mass Effect* that were never used. We revisited them and improved their fidelity and detailing for *Mass Effect 3*. The early red and white paint job was changed to reflect the blue and white Alliance colors. Below are various interiors for Alliance fighters and the Alliance shuttle.

FIGHTER COCKPIT

SHUTTLE COCKPIT

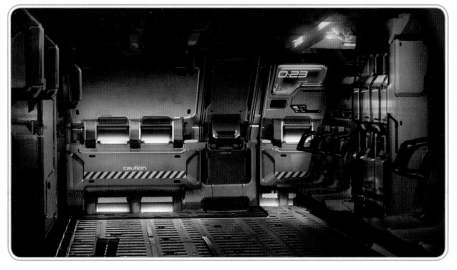

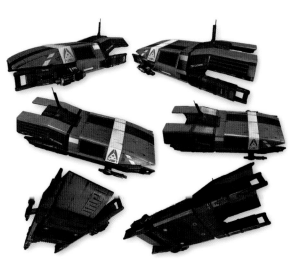

The interior of the Kodiak shuttle was a surprisingly important set piece, since Shepard has numerous conversations with the squad members on the way down to the surfaces of various planets. For the exterior, we blacked out the windows to make it feel more military and added guns to give it a more combat-ready appearance.

WEAPONRY

Each weapon variety maintains the iconic style of each group. For example, the N7-specific weapons share the same color scheme as Shepard's armor, while turian rifles share some of the angular features of their ships and architecture.

Pictured below are two variations of the submachine gun, a popular weapon. The color schemes indicate one was developed for the N7 soldiers and the other for Cerberus.

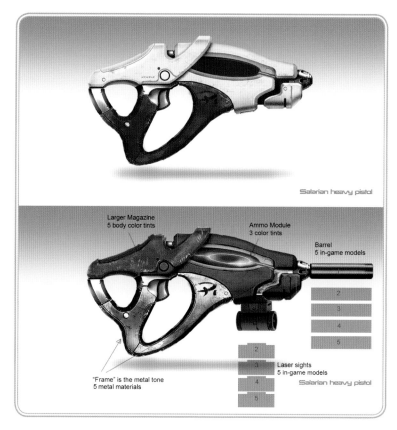

Salarian heavy pistol

Larger Magazine
5 body color tints

Ammo Module
3 color tints

Barrel
5 in-game models

2
3
4
5

2
3
4
5

Laser sights
5 in-game models

"Frame" is the metal tone
5 metal materials

Salarian heavy pistol

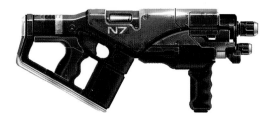

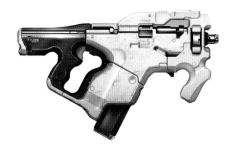

We added a customization system for weapons in *Mass Effect 3*. To show the five different levels of modifications for each weapon, concepts like the one above were created. The weapons' modifications could include scope, barrel, and muzzle attachments to visually show the effects of upgrades.

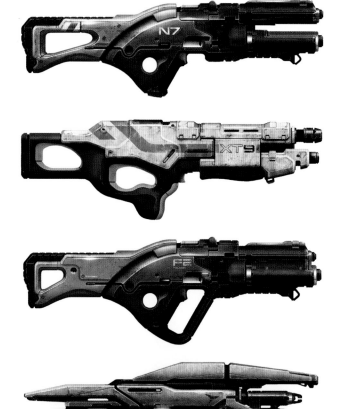

Assault Rifles

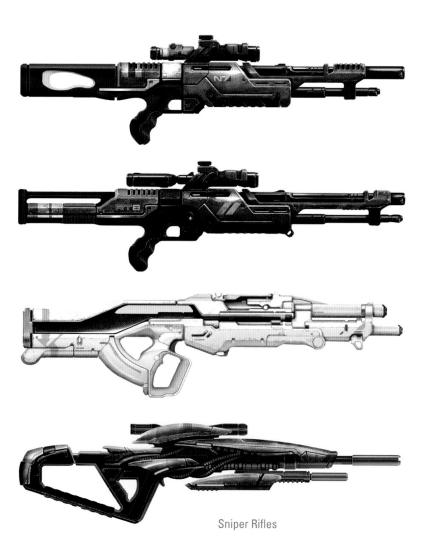

Sniper Rifles

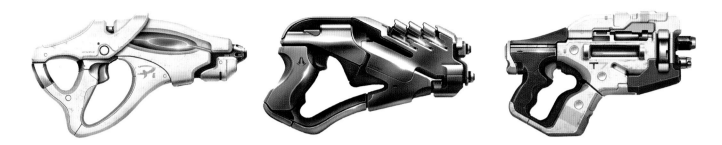

The pistols above show how their design was informed by the clothing and architecture of the species that developed the weapons. The salarian pistol on the left uses elements from Mordin's clothing. The middle pistol is quarian, while the one on the right is Cerberus, its design drawn from their color scheme and their armor's bulk.

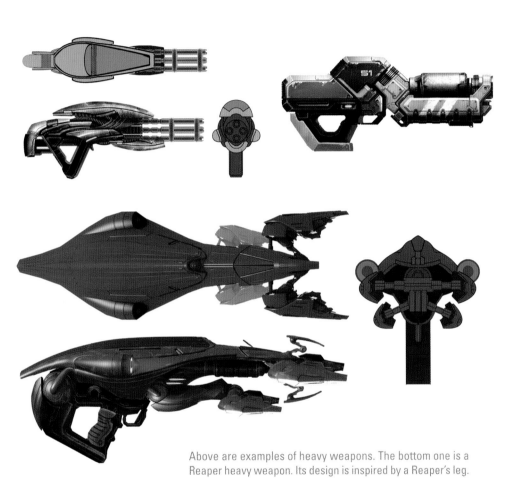

Above are examples of heavy weapons. The bottom one is a Reaper heavy weapon. Its design is inspired by a Reaper's leg.

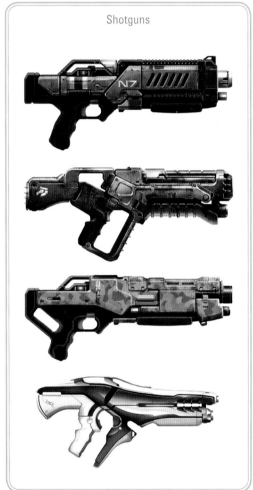

Shotguns

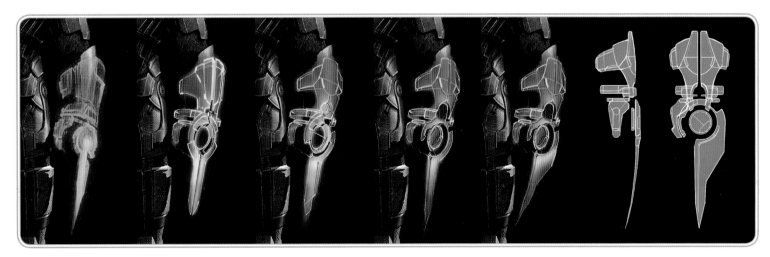

We created the omni-blade to make melee combat as exciting as gunplay. The blade is similar to the omni-tool from the previous games, but it is not entirely holographic. In *Mass Effect 3*, the omni-tool uses an ultrafast fabricator to manufacture a disposable blade almost instantly.

THE CRUCIBLE

The Crucible is meant to evoke an enormous, rocket-propelled bomb: something like a cross between the Trinity bomb and a NASA space probe. The inset image below shows how the outer, protective shell would blow off to expose its working parts.

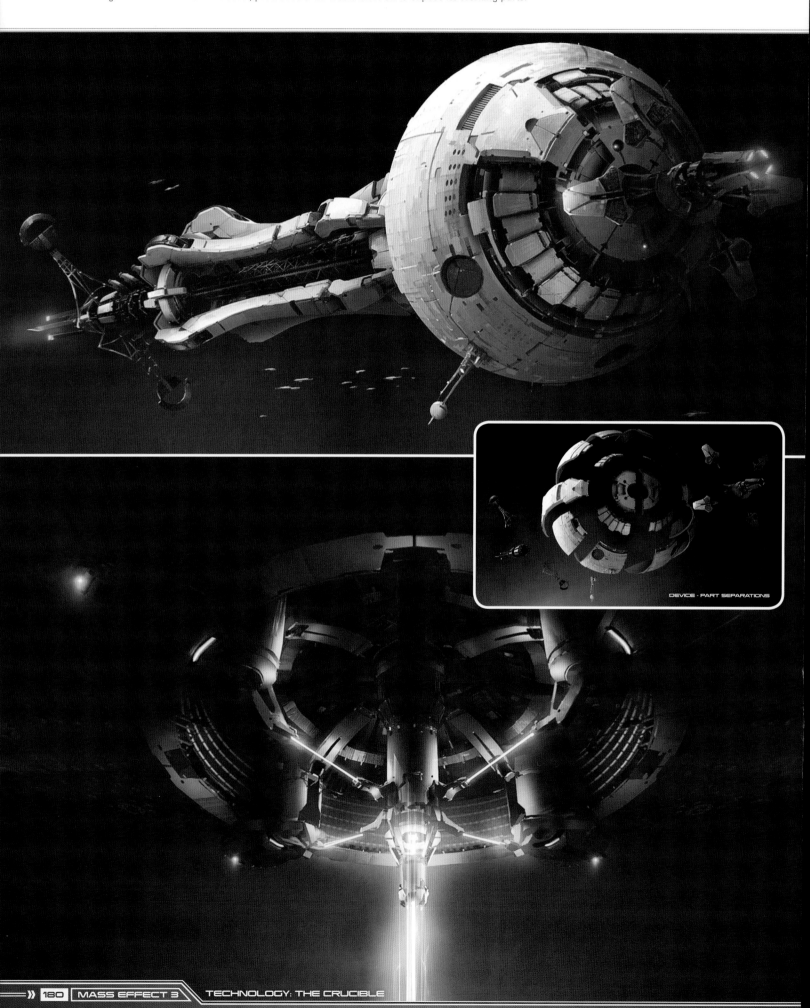

DEVICE - PART SEPARATIONS

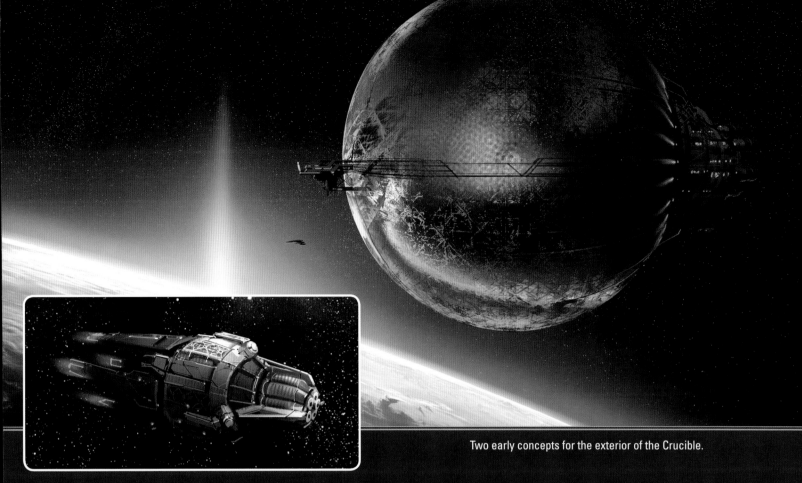

Two early concepts for the exterior of the Crucible.

CONSTRUCTION

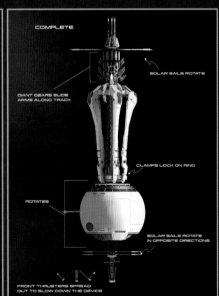

COMPLETE

SOLAR SAILS ROTATE

GIANT GEARS SLIDE
ARMS ALONG TRACK

CLAMPS LOCK ON RING

ROTATES

SOLAR SAILS ROTATE
IN OPPOSITE DIRECTIONS

FRONT THRUSTERS SPREAD
OUT TO SLOW DOWN THE DEVICE

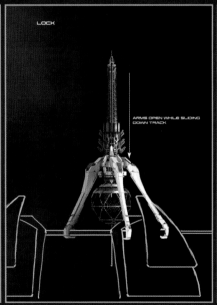

LOCK

ARMS OPEN WHILE SLIDING
DOWN TRACK

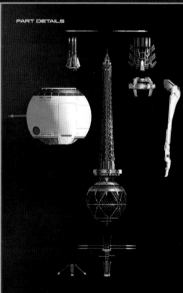

PART DETAILS

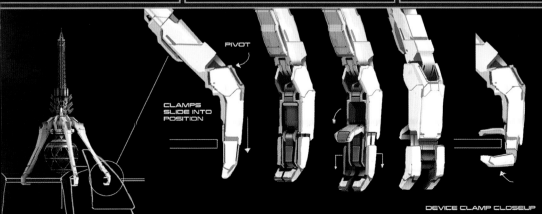

PIVOT

CLAMPS
SLIDE INTO
POSITION

DEVICE CLAMP CLOSEUP

It was such a complicated piece
of machinery that we had to draw
up numerous plans for its use. The
large arms slide down the structure
to clamp it in place.

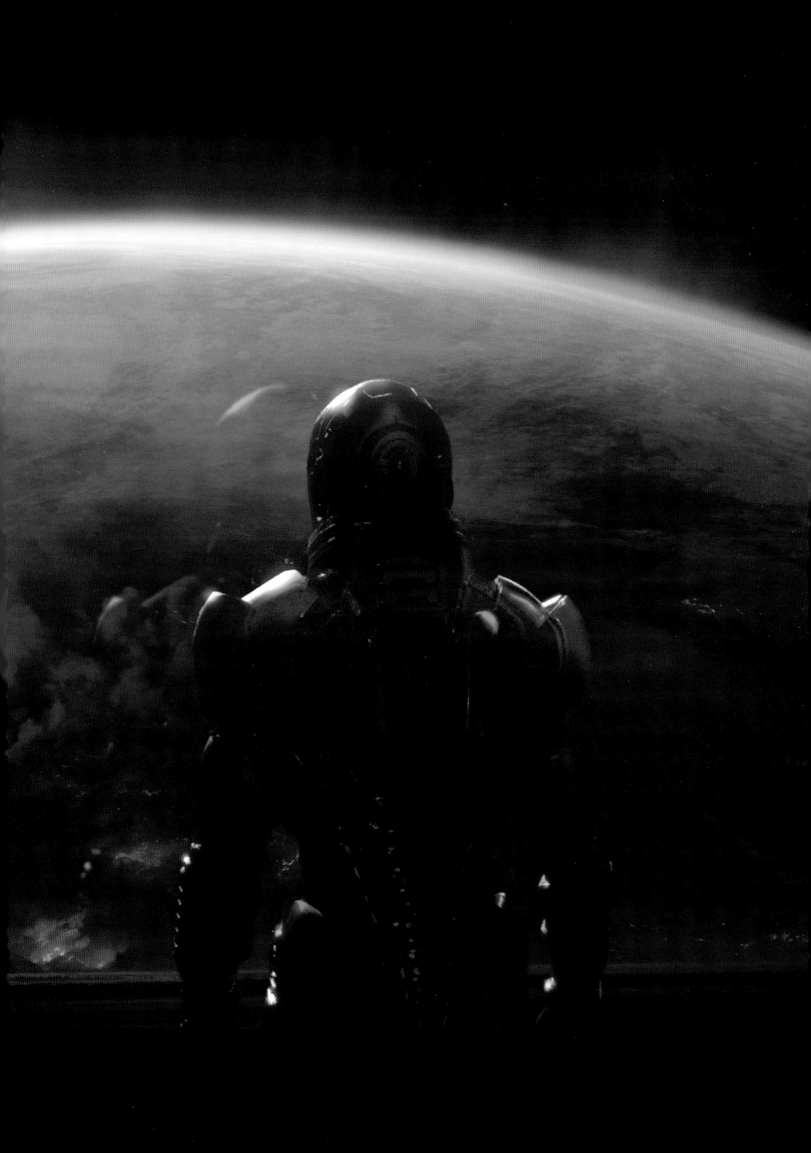